35mm PHOTOGRAPHY
THE COMPLETE GUIDE

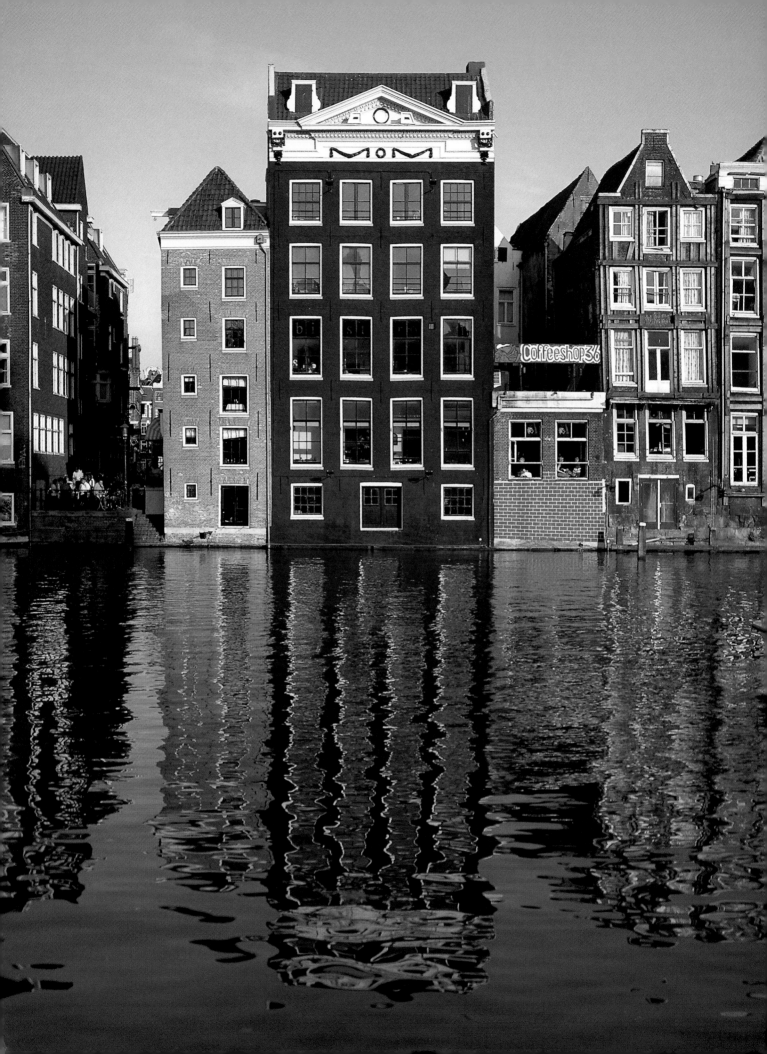

35mm
PHOTOGRAPHY
THE COMPLETE GUIDE

Steve Bavister

David & Charles

Page 2: CATCHING THE LIGHT
One of the great things about being on holiday is being able to return to spots when the light is right. This reflection of buildings in Amsterdam looked promising earlier in the day, but the light was too harsh. I returned four hours later to find it like this – just perfect.

A DAVID & CHARLES BOOK

First published in the UK in 2004

Copyright © Steve Bavister 2004

Distributed in North America
by F&W Publications, Inc.
4700 East Galbraith Road
Cincinnati, OH 45236
1-800-289-0963

A catalogue record for this book is available from the British Library.

ISBN 0 7153 1629 X hardback
ISBN 0 7153 1631 1 paperback (USA only)

Printed in Singapore by KHL Printing Co Pte Ltd
for David & Charles
Brunel House Newton Abbot Devon

Commissioning Editor Neil Baber
Senior Editor Freya Dangerfield
Desk Editor Lewis Birchon
Art Editor Sue Cleave
Production Controller Kelly Smith

Visit our website at www.davidandcharles.co.uk

David & Charles books are available from all good bookshops; alternatively you can contact our Orderline on (0)1626 334555 or write to us at FREEPOST EX2110, David & Charles Direct, Newton Abbot, TQ12 4ZZ (no stamp required UK mainland).

Contents

Why 35mm?

In an age that has seen so much technological change in so many areas – especially photography – it's astonishing to think that the 35mm format has been around for nearly one hundred years. It was in 1911 that a climbing enthusiast named Oskar Barnack got a job at the German optical company E. Leitz. To enable him to record his climbing trips, he set out to create a lighter, more compact alternative to the bulky, heavy roll-film cameras then available. After two years he came up with a prototype of the first Leica (which took its name from Leitz Camera), although it was not launched commercially until 1925. The Leica 1 was an extremely simple camera, but it sold well and before long other companies started producing rival models.

Initially, the 35mm 'miniature' format was derided by many enthusiasts and professionals because the quality of the prints made from the 24 x 36mm negatives was significantly inferior to that of prints from the plate and roll-film cameras that most people used. But the portability and handling of the new format made it popular, particularly among photojournalists, in whose work quality was not the overriding factor.

Although the early 35mm cameras were extremely basic – with no metering, no built-in flash, no modes, no integral winder, no autofocus – most

THE 35MM FORMAT

⊙ The name 35mm refers to the total width of the film, including the edge sprockets, but the actual image area is 24 x 36mm.

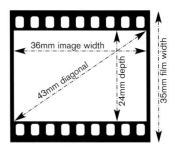

featured a good range of reliable shutter speeds, usually up to 1/500 sec, along with aperture control. Initially, photographers had to load film on to cassettes themselves in the darkroom – pre-loaded cassettes did not become available until later. Nor did the first 35mm cameras have reflex viewing. Most were rangefinder designs, with a separate viewfinder, though some did feature interchangeable lenses.

The concept of a single lens reflex camera – allowing the user to view the subject through the taking lens – had arisen as early as the 1860s, but the first SLR to become commercially available, the 'Sport', was introduced only in 1935. It was, however, extremely basic, and it wasn't until the late 1950s that the reflex camera as we know it was born, with the launch of key models from Pentax, Canon and Nikon. Over the last 50 years the initial design has been enhanced by the addition of numerous features and facilities intended to make photography easier and more foolproof, though the SLR has only ever really been used by enthusiasts and professionals. Alongside it, the 35mm 'compact' was developed for a mass market that wanted good quality results, but from a camera that was simpler to operate.

Slowly, steadily, over the course of the 20th century, 35mm grew to become the dominant format in imaging around the world – against

⊙ **LEICA I**
The Leica I is where it all began for 35mm photography some 80 years ago.

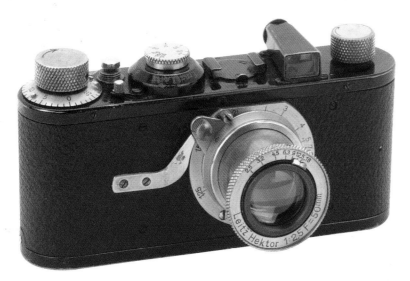

considerable opposition. Not only were excellent roll-film cameras being produced throughout the period, but several different formats were also introduced: 126 in 1961, 110 in 1971, Disk in 1981 and APS (Advanced Photo System) in 1995. None, though, was able to halt the seemingly inexorable rise in the popularity of 35mm.

There are many reasons for 35mm's enduring appeal, but it's hard to pin down one factor that on its own can be judged responsible. Certainly, size and weight have played an important part from the beginning. And, over time, cameras have become lighter and smaller, thanks to the development of new materials such as polycarbonate, and the introduction of electronic rather than mechanical operating systems. Modern 35mm cameras are extremely portable. You can easily slip a zoom compact into a pocket or handbag, while an SLR and a collection of lenses and accessories will fit into a bag that can be carried around comfortably.

Of equal importance has been the way in which automation has been incorporated to make cameras easier to use. The history of the 35mm camera, as the chart opposite shows, has seen the addition of increasingly advanced metering controls, the development of fast and accurate autofocus systems, and the inclusion of accessories such as built-in winders and flashguns. These developments were all part of a deliberate philosophy among manufacturers, particularly the Japanese, to make cameras as foolproof as possible. Many readers will remember the days when there was some doubt about whether a picture would 'come out'. But those days are long gone. Thanks to the appliance of science, it's now far from easy to produce a failure.

One of the benefits of all this automation has been to increase the options available. Many 35mm models now have built-in microprocessors that give users unparalleled control over a wide range of functions – from different exposure modes and metering patterns to when and how the flashgun fires and how the autofocus operates. This has made cameras not only more responsive than ever before, but also more creative. You can do virtually whatever you want to do with an SLR, quickly and easily. The only real limit is your imagination. Even 35mm compacts, which at one time were largely simple 'point and shoot' cameras, now often have sophisticated controls and wide-ranging zoom lenses that make them suitable for many different kinds of subjects.

Optical technology has moved forward significantly as a result of computer-aided design. Astonishingly, it's nearly 50 years since the first zoom lens was introduced. But while the earliest zooms were of indifferent quality, the latest versions are extremely good. It's a similar story with film. When 35mm started, the available film stock was derived from cine film. It not only produced grainy results and poor definition, but also had an ISO (or, as it was known then, ASA) rating of just 25, and of course only black and white was available. These days we can use films with sensitivity as high as ISO 3200, while films at the popular speeds – ISO 200 and ISO 400 – are able to reproduce every little detail with virtually no grain.

In fact, it's fair to say that the 35mm photographer has never had it so good. There's a fantastic range of cameras on the market, with something to meet every need. And with prices the lowest they've ever been in real terms, there's something to meet every budget as well.

NIKON F
The Nikon F was one of the first modern SLR cameras offering the versatility of reflex viewing and interchangeable lenses.

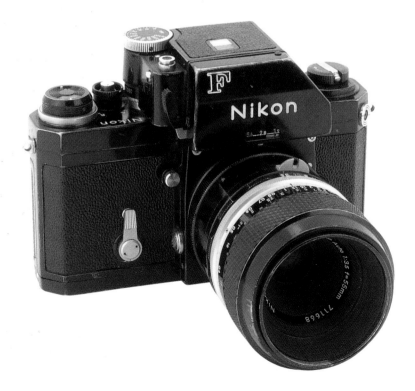

THE HISTORY OF THE 35MM CAMERA

» 1925 Leica 1 – first commercial 35mm camera

» 1936 Kine-Exacta – first SLR camera in the 35mm format

» 1953 Contax E – first camera with built-in (but uncoupled) meter

» 1956 Adox 300 – first camera with interchangeable film backs

» 1959 Nikon F1 – first interchangeable lens Nikon camera

» 1959 Voigtlander Zoomar – first zoom lens

» 1959 Contarex – first match-needle exposure control

» 1959 Savoyflex – first automatic exposure control (shutter-priority)

» 1960 Iloca Electric – first camera with built-in electric motor drive

» 1960 Konica F – first SLR with focal plane shutter, allowing a top shutter speed of 1/2,000 sec and flash sync at 1/125 sec

» 1962 Contarex Super B – first automatic exposure control with shutter speed and aperture visible in the viewfinder

» 1963 Topcon RE Super – first through-the-lens meter with match-needle control

» 1964 Voigtlander Vitrona – first camera with built-in flashgun

» 1968 Mamiya/Sekor 1000DTL – first camera with a choice of spot or average metering

» 1973 Fujica ST 801 – first camera with LED display in viewfinder

» 1976 Olympus OM-2 – first camera reading exposure off the film plane

» 1976 Canon AE-1 – first 35mm camera with built-in microprocessor

» 1977 Konica C35AF – first autofocus 35mm compact

» 1978 Canon A1 – first camera with programmed exposure

» 1980 Nikon F3 – first camera with LCD display in viewfinder

» 1983 Nikon FA – first camera with multi-segment metering

» 1983 Olympus OM3/4 – first cameras with meters integrating several spot readings

» 1985 Minolta 7000 – first SLR with integrated autofocus system

» 1988 Ricoh Mirai – first integrated 'bridge' camera

» 1992 Minolta 9Xi – first camera with 1/12,000 sec shutter speed

» 1992 Canon EOS 5 – first camera with features operated by eye movement

» 1996 Nikon F5 – first camera with RGB matrix metering

The 35mm SLR

Single lens reflex cameras, or SLRs as they're more commonly known, are the perfect choice for anyone who is serious about photography. While it's certainly possible to produce creative pictures using a compact 35mm camera, the unparalleled control and versatility you get with an SLR makes it possible to tackle virtually any subject and achieve almost any effect you can imagine.

This is especially true of modern SLRs, many of which are bursting with advanced technological features that increase the potential of the camera way beyond what was possible with earlier designs. Sophisticated metering options allow fine-tuning of exposure; a range of 'modes' makes it easy to select the optimum combination of shutter speed and aperture; highly developed systems ensure the right part of the scene is sharply focused; a built-in flashgun provides controlled light whenever you need it. Not every camera has every feature, and there are still a few simple, manual models around, but the majority provide more options than many photographers will ever get the chance to explore.

CREATIVE CONTROL

One of the best things about the latest SLRs is that they have been designed to allow you to take as little or as much control as you want. Most can, in fact, be used as 'point and shoot' cameras, so that as you press the shutter release all the technicalities are handled for you automatically: the light is measured and the exposure set, the lens is accurately focused, the built-in flashgun is activated if necessary and primed ready to fire. Then, when the picture has been taken, the film is automatically wound on ready for the next shot. This makes life easy, and you're virtually guaranteed decent results.

For many photographers, however, the whole point of using an SLR is to be able to set everything themselves so their images turn out exactly as they'd like them to be. One of the most important ways of taking control is by selecting the shutter speed and aperture, which determine not only the exposure but also the way in which movement is recorded and how much of the subject appears sharp in the finished photograph.

REFLEX VIEWING

A key SLR advantage is the reflex viewing system. This allows you – by means of a pentaprism at the top of the camera – to look through the lens that will take the picture. In a compact camera the viewfinder is separate from the lens, to one side or above it (often both), and this arrangement gives rise to 'parallax error'. With a distant subject this may not be a problem, but as you move closer to the subject what the viewfinder sees can be very different from what the camera lens captures, resulting in portraits of people with the tops of their heads cut off or inaccurately framed close-ups.

The WYSIWYG ('what you see is what you get') viewing system of an SLR enables you to compose your pictures with great accuracy. (The only minor complication is that some viewfinders show fractionally less of the scene than will actually appear in the finished picture.) As you switch from one lens to another, the viewfinder shows exactly what each lens is 'seeing', and the same is true of anything else you fit in the optical path, from filters to close-up accessories, allowing you to make adjustments until you get the effect you want.

On SLRs that have a depth-of-field preview system – unfortunately not all do these days – you can also get a visual idea of what will appear sharp and what will be out of focus in the finished picture.

EXTENDABILITY

An SLR camera body is only the beginning. It's the foundation stone, if you like, upon which an entire system can be built. As you get more involved in photography, you can extend your system to allow you to do more with your SLR, and what you buy

TYPICAL FEATURES ON A MODERN SLR

1 Viewfinder Typically showing 92–95 per cent of the actual picture area, it is surrounded by exposure, focusing and other information, so you don't have to take your eye away from it when making adjustments.

2 Exposure compensation Systems for fine-tuning exposure include AE-lock, exposure compensation, and sometimes auto-exposure bracketing.

3 Shutter speed The range varies but is commonly from 30 sec to 1/2,000 sec – though one model goes up to 1/12,000 sec.

4 Aperture On older cameras the aperture was set using a ring around the lens barrel; it is now more often selected electronically.

5 Film speed setting On virtually all cameras film speed is set automatically via the DX coding system, but some provide an override to allow the film to be 'pushed' or 'pulled'.

6 LCD (liquid-crystal display) panel Provides information about shutter speed, aperture and other aspects of operation.

7 Custom functions Some advanced SLRs allow you to tailor operation to your own preferences – such as by leaving the film leader out or winding it in when rewinding.

8 Zoom lens Most SLRs come with a high-quality 'standard' zoom lens ideal for general picture-taking.

9 Focusing system Autofocus is the commonest system, sometimes featuring several different sensors across the image area. A few models have 'eye-control' systems in which the required sensor is activated simply by looking at it.

10 Exposure meter While some inexpensive SLRs offer only one 'centre-weighted' metering system, an increasing number also feature partial, spot and multi-zone options.

11 Shutter release Gentle pressure activates metering, firmer pressure takes the picture. The shutter release also often acts as a focus lock.

12 Input dial Finger-operated wheel used in conjunction with other controls to set shutter speed or exposure mode.

13 Motorized film advance Most SLRs have automated film loading and advance, with a typical speed of two frames per second – though some go as fast as eight fps.

14 Exposure modes To some extent, the more exposure modes the better: there are usually four 'creative' modes and a number of subject-based modes, often selected via a 'mode dial'.

15 Accessory hot shoe To accommodate more powerful flashguns.

16 Lens release Allows the lens to be removed and swapped for other optics.

17 Built-in flashgun This usually has a guide number of 12m/ISO 100, sufficient for shots up to around 3–4m (10–13ft).

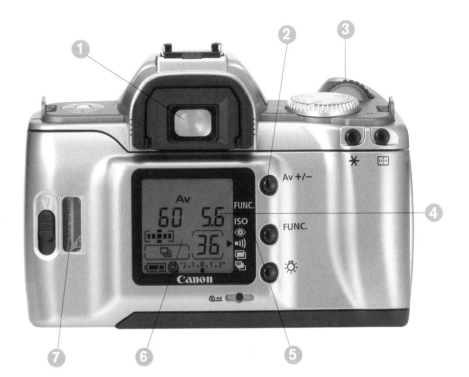

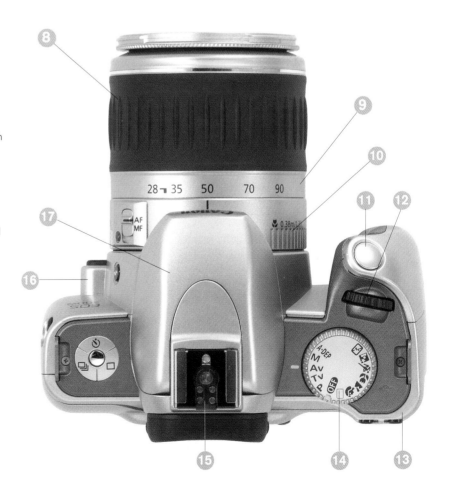

will be determined by the subjects you like to shoot and the kinds of pictures you want to take.

One of the key ways to expand your options is to invest in additional lenses. Bought 'off the shelf', most SLRs come with a standard zoom, from 28mm or 35mm up to 70/80/90/105mm. While this is great for general picture-taking, and will handle many of your requirements, sooner or later you'll feel the need to add more optics to your outfit.

Fitting a lens with a wider angle of view not only allows you to include more in the frame, it also enables you to open up perspective for a more dramatic image. The ultimate is a fisheye lens, which captures a full 180°, including – if you're not careful – your toes and the tips of your fingers.

Investing in a powerful telephoto lens, meanwhile, not only enables you to pull in distant subjects, such as Formula 1 action or birds on the wing, it also allows you to isolate your subject in sharp focus, rather than including everything, which can result in a picture that lacks impact.

You can also extend your system by choosing accessories that allow you to take close-up photographs of tiny subjects such as insects or flowers, illuminate large areas by using an add-on flashgun, or creatively modify images by fitting dozens of different filters over the lens. And once you've mastered your camera in the field, there's a whole new world of photography to be explored in the studio, where your camera can be linked to flash or continuous lighting set-ups.

JOURNEY OF DISCOVERY

For all these reasons, SLRs continue to be the ideal tool for the enthusiast photographer. Although current models offer better quality and more sophisticated control than ever before, they have never been cheaper in real terms. For many people, buying an SLR is a statement that they are taking photography more seriously, and marks the first step in a journey of discovery. For many it is a journey that will last a lifetime – and one of which they'll never tire.

HOW AN SLR WORKS

Take the lens off an SLR, open up the back (check there's no film in it first!), and you'll get some idea of how an SLR works. What happens is that the image coming in through the lens is reflected upwards by a mirror at 45°. There it passes through a pentaprism – a block of glass with five sides – the purpose of which is to provide an image in the viewfinder that is the right way up and not laterally reversed, which is what you would see if it were not there. If you choose a long shutter speed or the 'B' setting then fire the shutter, you'll see the mirror flip up and the blinds open: this allows the image formed by the lens to pass through the body of the camera on to the film. Once the exposure time has been completed, the blinds close and the mirror flips back down. This procedure happens every time you take a picture. Most modern SLRs have a focal plane shutter, which consists of two blinds that follow each other, so that at shutter speeds longer than 1/60 sec the exposure is made by a moving slit.

FACTORS TO CONSIDER WHEN BUYING AN SLR

There's a wide range of SLRs from competing manufacturers on the market, with many different features available, so choosing the right model can be confusing. Here are some factors to consider:

Brand

⊘ Consumers are increasingly 'brand conscious', choosing products and services that seem to reflect their lifestyles and aspirations. The photographic market is not immune from this trend, and 35mm SLRs produced by certain companies have come to be regarded as more 'desirable' than others. Since the launch of its EOS system in 1987, Canon has been one of the leading players, with a large market share. Nikon, because of its association with professional photography, is also highly regarded – as are companies such as Pentax and Minolta. In addition, there are a number of smaller companies. Olympus, once a major force, is no longer seriously active in the 35mm SLR market. Whatever your preference, the truth is that other than out-and-out budget cameras, made as cheaply as possible to sell at a specific 'price point' with a stripped-down specification, you'll find little difference in the quality of the finished picture from most of the leading brands.

Price/specification

⊘ So why do some cameras cost a lot more than others? First and foremost, this is about specification. Expensive 35mm SLRs generally have more features: they usually have more advanced metering and focusing systems, a faster motor drive and extra facilities such as auto-exposure bracketing or multiple exposure. They are often more solidly built, from stronger, more durable materials. However, while additional sophisticated

features may give you more options, spending more does not in itself result in better quality images.

Automation

⊘ All but a handful of modern SLRs have a high degree of automation, setting everything for you if you want them to. This is valuable because it makes them easy to use. But if you want to pursue photography as an interest it is important that you have as many overrides as possible – particularly in the areas of setting the shutter speed and aperture, but also, if possible, for focusing, exposure compensation and flash control.

System back-up

⊘ Few photographers stop at one camera body and one lens. For most that's the starting point of a comprehensive system that may include several lenses, a flashgun, a second body, and sometimes accessories for a specialist area of interest. It makes sense, therefore, to check out the system back-up that is available before parting with your hard-earned cash. Imagine the nightmare of buying a camera and then finding out that a particular lens or accessory you need is not available. Do your homework: get a system brochure and make sure the available range meets your needs. With most of the leading brands this won't be a problem – if anything, you'll be spoilt for choice – but with some of the smaller companies selling fewer cameras there can be significant and surprising gaps within the range. Lenses for the popular camera systems are also available from independent manufacturers – often at substantial savings compared with marque products – but for economic reasons they are not produced in some lens mount fittings, and this may restrict your choice.

The 35mm compact

⬆️ ➡️ **35MM COMPACT**
35mm zoom compacts
make it possible to take
quality pictures of popular
subjects from people to
travel.

It used to be easy choosing between a compact and an SLR. Compacts were simple, automated cameras with a basic exposure system, so-so optics and a limited range of features, and were really only suitable for taking snaps. SLRs, on the other hand, were sophisticated, high-quality machines that boasted a wide range of features and gave the user great control over the picture-taking process: ideal for the enthusiast. But the last few years have seen the distinction between compacts and SLRs blur, as compacts have added more features and control. While SLRs are still more flexible and versatile, it's now possible to use a compact for serious photography, and many people do.

PORTABILITY

One reason compacts are so popular is their size – or their lack of it. A typical zoom compact will slip easily into a coat pocket or handbag. Even compacts that go all the way up to 140mm or 200mm are still highly portable, while models without a zoom lens can look like miniature jewellery. You'd need a big pocket to house an autofocus SLR, with its bulging handgrip and pentaprism. Because compacts are small and light, many people carry them around with them, taking pictures as part of their everyday lives, rather than just on special occasions or when they set time aside to do so.

Compact cameras are designed to be pretty much all-inclusive. Everything is built-in – flashgun, zoom lens, winder – leaving little to be added later. In fact the only accessories you could buy to enhance a compact are a tripod to guard against camera-shake, filters – which on most models you have to hold in front of the lens yourself – and a case to keep it in.

While there's no denying the benefit of being able to swap lenses, you can tackle many popular subjects effectively using the fixed zoom lens found on most compacts. If you expect to shoot groups, interiors and landscapes, choose a model on which the lens is as wide-angle as possible – some go

down to 28mm. If, on the other hand, it's action, candid shots and natural history that interest you, opt for a model with greater telephoto coverage – up to 160mm or even 200mm. Care does need to be taken, though, when photographing subjects in close-up – for two reasons. One, the close-focusing distance on most compacts is around 1m (3ft), and two, parallax error: what you see through the separate viewfinder is different from what the lens 'sees'.

POINT AND SHOOT

Most 35mm compacts now feature autofocus, with a sensor at the centre of the viewfinder image. To ensure the most important part of the scene is sharp in the finished picture you need either to place it in the middle or use the focus lock provided.

The 'programmed' operation of most compacts – you press the shutter and the camera does the rest – can be considered a good thing or a bad thing, depending upon how creative you want to be. It certainly makes a compact quick and easy to use – truly 'point and shoot' and extremely responsive – but leaves very little room for input from the user.

Normally the exposure is set automatically by the camera's metering system, and while this generally produces satisfactory results, there's no override that allows you to select the shutter speed or aperture, so you have no direct control over the way in which action is recorded or the depth of field. Increasingly, though, compacts offer a range of subject and technique-based modes (landscape, sport, close-up and night are examples of the most common) that allow the user to influence the bias of the shutter speed and aperture. There are usually also a number of flash options to cope with different situations.

Compacts have a smaller range of shutter speeds than SLRs – typically the top speed is 1/500 sec compared to 1/2,000 sec – but in practice this makes little difference since most pictures are taken at speeds between 1/60 sec and 1/500 sec.

At the end of the day the most important thing is the photographer's eye for interesting subjects and appealing compositions – and if you've got that you'll be able to produce good pictures with a compact.

TYPICAL FEATURES ON A MODERN COMPACT

1 LCD panel Not featured on every compact, but useful for showing how many pictures have been taken, the mode selected and so on.

2 Shutter release Used to take the picture, and generally also works as a focus lock.

3 Winder Film is loaded automatically, winds on for the first frame, and is advanced after each picture is taken.

4 Viewfinder The direct vision viewfinder works well with subjects at distances of 1.5m (5ft) or more, but suffers from parallax error when shooting close-ups.

5 Modes An increasing number of compact cameras offer a range of picture-taking modes. These adjust the shutter speed and aperture to make the most of subjects such as portraits, landscape and action.

6 Film window To check what kind of film is loaded and how many exposures are on the film.

7 Flashgun The built-in flashgun normally fires automatically when required, and there's often a red-eye reduction facility along with a menu of flash options.

8 Tripod socket Allows the camera to be used on a tripod or other screw-threaded support.

9 Lens Most compacts have a zoom lens, usually with a range from wide-angle to telephoto, that is ideal for general picture-taking.

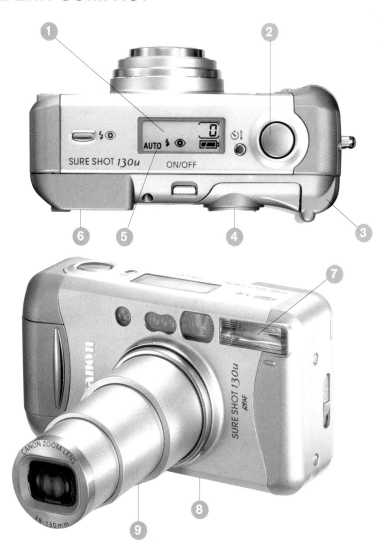

Specialist 35mm cameras

The overwhelming majority of 35mm cameras bought and used are compacts and SLRs, and that is what this book will concentrate on. But a number of specialist cameras are worth knowing about as, for some photographers, they will be the perfect tool.

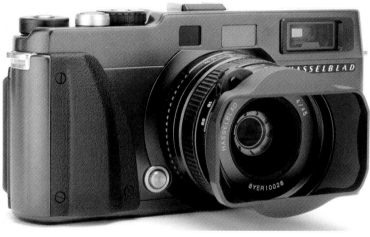

well as being able to shoot panoramic compositions of subjects such as landscapes, buildings and groups – 13 shots on a 36-exposure roll – you can also take standard 35mm full-frame images. This makes the camera extremely versatile, and a great buy if you can afford it.

35MM RANGEFINDER CAMERAS

You might have thought that once 35mm SLRs and compacts came along traditional rangefinder designs would fade away and die. In fact, they're still extremely popular, despite high prices and the limited number of models on the market. They are particularly favoured by reportage and documentary photographers because, with no mirror to flip up and down, the shutter is far quieter than on reflex cameras. As well as current versions of classic designs from Leica, there's also a superb system from Contax. Rangefinder cameras are smaller than SLRs but more versatile than compacts – and are in

⬆ **PANORAMIC CAMERA**
The Hasselblad XPan II enables you to take panoramic images using standard 35mm film.

➡ **PANORAMIC LANDSCAPE**
Panoramic composition is ideal for landscapes, especially when you want to give a sense of the scale of a place.

PANORAMIC 35MM: HASSELBLAD XPAN II

While it is possible to produce long, thin panoramic prints from standard 35mm negatives, either by printing conventionally or cropping in a computer, the quality isn't that good because you're throwing away a large part of the picture area when you lose the top and bottom of the image. But if the idea of taking pictures of this kind appeals, there's a better – though considerably more expensive – option. Hasselblad produces a special panoramic camera called the XPan II that uses standard 35mm film but produces a negative size of 24 x 65mm. It's a beautiful piece of equipment, built to the highest standards, with a comprehensive specification, including aperture-priority and manual operation, shutter speeds from 8 sec to 1/1,000 sec, exposure compensations and auto-bracketing, and integral winder.

Most importantly, there's a choice of three interchangeable lenses: 30mm, 45mm and 90mm. As

many ways an ideal compromise between the two. Lenses are interchangeable, but with only a limited range of focal lengths. The rangefinder focusing system is very different from the reflex viewing on an SLR. Instead of having a single image, which you bring to sharpness by either pressing the autofocus button or turning the focusing ring, a rangefinder system presents you with two images, which you have to coincide to bring the lens to focus. This can take some getting used to, but once you've got the hang of it it is quick and easy.

SINGLE-USE 35MM CAMERAS

Some inexpensive cameras designed to be used once and then thrown away are loaded with 35mm film – others use Advanced Photo System (APS) cartridges. If you already own a 35mm SLR or compact, you might not give such 'disposable' cameras a thought, but there are times when they can be useful. When you're going to the beach, for instance, you'll almost certainly want to take pictures, but you may not care to risk getting sand or sea water in your equipment and ending up with an expensive repair bill. Or if you're wary of carrying a

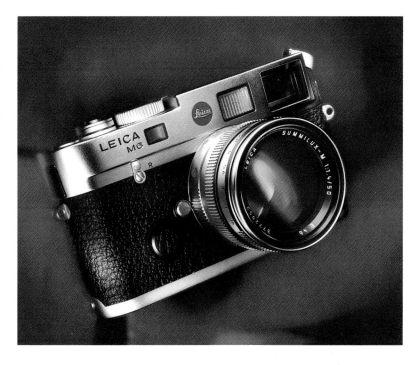

valuable outfit when you're going into an area where crime levels are high, taking a disposable camera would be less risky. While the results from single-use cameras obviously won't match a quality compact or SLR, they're surprisingly good when used within their limitations – that is, on a sunny day or using flash up to about 2m (6ft 6in).

LEICA RANGEFINDER 35mm rangefinder cameras are quiet in operation and have the versatility of interchangeable lenses.

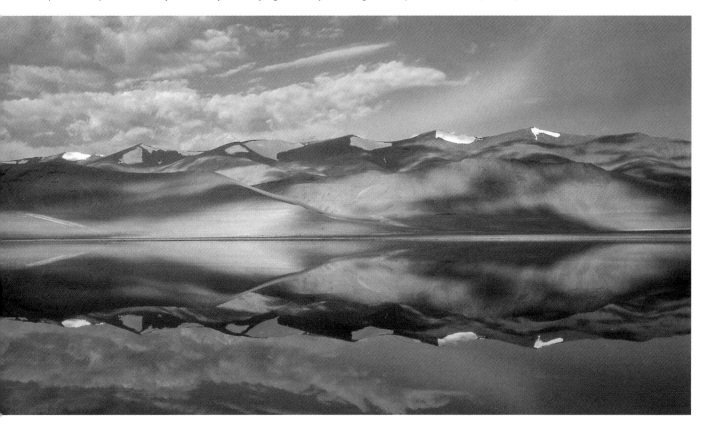

Digital 35mm SLR

The idea of 'digital' 35mm is, of course, nonsense. By definition, a 35mm camera is one that uses 35mm film – and digital cameras don't use any film at all. But, increasingly, digital SLRs compatible with existing 35mm systems are being introduced and becoming more affordable.

Many early digital cameras were designed to dramatize the difference between the new and old technologies, and as a result they didn't look much like the film models we'd grown used to. But clearly there was a realization that much of what had gone before still had value, and later generations began to resemble familiar designs.

The first digital cameras were all compacts. This was fine for those who wanted relatively simple, easy-to-use models, but posed something of a problem for photographers who wanted to embrace the new technology but who had built up a collection of lenses and accessories, perhaps even a complete system. Many tackled this dilemma by continuing to shoot film, then scanning the resulting prints, slides or negatives. Although this remains a viable option (see 'Digitizing 35mm originals', page 136), it denies users the benefits of digital capture, including the immediate availability of images and the fact that there is no longer any need to buy film or pay for processing.

DIGITAL SLRS

The advent of high-quality digital SLR bodies that can replace film bodies has allowed continuity for those who have already invested a considerable amount in their SLR outfits, making the transition to digital relatively painless. Prices were inevitably high initially, but as they have continued to fall more and more photographers have been able to make the switch.

However, there are complications. For technical reasons the first digital SLRs had a 'lens magnifier effect', which increased the focal length of the lenses by 1.6x. While this is great news for telephoto fans – because it transforms a typical 70–300mm zoom into a 112–480mm zoom capable of handling everything from wildlife to sports – it has serious implications for wide-angle photography. If you use a 24mm lens, all you really end up with is 38.4mm – and even a 14mm ultra-wide becomes just 22.4mm.

Fortunately, full-frame digital SLRs are now available, with lenses that retain their focal length. Although at present they command a considerable premium and are beyond the means of many amateurs, it seems inevitable that in time they will become the norm.

Most digital SLRs are similar to – and often based on – their film cousins, so their specifications are usually high, with autofocus, a range of modes, different metering patterns, integral motors and flashguns as standard. In addition, of course, there are all the digital controls, which allow you to review the images you've taken, adjust the balance for different lighting situations, and capture images at different resolutions.

One of the most exciting developments in digital SLR photography has been the introduction of cameras whose resolution outperforms 35mm film, making it possible to achieve degrees of enlargement that would previously have been possible only on a larger-format professional camera. The development of high-capacity removable storage devices also makes it possible to capture several hundred images without having to load or unload any film – so you don't miss a shot.

With all these advantages, you might think the days of film, and the 35mm format, are numbered, but the large number of cameras in circulation, along with the quality of images it's possible to get, means that film will be around for quite a while yet.

TYPICAL FEATURES ON A DIGITAL 35MM SLR

1 Flash A flashgun is often built in but there is usually provision for an external gun.

2 Output sockets These sockets allow the images to be output directly to a computer or television via a lead, although the memory card is used more often for transferring pictures.

3 Modes There is usually a wide range of exposure modes on offer, both creative and subject-based.

4 Focusing system Most digital SLRs have autofocus, often featuring advanced predictive systems.

5 Information panel Provides status details of important controls such as mode, shutter speed, aperture and metering.

6 Memory card Images are captured on removable memory cards and can be downloaded directly to a computer.

7 LCD monitor This allows images captured to be reviewed, but doesn't give a 'live' display of subjects.

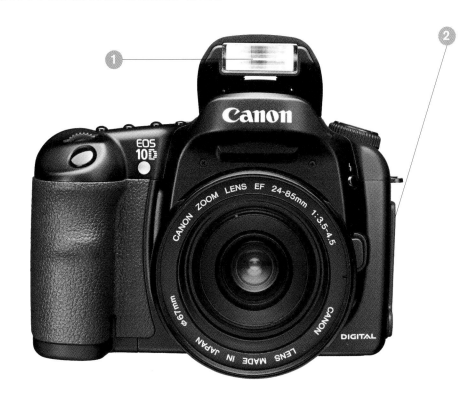

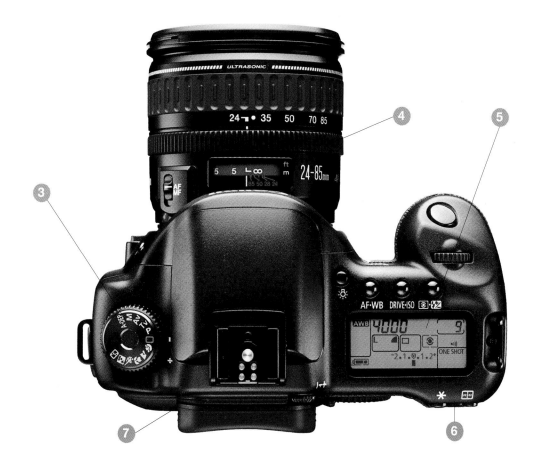

Focusing

↑ AUTOFOCUS
Left to their own devices, autofocus cameras will focus on whatever's at the centre of the frame. When there are two people in the picture, the sensor can all too easily go between the heads and focus on the background (top). Getting them to put their heads together, or using the camera's focus lock, avoids the problem.

The majority of 35mm cameras sold these days, both SLR and compact, have autofocus, though some manual-focus models are still produced, and a great many more are still in use and widely available at attractive prices on the secondhand market.

The reasons autofocus has proved so popular are not hard to find. Focusing, along with setting exposure, was something many users of SLRs found tricky to do manually. When the option of an automated focusing system became available in 1985 it was an instant success, and as it became more affordable an increasing number of photographers made the switch.

Autofocusing is a boon in particular for those with eyesight deficiencies. While these may not be bad enough to demand the wearing of spectacles, they can be sufficient to contribute to a loss of focusing crispness. It has also made cameras a lot more responsive. These days it's possible to see a photogenic subject, pick up an SLR and take a pin-sharp picture in less than a second. That was never possible with manual focusing, even for those skilled in its use. You can even take a shot of a subject a metre in front of you and another at infinity without catching breath.

Even better, advances in autofocusing technology mean that it is now possible to photograph a moving subject with the camera tracking its movement and predicting exactly where it will be when the picture is taken.

USING AUTOFOCUS

For all their advantages, autofocus SLRs are not foolproof – they need to be used with intelligence if you're to get the best from them.

The key thing to watch out for is that the focusing envelope in the viewfinder falls over the part of the subject you want to be in focus. This is also true if you have an autofocus 35mm compact. One of the classic errors occurs when you're photographing two people and the sensor goes between their heads and focuses on the background. What you need to

do is place the envelope over one of the faces, lock the focus position by holding first pressure on the shutter release and then reframe the shot. The same procedure should be followed when photographing scenes where the subject is off-centre. When you first use the focus lock you have to think what you're doing, but after a few times the technique becomes automatic, and can be carried out quickly and easily without slowing down the picture-taking process.

Some of the latest cameras have more advanced focusing systems to minimize the problems caused by subjects that are not in the centre of the frame. If your SLR has a 'wide-area' focusing envelope, which covers a greater proportion of the picture area, your subject has to be much nearer the edge of the frame for it to be missed.

The most sophisticated focusing systems, though, have been pioneered by Canon, and an increasing number of their cameras feature multi-point autofocusing. With a much larger number of sensors ranged across the viewfinder, and advanced software controlling it, the system is capable of astonishing accuracy, even with the most difficult of subjects.

→ MULTI-POINT FOCUSING
Advanced SLRs with multi-point focusing will handle off-centre compositions like this easily, but users with a standard system need to use the focus lock or switch to manual.

The most technologically advanced systems are even capable of being controlled by the user's eye movements. This may sound like science fiction, but they really work. Once calibrated – and this takes only a couple of minutes – they can detect which of the sensors you're looking at, and the camera is focused accordingly.

⬆ CANON'S 45-POINT AUTOFOCUS SYSTEM
One of the most advanced focusing systems available features 45 individual focusing points across a wide area of the screen.

FOCUSING MODES

Many autofocus (AF) cameras offer a choice of focusing modes, and you need to make sure you're using the right one.

• Single shot AF

As its name suggests, this is intended to allow you to take just one shot at a time, and is for general picture-taking. The aim is to eliminate out-of-focus pictures by locking the shutter until the lens is focused. A first pressure on the shutter release activates the autofocusing system, which focuses the lens and then locks the focus so it doesn't change until the pressure is released, allowing you to frame the shot. Increasing the pressure takes the picture. Single shot autofocus is best for general photography, where the subject is either static or slow-moving.

• Servo AF

This is best reserved for moving subjects. It enables the autofocusing system to refocus the lens continually as required to keep a moving subject sharp. Once the lens has been focused it remains locked unless

FOCUSING TECHNIQUES

Follow focusing

➡ This useful technique involves continually refocusing to follow a moving subject. It can be done either manually or using autofocus, and works well when the subject is relatively slow-moving, but is more difficult as speeds increase. Then you need to resort to pre-focusing, in which you focus on a spot ahead of the subject, which it will pass, and fire the shutter as it does so. At an event with a predetermined route this is easy. Otherwise you need to be alert and anticipate which way the action will move. Timing is critical: fire the shutter a fraction of a second too soon or too late, and the subject will be out of focus.

Tracking

➡ This technique involves shooting a moving subject from a moving camera. The theory is simple: if the subject and the vehicle carrying the photographer are moving at the same speed they do not move in relation to each other. Autofocus will be quick and accurate, or you can pre-focus on manual and let depth of field give the sharpness required. However, the subject and the camera are moving in relation to the background, which will streak dramatically. The degree of streaking depends on three main factors:

- The speed of the vehicles: the faster they're going, the more blurred the background will be.
- The shutter speed: the longer it is, the more pronounced the streaking.
- The focal length of the lens: the wider the angle of view, the more background will be included, enhancing the movement. As a starting point for your own tests, use a 35mm or 28mm lens, 1/125 sec, and travel at around 80kph (50mph). A vehicle with an open back, such as a jeep, pick-up truck or convertible, offers a safe platform. Or you could always sit rear-facing on a motorbike for a grandstand view.

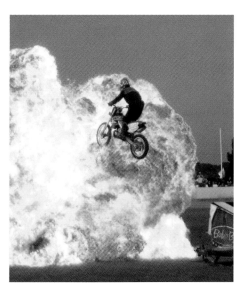

➡ TRACKING SHOT
To make sure this motorcycle was sharp at the decisive moment the photographer tracked its movement as it approached the jump.

the subject moves, in which case it refocuses automatically. All you have to do in this mode is keep your finger pressed halfway down on the shutter release.

• Predictive AF

On advanced SLRs, this system kicks in automatically when it detects the subject moving at a certain speed. It tracks its speed and direction and then adjusts the focusing accordingly. Also called focus tracking, predictive autofocus anticipates where moving subjects will be at the moment the shutter is opened and sets the focusing in order to give a sharp result.

MANUAL FOCUSING

Even the best autofocus cameras will struggle in some situations – such as where there's very little contrast or light levels are low – and you may need to switch to manual focusing. Of course, you may be using a manual focus camera and, if so, there's no need to feel like a second-class citizen. Despite the undoubted charms of autofocus, many photographers still prefer to focus manually. It may take a fraction of a second longer, but it makes them feel more in touch with the picture-taking process.

Focusing manually is just a matter of rotating the focusing ring on the lens until the picture looks sharp. Often there is a microprism/split-image focusing aid in the centre of the viewfinder to act as a guide, or some models have a focusing confirmation light, which is illuminated when the focusing is correct.

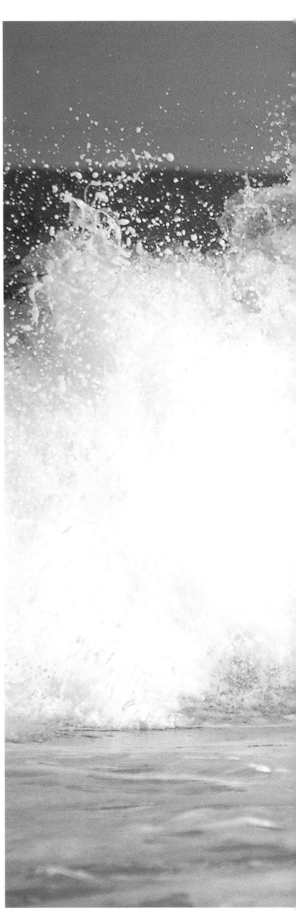

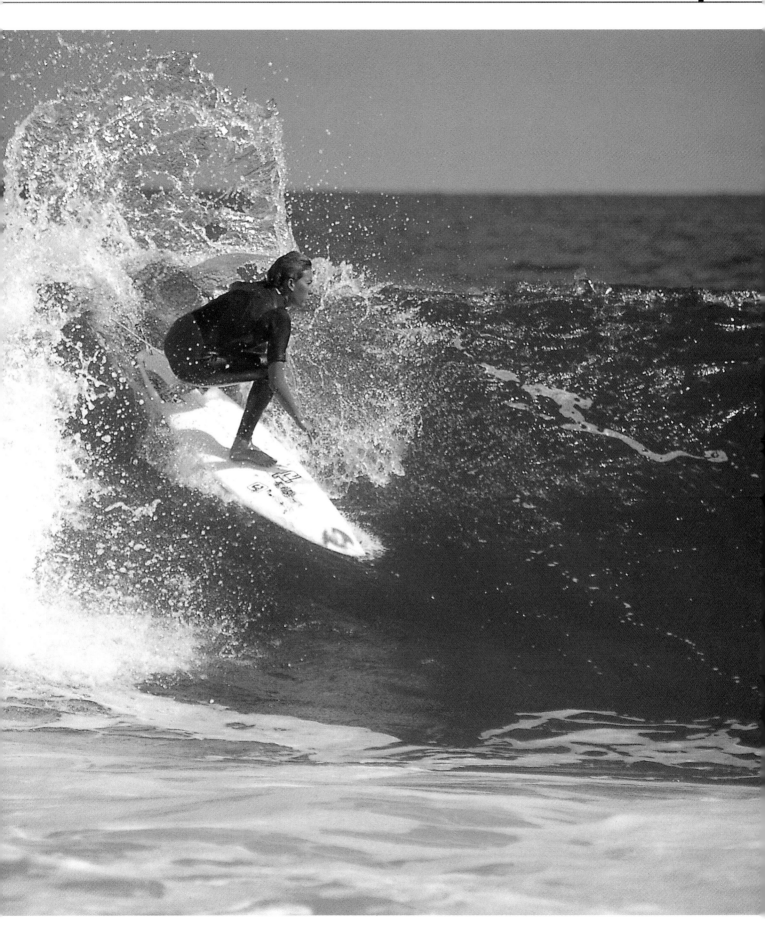

Exposure basics

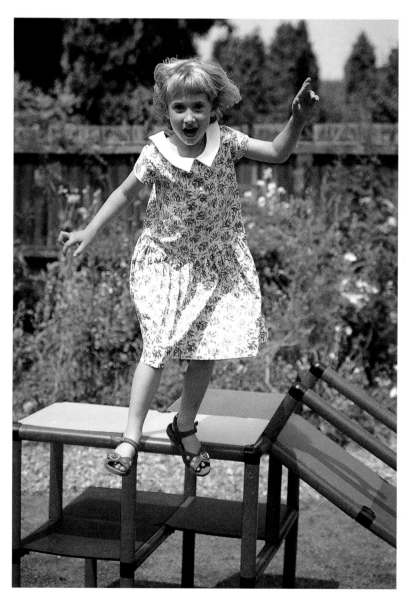

FAST SHUTTER SPEED
You don't have to go to sports events to find subjects that benefit from fast shutter speeds – everyday situations offer plenty of opportunities. A shutter speed of 1/500 sec was used to freeze the movement of this girl jumping from play equipment.

The great advantage of modern cameras is that because they're so automated virtually anyone can pick one up and start taking decent shots immediately. But in the same way that you'll probably get the best from your car if you've got some idea of what's under the bonnet, so you'll make the most of your camera if you understand a little about how it works.

This is particularly true of exposure. Have you ever had your pictures back from processing and wondered where you went wrong? Do you find yourself asking why this one came out too dark or that one too light? If so, and if you don't have the answers, you need to learn the basics of exposure.

EXPOSURE CONTROL

Modern cameras may be packed with exposure goodies, with numerous modes and metering patterns, but if you don't know how they work and what they're trying to achieve, you'll never make the most of the potential they offer. The first thing an exposure meter aims to do is to put the right amount of light on the film to give a good picture. To do this it reads the light that is being reflected back to the camera from the subject and analyses it using a metering pattern. This establishes the correct exposure level for the shot.

There are two controls that regulate the amount of light getting on to the film. One determines the aperture – the hole behind the lens that can be varied in size. The control is marked with a series of numbers (f/32, f/22, f/16, f/11, f/8, /5.6, f/4, f/2.8, f/2) that express the aperture size: each setting lets in either twice as much or half as much light as its neighbour (see also pages 26–7).

The other control is the shutter speed, which is the time for which the shutter is opened to take the photograph. This is measured in fractions of a second (1/1,000, 1/500, 1/250, 1/125, 1/60, 1/30, 1/15, 1/8 and so on). Again, each setting lets in either twice as much or half as much light as its neighbour.

In any situation there are different ways in which aperture and shutter speed can be combined to put the right amount of light on to the film. As the aperture increases, a faster shutter speed is needed to give the same exposure. On a sunny day, for instance, when using ISO 100 film, you could choose any of the following combinations:

Aperture	Shutter speed
f/32	1/15 sec
f/22	1/30 sec
f/16	1/60 sec
f/11	1/125 sec

Aperture	Shutter speed
f/8	1/250 sec
f/5.6	1/500 sec
f/4	1/1,000 sec
f/2.8	1/2,000 sec

However, although the exposure level might remain constant at all these pairs of settings, the photographic effects would be very different. That's because both aperture and shutter speed are also important creative controls.

SHUTTER SPEED

The shutter is one of the key picture-taking controls on a camera, opening up as you take the picture to let though the light that exposes the film. On simple cameras, including some 35mm compacts, the shutter opens only for a fixed time, often 1/125 sec, but on modern SLRs there's usually a wide range of shutter speeds – from at least 1 sec to 1/1,000 sec; some cameras can be set at speeds as brief as 1/12,000 sec or as long as 30 sec.

There are two main reasons for this wide range. The first is that shutter speeds control the amount of light falling on the film. Fast shutter speeds limit the amount of light admitted – which is useful in bright conditions or when working with fast film – while long shutter speeds make it possible to continue taking pictures when light levels fall, even if slow film is being used. The second reason is that the choice of shutter speed plays an important part in determining how the finished picture looks, especially when it involves movement. Within the limits imposed by the amount of light in the scene, the speed of the film you're using and the maximum aperture of the lens, you can select whatever speed you want.

CAPTURING MOVEMENT Choose your shutter speed carefully, and you can keep most of the subject sharp and have just the fast-moving part of it blurred – the perfect blend between freezing and expressing movement.

↑ CAMERA-SHAKE
Many people overestimate their ability to hand-hold without camera-shake being apparent – and the difference shutter speed makes can be dramatic. A speed of 1/60 sec with a telephoto zoom results in a surprisingly blurred image, while switching to 1/500 sec (right) renders the subject pin-sharp.

↑ IMAGE STABILIZER
Some modern lenses feature an image-stabilizing system that compensates for photographer movement. Typically you can safely take pictures at a shutter speed two stops slower than the table indicates – for example, 1/60 sec with a 200mm lens.

On traditional manual focus cameras there's usually a dial on the camera's top-plate, marked with the speeds, that allows you to control the shutter speed. All you have to do is rotate the dial to select the speed required. More recent cameras, especially autofocus models, feature advanced electronics that allow you to select your shutter speed by means of push buttons and input dials. Such cameras often have a large number of exposure 'modes' that give you even more control over how you choose the shutter speed, either directly through shutter-priority mode, or indirectly by means of one of the other modes.

AVOIDING CAMERA-SHAKE

Control of shutter speed is an important weapon in the battle against camera-shake. Even the slightest movement of the camera at the moment of exposure can lead to unsharp results when you're hand-holding – but the faster the shutter speed you set the less likely you are to get unsharpness. However, that doesn't mean you need to take all

your pictures at 1/1,000 sec. The lens you're using is also relevant: the longer its focal length the faster the shutter speed needs to be. As a rule of thumb, a 'safe' speed is one that is the reciprocal of the focal length in use. With a zoom, it's the actual setting used that's important, not the range of the lens. Here's a guide to the minimum speeds to use with a variety of lenses.

Focal length	Shutter speed
90/100mm	1/125 sec
135/200mm	1/250 sec
300/400/500mm	1/500 sec
600/800mm	1/1,000 sec

FREEZING OR BLURRING

If there's no movement in the picture, the shutter speed makes little creative difference and the choice of aperture may be more important, because of its effect on the depth of field. Most everyday pictures are taken using shutter speeds in the range 1/60–1/500 sec.

When there's some kind of action, such as someone running or a speeding car, you need to decide whether you want to freeze or blur the movement. If you use a brief shutter speed – 1/1,000 sec or faster – there will be so little movement while the shutter is open that it will look as if the subject is standing still – producing a frozen image that is perfectly sharp. But if you use a longer speed, say 1/30 or 1/15 sec, the subject's movement during the period the shutter is open will result in an image in which the subject is blurred.

These options are explored in more detail in the section entitled 'Action photography' (see page 108).

APERTURE

In simple terms, the aperture is the hole through which light passes to reach the film. Its size is varied by means of a series of thin, curved iris blades within the lens that open up to let more light through and close down to reduce it. On manual focus cameras, it is generally controlled by an aperture ring on the lens. This is turned by hand, and clicks into position against a range of aperture num-

bers. On more recent cameras, especially auto-focus SLRs, the aperture is controlled electronically, by push-button controls, and the setting is usually displayed on an LCD screen.

The standard numbering sequence for apertures is f/1, f/1.4, f/2, f/2.8, f/4, f/5.6, f/8, f/11, f/16, f/22 and f/32, and each number is known as an f-stop. The values are calculated by dividing the focal length of the lens by the effective aperture, but in practice what's important is that each step along the scale represents a doubling or halving of the light transmitted. So f/8 lets in twice as much light as f/11, but only half as much as f/5.6. 'Small' apertures are those in which the hole produced by the iris blades is literally small, and – obviously – large apertures are those in which the hole is physically large. Confusingly, though, small apertures have high numbers, such as f/11, f/16

and f/22, while large apertures have low numbers, such as f/2.8, f/4 and f/5.6. The distinction between 'small' and 'large' is important, because the size of the aperture determines the depth of field in the finished picture.

Being able to adjust the aperture by full-stop increments isn't really accurate enough, especially with transparency film, so most cameras offer the option of half-stop settings – f/1, **f/1.2**, f/1.4, **f/1.7**, f/2, **f/2.4**, f/2.8, **f/3.5**, f/4, **f/4.5**, f/5.6, **f/6.7**, f/8, **f/9.5**, f/11, **f/13**, f/16, **f/19**, f/22, **f/27** and f/32 – with the intermediate settings shown in bold.

There are some professional specification cameras that feature advanced aperture control in 1/3 stops, although this facility is of little benefit to most amateur photographers shooting colour negative film.

CREATIVE BLURRING
Movement doesn't have to be fast to provide the potential for interesting results. Setting a shutter speed of 1/8 sec has created an impressionistic image of these poppies blowing in the wind.

Depth of field

⬇ DEPTH OF FIELD
DEPTH OF FIELD
Depth of field is controlled principally by means of the aperture. Here, using a 50mm lens, the aperture was set at f/16 for the one on the far left and f/2.8 for the shot on the left – and the results are very different.

U nless you're completely new to photography, you'll be aware that the way a subject is reproduced in a photograph can be very different from how it looked to you as you took the picture. When you cast your eye over a scene, everything in it seems more or less equally sharp, but sometimes in the finished shot only part of the subject appears acceptably sharp.

This zone of sharpness is called the depth of field, and it extends in front of and behind the point on which you actually focused. The size of the zone is determined by three main factors: the aperture size, the focal length of the lens used, and how far away you are from the subject. Varying these three

elements allows you almost complete control over the depth of field in a picture.

When most of the picture is sharp, it's described as having a large of depth of field. When only part is sharp, depth of field is said to be limited. As we'll see later, whether you go for extensive or limited depth of field depends upon the subject matter and how you want to depict it.

Let's take a look in turn at each of the three main factors:

• Aperture size
There's a simple, direct relationship between aperture size and depth of field: the smaller the aperture,

the more extensive the depth of field. If you want to keep as much of a picture as possible sharp, you should set a small aperture – preferably f/16, or even f/22 if your lens offers it. Depending upon the lighting conditions and your film stock, you may need to use a tripod or some other form of support at such small apertures, as the resulting long shutter speed will introduce the risk of camera-shake.

If, however, you want to concentrate attention on just one part of the scene it can be more effective to throw the rest out of focus, and for this you should select a large aperture. Exactly how large this can be will depend upon the maximum aperture of the lens you're using. On a 50mm standard lens it will be f/1.7, f/1.8 or f/2, but on a standard zoom it will typically be f/3.5 or f/4.5.

For general picture-taking, when you want most of the picture to be in focus, you might want to set a middling aperture of around f/8 to f/11. This is what a programmed exposure mode would be likely to set when left to its own devices, but whenever possible you should take control of aperture selection and use either an aperture-priority or manual mode.

• Focal length of lens

Although in theory depth of field does not change with focal length, in practice it seems to. Slip on a wide-angle lens and you'll benefit from extensive depth of field, which will make it easy to keep everything in focus. The wider the angle of view, the greater will be the depth of field. If you choose a telephoto lens the depth of field will immediately be more limited. The longer the focal length, the more restricted the zone of sharpness will be.

• Camera-to-subject distance

For various technical reasons, the closer you get to the subject the more limited the depth of field becomes. In fact, when shooting close-up subjects it can extend to just a few millimetres in front of and behind the subject.

USING DEPTH OF FIELD

So much for the theory. But what does it all mean in practical picture-taking terms? How can depth of

DEPTH-OF-FIELD PREVIEW

What you really, really need to anticipate what will and won't be sharp in the finished picture is a depth-of-field preview facility. This handy little feature allows you physically to close down the aperture, which gives you an indication in the viewfinder. But, sadly, camera manufacturers no longer seem to consider a depth-of-field facility to be essential, so your camera may not have one.

However, you may have a depth-of-field scale on the barrel of your lens – but don't count on it. Incredibly, these indispensable scales have begun to disappear since the advent of autofocus lenses. If you have an older lens you probably have one. The scale requires little effort to master and you'll find it extremely helpful.

» Here's how to use it. To either side of the line that shows where you've focused, you'll see a series of f-stops, generally f/5.6, f/8, f/11 and f/16 – although sometimes one or two are missing. Find the stop (it will appear twice) that matches the aperture you're using to take your picture, and read across to the distance scale. This will tell you the closest and most distant points that will be sharp at that aperture.

field be put to work when planning a shot? Let's consider four common approaches, looking at when and where they're applicable, and how to achieve them:

• **Everything sharp.** With subjects such as landscape, groups of people, interiors and travel you'll usually want to keep everything in the picture sharp. Naturally you'll have fitted a wide-angle lens and set a small aperture, and that in itself will give you extensive depth of field, perhaps from 2m (6ft 6in) through to infinity. But there will be times when you want to include foreground interest that's closer than that. In these instances you'll need to resort to a neat little technique called 'hyperfocal focusing' that allows you to make maximum use of the available depth of field.

As a rule of thumb, there is twice as much depth of field behind the subject on which you are focusing as in front of it. If you are photographing a distant subject such as a landscape and you focus on infinity, you're 'wasting' a lot of the depth of field. By focusing a little closer, you extend the frontal depth of field so it's nearer to the camera, while still making sure that infinity falls within the depth of field behind the point of

focus. However, you can only use hyperfocal focusing if your lens is marked with a depth-of-field scale. This used to be seen as an essential tool, but with the development of wide-ranging zooms many manufacturers now regard it as optional. If you do have such a scale, simply line up the infinity mark against the mark for the aperture you've set and, although the image in the viewfinder will look out of focus, the finished image will be sharp from front to back.

• **Main subject sharp, with background completely out of focus.** There are some situations where you want the main subject to stand out strongly from an out-of-focus background. Portraiture, where the emphasis is on the person

rather than the location, is probably the area where this kind of treatment is most popular. What you need in this case is to use a telephoto lens at its widest aperture. It also helps to move the subject as far away as possible from the background. Take care, though, that you focus accurately, as the limited depth of field will be unforgiving of any focusing errors.

• **Main subject sharp, with background out of focus but still recognizable.** Sometimes throwing the background completely out of focus is going too far. You may want to show the subject in the context of its environment to add interest to the picture, but with the background toned down so it doesn't compete for attention. The subject might be a person on the beach, for instance, an animal in the zoo or in its natural habitat, or a flower in a garden. In this case a standard to short telephoto lens – from about 50mm to 135mm – is ideal, especially if it's coupled with a middling aperture of around f/8.

• **Zone of sharpness deliberately limited.** Occasionally you may want to limit the depth of field to a very specific zone. Maybe in a portrait you want just the eyes in focus, and not even the ears or the tip of the nose. Here again, a depth-of-field scale on the lens helps or, failing that, a depth-of-field preview facility on the camera. The latter will give a visual indication of what will and won't be in focus by manually stopping down the lens.

Overall, the practical use of depth of field can be summed up as follows:

If you want to maximize depth of field and have as much of the photograph in sharp focus as possible, you should:
• use a wide-angle lens
• set a small aperture
• stand back from your subject.

If you want to minimize depth of field and have only a small zone of the scene sharp, you should:
• use a telephoto lens
• set a large aperture
• get closer to your subject.

ISOLATING A SUBJECT This beach was potentially an extremely distracting background, so a telephoto zoom was used at 200mm and at its maximum aperture of f/4 to help the subject stand out.

IF YOU HAVE A 35MM COMPACT

… you won't have any direct control over the shutter speed. It, along with the aperture, will be set automatically by the camera's exposure system. However there are a few things you can do to bias the meter towards long or short shutter speeds.

To achieve a shorter shutter speed:

⏩ Shoot in bright sunlight.

⏩ Load up with more sensitive film, with a higher ISO number.

⏩ If you have a zoom compact, set the lens to its shortest focal length, which will have the largest maximum aperture.

To achieve a longer shutter speed:

⏩ Shoot in overcast weather.

⏩ Load up with less sensitive film, with a lower ISO number.

⏩ If you have a zoom compact, set the lens to its longest focal length, which will have the smallest maximum aperture.

⬆ **EVERYTHING SHARP**
To maximize depth of field in order to keep both the design in the foreground and the building in the background in focus, an aperture of f/22 was used on a 20mm lens. Bright conditions made this possible without the need for a tripod, despite the use of slow film.

EXPOSURE MODES

Most 35mm SLRs and some compacts offer a selection of different exposure modes that suit not only a variety of subjects and situations but also the photographer's preferred way of working. While some people like to leave the exposure chores as much as possible to the camera, others would rather take control to gain creative flexibility.

Not all models offer all modes. The majority of 35mm SLRs manufactured since the mid-1980s feature the four main modes – program, shutter-priority, aperture-priority and manual – and some have additional subject-based modes. Before that time, the program mode was less common, and not all cameras had both shutter- and aperture-priority. Even today, some SLRs have a pared-down range of exposure modes, either to keep the price down or because they are aimed at photographers who are purists and like to work in a traditional manual-only way.

A wide range of exposure modes is less common on compact cameras. Inexpensive models often have systems that are fully automatic, offering no control at all, while some of the more sophisticated types provide various options, which are usually based on the types of subjects most commonly photographed.

All the modes will put the right amount of light on to the film, but taking control of the aperture and shutter speed combination puts you in charge, enabling you to produce images that are interesting and original.

Program mode

Program mode sets both the shutter speed and the aperture for you automatically, so you don't have to worry about exposure at all. On most cameras all you have to do is select the 'P' setting. This may be on a top-plate dial, or via an electronic mode system.

When you're starting out in photography using program is great because it guarantees you good results while you're getting to grips with the technicalities. And even when you're more experienced, there may still be times when you want to concentrate on picture-taking without having to worry about setting shutter speeds and apertures – such as when you're on holiday or at a show of some kind.

The only real drawback of program modes is that they don't know what it is you're trying to do creatively, so they set exactly the same shutter speed whether you're taking a portrait, landscape or action shot. In practice, this means well-exposed but rather bland results, which is why other modes are often better. Some of the drawbacks can be overcome if the camera is provided with a program 'shift' option, which allows you to alter the emphasis – towards either the shutter speed or the aperture – while staying in the program mode.

On some advanced autofocus SLRs the program takes account not only of light levels but also the focal length of the lens used, making it slightly more sophisticated.

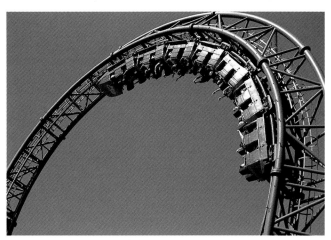

Shutter-priority mode

When using shutter-priority mode, you select the shutter speed yourself and the camera provides the aperture required for a correct exposure. This makes it ideal for photographing action.

Having direct control over the shutter speed allows you to match it against the movement of your subject, to ensure that it's perfectly frozen. For Formula 1 racing you'd need a speed in the region of 1/1,000 sec, while for runners passing outside your house 1/250 sec would probably be sufficient. Shutter-priority can also be used to avoid camera-shake, by setting a shutter speed that's faster

than the reciprocal of the focal length of the lens in use. So, if your lens is 200mm, you'd need a shutter speed of at least 1/250 sec; with a 50mm lens, 1/60 sec would normally be sufficient.

When setting a very fast shutter speed you need to make sure there's enough light for the camera to be able to provide a matching aperture. There's usually a warning system if you go too far. You should also be aware that a fast shutter speed can produce a large aperture – and limited depth of field. This means that focusing must be extremely accurate, especially when using a telephoto lens.

lots of depth of field, and keep most of the picture in focus, which is ideal for landscape photography and large groups of people. Large apertures, such as f/2.8 and f/4, restrict how much of the image appears sharp, and are great for concentrating attention on your subject when shooting subjects such as portraits.

In practice, many experienced photographers operate in aperture-priority mode most of the time. This is because in general picture-taking the aperture has more creative effect on the finished picture than the shutter speed. However, you need to be aware of the effect the aperture you set is having on the shutter speed. If you choose an aperture that's very small, such as f/16 or f/22, this can drive the shutter speed down to a level where there's a risk of camera-shake.

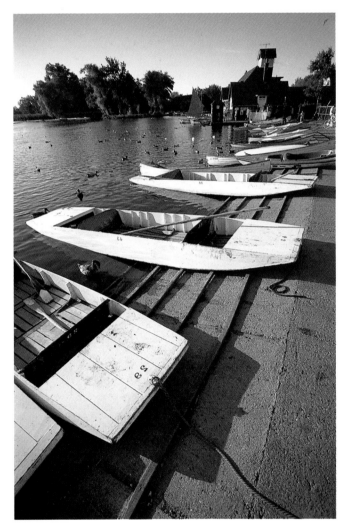

Manual mode

When you want full control over the settings that provide the exposure you should choose manual mode. This may be for a number of reasons: in some circumstances you may be able to predict that the camera will give an incorrect exposure, or you may prefer to take a reading with a separate hand-held meter.

Selecting both the shutter speed and the aperture independently gives you total control, but is more risky. Unless you're knowledgeable and experienced about exposure, it's much easier to make a serious mistake in manual mode. The worst you can do in any of the automated modes is get the emphasis wrong – the exposure itself will still be correct. If you make a mistake in manual mode, your pictures can be so over- or underexposed that they're unusable.

Aperture-priority mode

This mode allows you to select the aperture yourself, and then provides the shutter speed that will give the correct exposure. Aperture-priority is a good mode to use when you want to control the depth of field to determine how much of the scene comes out sharp in the finished picture. Small apertures, such as f/11 and f/16, provide

PICTURE PROGRAM MODES

To help newcomers to photography get good results from the start, many manufacturers now include a selection of modes designed to tackle a range of popular subjects. The four most common modes are portrait, landscape, action and close-up, which are indicated by icons showing, respectively, a head, mountain, runner and flower.

When you select one of these modes, the camera automatically sets what it considers to be the optimum shutter speed and aperture for the subject. The systems on some SLRs can also vary the metering pattern, choose single or continuous film advance, activate an integral flashgun, or select the most appropriate autofocus setting.

Such 'picture' modes can produce excellent results, but to make the most of them you really do need to understand exactly what they're doing – or you might not get the results you expected.

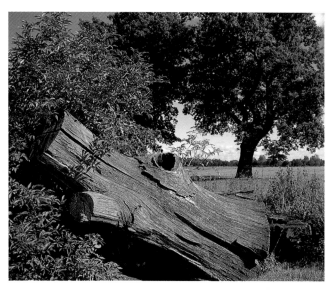

Portrait mode

It goes without saying that you use this mode when you want to take pictures of people. Its aim is to concentrate attention on your subject by setting a large aperture to help throw the background out of focus. Typically, this will be in the region of f/6.7 to f/8, depending upon the camera and conditions.

Assuming you are using a lens with a focal length between 80mm and 120mm – which gives excellent perspective for portraits – and your subject is not too close to the background, this mode would produce an excellent 3-D result.

When you want to take 'environmental' portraits, showing your subjects in their surroundings, you should avoid the portrait mode. Switch instead to aperture-priority and, if lighting levels allow, go for an aperture of f/11 or f/16 to keep everything sharp.

Landscape mode

When you're shooting landscapes you normally want as much depth of field as possible so that everything in the picture, from front to back, is in focus. Not surprisingly, then, landscape modes aim to set as small an aperture as possible, to maximize depth of field.

Assuming you're using a wide-angle lens in good light, most such modes will provide you with an aperture of around f/16, which is more than sufficient to give the effect required. On some cameras, notably the Canon EOS range, the system is more cautious, and an aperture of f/8 or f/11 is more commonly selected. But unless any part of the subject is extremely close to the camera, it should still be sufficient to hold everything in the picture in focus.

Action mode

As its name indicates, the action mode is designed to tackle moving subjects – whether they are racing cars hurtling round a track or your kids going down a slide in your garden – and render them in sharp focus. The first

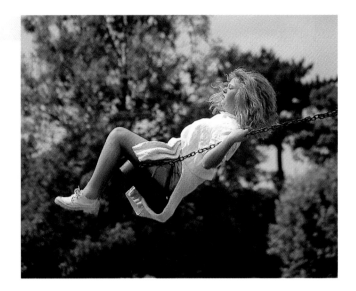

requirement when you need to freeze action is, of course, a fast shutter speed, and in bright conditions there's normally no problem achieving this. But when light levels are lower or the maximum aperture of the lens is limited, things can be more problematic. In practice, though, if you load up with an ISO 400 film and shoot in sunlight, the mode will give you a shutter speed of 1/500–1/1,000 sec.

Close-up mode

Many photographers would like to tackle close-up photography, but are unsure exactly what settings are required. In fact it's a balancing act.

The aperture needs to be small enough for adequate depth of field, while a reasonably fast shutter speed is required to minimize the risk of camera-shake and subject movement. The close-up mode on most cameras gets it about right, with the aperture typically around f/8, and the shutter speed chosen to match.

OTHER MODES

A number of other modes are found on some cameras. While they are not as common as the principal modes, for the sake of completeness here's a summary of what they offer.

Night mode

This gives a long exposure to cope with night and low-light scenes. As a general rule, the lens is set to maximum aperture, producing the shortest shutter speed possible. Even so, some kind of support is essential if camera-shake is to be avoided. A variation on some cameras is a night/portrait mode that aims to balance the long exposure required for a night or low-light background with a burst of flash to illuminate a foreground subject such as a person or group.

Slow action mode

You don't always want to freeze action, and this mode sets a shutter speed around 1/30–1/60 sec to allow techniques such as panning to be used when photographing moving subjects.

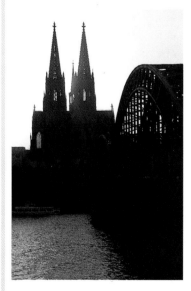

Silhouette mode

Available only on Nikon SLRs, the silhouette mode biases the exposure towards the background in contre-jour lighting conditions, so that the foreground subject is reproduced as a silhouette.

Metering

Before a camera can start setting shutter speeds and apertures, it has to measure how much light is in the scene, and that's the job of the built-in meter. Most SLRs feature through-the-lens (TTL) metering, while as a rule the meters on 35mm compacts are above the lens and slightly to one side of it. Early meters read the whole picture area, and were prone to error, but ever more sophisticated patterns are being developed in a bid to improve exposure accuracy. Some cameras have only one metering pattern, which is usually centre-weighted, but top-end models now sometimes have two or more patterns on offer.

• Centre-weighted

This is a tried and tested pattern that most cameras feature. The design is based on the assumption that the main subject will be in the centre of the picture, so most exposure emphasis is placed there. It's accurate in many situations, though more recent innovations now have the edge.

• Multi-segment

This computer-based pattern has become increasingly sophisticated since it was first introduced in the mid-1980s. The metering sensor breaks the picture area down into a number of segments, and compares the light level of each against information stored in its databank to give unparalleled exposure accuracy. Leading examples are Canon's Evaluative metering. Minolta's Honeycomb, and Nikon's 3-D Matrix metering.

• Partial

Less common than the other patterns described here, partial metering restricts measurement to a central portion of the viewfinder image – typically between 6 and 15 per cent depending on the camera model, and often defined by the size of the focusing aid or autofocus envelope. Used with judgement, it can assist accurate exposure, and is particularly useful when used in conjunction with an AE-lock facility.

• Spot

Spot metering limits exposure to a very small area at the centre of the viewfinder image – usually no more than 2 per cent of the picture area. This makes it potentially a very accurate way of measuring exposure, but it will only give you good results if used correctly. The key point to understand is that spot meters are calibrated in the same way as other meters, and will render whatever you read as a mid-tone. This is fine if the spot you pick actually is a mid-tone, but if it's significantly lighter or darker you'll get an incorrect exposure.

• Multi-spot

This pattern goes further and allows you to take readings from a number of different points – often up to eight – averaging them to give the exposure. On some models you can take a reading from the lightest or darkest points and press either a 'highlight' or 'shadow' button to make sure the exposure is biased towards them. It's a great system, but once again requires considerable understanding on the part of the operator to get good results.

WHY METERS FAIL

The important thing to understand about camera meters is that most of them are incredibly stupid. Why? Because they are calibrated on the basis that if you take all the tones in a subject – dark, middling and light – and average them out, you'll get an 18 per cent mid-grey. While that's often true, or near enough not to matter, there are subjects and situations where an imbalance of light and dark tones will show how dumb your meter is. But before you get alarmed and start losing confidence in your camera's meter, it's worth stressing that most of the time it will serve you very well indeed, delivering at least a 90 per cent success rate.

If you're serious about photography, though, that won't be good enough for you. You'll want to chase after the other 10 per cent of shots that get away. And you're right to – because it's in the tricky

1 HIGH CONTRAST
In high-contrast conditions getting exposure right can be challenging – the important thing is not to allow the highlight areas to burn out.

2 SUBJECT IN SHADOW
When the background is lighter than the subject there's always a danger of underexposure.

3 WHITE SUBJECT
Dark backgrounds can easily cause white subjects to overexpose, and care needs to be taken so that detail is retained.

4 SHOOTING INTO THE SKY
Whenever there's lots of sky in the picture, meters can easily be misled into underexposure, and adjustments may need to be made.

5 SHOOTING INTO LIGHT
When shooting into the light you need to make sure the shadow part of the subject is correctly exposed, by using compensation or an AE-lock, or you'll end up with a silhouette.

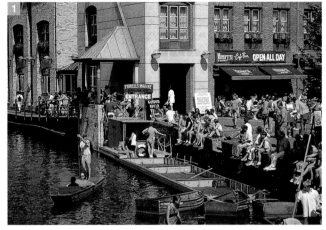

TRICKY SITUATIONS

Light subject

➡ If the subject is unusually light, such as a bride in a white wedding dress or the wall of a Spanish villa, you'll get underexposure that will reproduce the white as grey. To correct this, increase the exposure by around one to two stops.

Dark subject

➡ When your subject is unusually dark, such as a black cat or a school blackboard, the meter will overexpose, making the black appear grey. To correct, reduce exposure by around one to two stops.

Light background

➡ If your main subject is in front of a light background, such as a person standing in front of a white wall or the sea, then the meter may be fooled by the background and the subject will be underexposed. To correct, go in close and take a reading direct from the person.

Dark background

➡ When the background is much darker than the subject, such as a spotlit performer, this can lead the meter into overexposing. To correct, make sure you take a reading from the subject only, with the background excluded.

Into the light

➡ In contre-jour or into-the-light photography, the light streaming from behind the subject into the lens will cause underexposure. To correct you should either take a reading from the subject only or increase exposure by around two stops.

Lots of sky in the picture

➡ If you point your camera upwards to photograph a tall building, or shoot a landscape with a lot of sky, you may suffer underexposure as the meter is misled by all the light bouncing around. To correct, take a reading that excludes the sky.

Light source in the picture

➡ When the light source is actually in the picture, as with a setting sun or a lamp, there's likely to be underexposure. How much will depend upon the strength of the light source and where it is in the picture. To correct, take a reading of the scene with the light source excluded.

lighting situations that fool meters that the most successful pictures are taken: into-the-light shots and subjects projected strongly out of dark backgrounds, to name but two. So it's obvious that the key to getting the best from your meter is knowing when you're in a situation where it's going to be fooled into giving the wrong exposure. Although there are many different situations that mislead camera meters, there are, in fact, only a handful of different types of situation. Once you learn to recognize these, you're in a position to take action to avoid exposure errors occurring.

EXPOSURE COMPENSATION

Given that built-in meters are far from perfect, what can you do to ensure your picture is accurately exposed when faced with a tricky lighting situation? The answer is that you can compensate, increasing or decreasing exposure by the appropriate amount. Precisely how you do this will depend upon your camera and its features. Here are the commonest ways of making adjustments.

- **Backlight button:** A relatively unsophisticated way of compensating, and not as common as it was, the backlight button increases exposure, typically by one and a half stops. It's useful if you need to work quickly in into-the-light situations, but other options offer more accurate control.

- **AE-lock:** This is a quick and effective way to improve your success rate. Simply go in close to your subject – or in the case of landscapes tip the camera down to exclude the sky – and press in and hold the AE-lock button. This will then store the correct exposure for the subject, allowing you to return to your original position and take the shot in the knowledge that the exposure won't be affected by other factors.

◉ BRACKETING WITH SLIDE FILM
In tricky lighting conditions, such as when shooting into the sky, it may be worth bracketing exposures on slide film to ensure that at least one shot is correct. Here the images have been bracketed in one-stop increments, and the differences are clear: overexposure gives pale, washed-out images, underexposure muddy, dark results.

CREATIVE EXPOSURE

Sometimes, every now and again, the 'correct' exposure isn't right at all, and deliberately underexposing to lose shadow detail, or overexposing to burn out highlights, can produce a much more dramatic and satisfying result. Like any creative technique, it's a bit hit and miss. The trick is to make the treatment appropriate to the technique – and that requires a willingness to take a risk and try something different.

◉ SHOWING DETAIL
The exposure for this shot was bracketed because the photographer wanted just a little detail in the subject rather than a complete silhouette.

- **Exposure compensation facility:** This is the most accurate way of compensating, providing you know by how much you want to compensate. On older cameras it normally takes the form of a dial, while on more recent models it's often an electronic system accessed by buttons and input wheels. See the panel 'Tricky Situations' (page 37) for advice on levels of compensation for different situations.

- **Changing film speed:** If your camera lacks any of the above, you can improvise exposure compensation by temporarily changing the film speed setting, with every doubling or halving giving a one-stop compensation. If, for instance, you are using ISO 100 film and want to increase exposure by one stop you need to alter the setting to ISO 50. To underexpose by one stop, switch to ISO 200. Remember to change the rating back afterwards.

- **Switching to manual:** This is the most reliable way of controlling your exposure, especially if you are taking a series of shots of the same subject. Simply take a reading directly from your subject,

and enter the settings manually into the camera, and you're virtually guaranteed to achieve the correct exposure.

BRACKETING

Bracketing is a technique that should be part of the armoury of every photographer, and it's one that can be called upon whenever you are faced with taking an unrepeatable photograph in difficult lighting conditions.

It involves taking a series of shots at exposures above and below what the camera believes to be correct. That way you know you're going to get at least one good shot. Unless your camera has an AEB (automatic exposure bracketing) control, which will do it for you automatically, the easiest way to bracket is to use an exposure compensation facility. This allows you to increase and decrease the exposure quickly and accurately.

However, it's not a technique you should use every time. First, it's unnecessary – your camera will get the exposure right at least 90 per cent of the time anyway – and second, it will cost you an arm and leg in terms of extra film and processing costs. How much should you bracket? It depends upon what kind of film you're using and what the situation is.

Colour print film is now capable of giving acceptable results with exposure three stops above or below the correct level, so it's only really worthwhile bracketing it in big chunks. In most situations, the best way to bracket when using colour negative film would be in three frames: correct exposure, one and a half stops above and one and a half stops below.

Transparency film, on the other hand, has very limited latitude, and even half a stop above or below can make a big difference. So in this case you'll want to bracket in half stops, up to one stop above and below, as follows: correct, half stop above, one stop above, half stop below and one stop below. But in extreme situations, it may be necessary to bracket even more widely than that.

Whatever method you choose, you need to take care, especially when increasing exposure, that your shutter speeds don't drop to levels that will cause camera-shake.

HAND-HELD METERS

The problem with all integral meters is that they measure the light reflected back from the subject, so there's always a danger, no matter how sophisticated they become, of uneven lighting misleading the meter and causing over- or underexposure. For that reason it's still worth considering getting a hand-held meter that features an incident reading facility. This measures the light falling on to the subject, so it is not affected by unusually light or dark surroundings.

If you shoot colour negative film, this probably isn't necessary, because the film's enormous exposure latitude means that only very occasionally will you suffer any kind of failure – and that's more likely to be due to the printing than the exposure.

But if you're regularly shooting colour transparency film, which has less latitude and demands extremely accurate exposure, or tackling professional work where you need to achieve successful results every single time, then a separate meter is still a worthwhile choice.

For most amateur photographers, though, the current in-camera meters are incredibly reliable, and more than sufficient.

HAND-HELD METER Using a separate meter virtually guarantees correct exposure, whatever the circumstances.

ADVANCED ZONE EXPOSURE

The Zone System is an advanced and rigorous exposure system pioneered by the great American landscape photographer Ansel Adams. It breaks down the brightness range of a subject, from black to white, into ten zones – usually indicated by Roman numerals from 0 to IX.

Each of the zones is one stop lighter or darker than its neighbour: Zone 0 is solid black, Zone IX (9) is pure white, and Zone V (5) is the 18 per cent reflectance mid-grey to which meters and grey cards are calibrated.

Through an exhaustive series of tests, involving film speed (or exposure index, as it's known), developing times and printing times, practitioners of the Zone System reach the stage where they are able to 'previsualize' exactly what the finished print will look like at the time of taking the picture.

It's worth saying that the Zone System was developed for black-and-white photography using large-format cameras, although the principles can to some degree be adapted for colour and smaller formats. If you want to find out more about the Zone System, get hold of copies of two classic books by Ansel Adams: *The Negative* and *The Print*.

Building a lens system

One of the best things about SLRs is their ability to take different lenses that allow you to tackle different subjects. With the twist of a bayonet mount – or, increasingly, the turn or slide of a zoom – you can go from shooting architectural subjects or groups of people to photographing birds or taking candid shots.

But which lenses do you need? And which should you buy first? It all depends, of course, on what kind of pictures you like to take. In time you'll want to build up a comprehensive system that will let you handle just about any situation. But that takes time and money, and unless you have deep pockets or an understanding bank manager, choices have to be made in the short term

This section assumes that you either have an SLR with interchangeable lenses or have an interest in learning about them. If you have a zoom compact, the information relating to the various focal lengths and how to make the most of them will still be valuable, but you obviously won't have the flexibility of changing from one lens to another.

Most SLR bodies these days are supplied with a 'standard zoom'. This will typically have a range from wide-angle, usually 28mm or 35mm, to telephoto, generally 80mm, 105mm or 135mm, and will allow you to tackle a wide range of subjects. You might, though, have gone instead for a 'super-zoom', from 28mm all the way up to 200mm or even 300mm, allowing you to pull in more distant subjects. Or perhaps you chose a zoom starting at 24mm and going up to anything from 85mm to 140mm, increasing the amount you can get into the picture. In fact, those looking to buy

LENS OPTIONS
Lenses come in many shapes and sizes, and most keen photographers will want to build up a comprehensive system.

UNDERSTANDING LENS TERMS

Angle of view

The technical term used to describe the covering power of a lens – that is, how much of the scene it will take in – is 'angle of view'. This is always expressed in degrees. The larger the number, the greater the angle of view. Halving the focal length roughly doubles the angle of view. So a 24mm lens, which has an angle of view of 84°, allows you to include nearly double what you would get with a 50mm standard lens, for which the angle of view is 46°.

Focal length

The term 'focal length' has both a technical and an everyday meaning. Technically, it's the distance between the principal point of a lens and the focal point, at which light rays from a distance are in focus. But unless you know a bit about optics, that doesn't tell you very much. At a practical level, all you need to understand is that 50mm is a baseline reference point. As you increase the focal length the angle of view is narrowed and the magnification increases. The same object will, therefore, appear twice as large on film when photographed with a 100mm lens as with a 50mm lens. As you reduce the focal length, the object will appear smaller on the film, and the angle of view will open up. The 50mm focal length is said to be 'standard'. Any lens above 75mm is 'telephoto', and a lens of 35mm or below is 'wide-angle'.

Maximum aperture

A 'fast' lens is one with a maximum aperture that is larger than normal for its focal length. For instance, a typical 300mm lens has a maximum aperture of f/4, while a 'fast' 300mm lets in a stop more light with its maximum aperture of f/2.8. The extra light-gathering power allows you to set a higher shutter speed or a smaller aperture for the same lighting situation – but you often have to pay a significant premium for this privilege.

Minimum aperture

There is also a 'minimum' aperture, which is the smallest aperture available. This is often f/16 or f/22, though some lenses go to f/32. Having an extended minimum aperture offers no great advantage to most photographers.

lenses for a 35mm SLR have never had it so good. The development of digital photography in recent years has, paradoxically, reinvigorated 35mm photography, particularly in respect of lens development and choice. Focal lengths and zoom ranges that were once beyond the means of most amateurs – and some professionals – are now available at reasonably affordable prices.

Unless you have a particular interest that demands some kind of specialist lens, you'll probably find that 90 per cent of your picture-taking needs will be satisfied by just a couple of lenses covering the popular focal lengths, and they should be the first optics on your shopping list. It's important, however, to choose them carefully and try to think about your possible future needs, to avoid having to change lenses as your experience and interests develop.

Fisheye lens

PRIME VS ZOOM

One of the key factors to consider when building up a lens system is whether to buy zoom lenses or fixed focal length prime lenses – or a mixture of the two. Most people automatically go for zooms, which greatly outsell primes these days. The great advantages of zoom lenses, which have focal lengths that can be continuously varied from one end of the range to the other, are cost and convenience. Because they're bought in large qualities, prices are extremely reasonable, and a single zoom is certainly a lot cheaper than several prime lenses.

Zoom lens

Many photographers choose an outfit with two, sometimes three, zooms: a standard zoom, from 28mm or 35mm wide-angle to 80mm, 105mm or 135mm; a telezoom, from 70mm or 80mm up to 200mm or 300mm; and sometimes a wide-angle zoom. This is an excellent approach. Since you're not endlessly swapping from one lens to another you're always ready for the next shot. You'll use the standard zoom for everyday photography, the telezoom for details, portraits and more distant subjects, and the wide-angle for groups, buildings and landscapes.

Telephoto lens

Some photographers prefer to go for a super-zoom, such as 28–200mm or 28–300mm, which offers the ultimate in convenience. But designing

complex zooms is all a matter of compromise, and generally such lenses aren't the optical equal of most primes.

Both contrast and resolution are superior in lenses of fixed focal length. Aberrations are more often to be found on budget- to medium-priced zooms, with barrel distortion (in which the image appears to bulge outwards) prevalent at wide-angle setting and pincushion distortion (in which it is pinched in) common at the telephoto end.

The physical size of these lenses when at full stretch can make it more difficult to hand-hold without causing camera-shake at longer shutter speeds. And the close focusing on many super-zooms is restricted.

So, as in most areas of life, there's no such thing as a free lunch, and you won't be surprised to hear that prime lenses have plenty in their favour. For a start, they're usually much smaller and lighter, making them handle better on the camera. This is because they contain fewer elements and have a simpler configuration: a typical 28mm lens will have 5 elements in 5 groups, a 28–80mm 11 elements in 9 groups, and a 28–200mm 17 elements in 14 groups.

With less glass in them, prime lenses also tend to have larger maximum apertures. A fixed 90mm or 135mm would offer at least f/2.8 and possibly

even f/2.5, while the maximum aperture on the average 70–300mm is rarely better than f/3.5, and may only be f/4 or f/5.6. Many fixed focal length lenses have a maximum aperture that's a full two stops larger than in the equivalent zoom. This gives a brighter viewfinder image and allows you to take pictures in lower light without the need for fast film or additional lighting.

Overall, then, you'll probably get sharper pictures if you shoot with primes. If you can afford them, and don't mind carrying half a dozen (or more) lenses around, this is definitely the best way to go. But we all live in the real world and the truth is that modern zooms are of high quality and capable of producing sharp prints up to 10 x 8in and beyond. So an outfit based around two or three zooms with a 3x or 4x ratio – perhaps with the odd prime lens thrown in – would offer a good balance between convenience and quality.

Superzooms such as 28–300mm, however, which have a ratio of 10x, can suffer compromised performance in terms of both optical quality and close focus. You should really consider one only if your overriding concern is the convenience of covering all the bases with one lens.

APOS VS NORMAL LENSES

Apochromatic lenses – more commonly known as 'apos' – have become popular in recent years, thanks largely to the pioneering efforts of Sigma, which was one of the first companies to offer a comprehensive range. But can you answer this question: what's the opposite of an apochromatic lens? Don't know? Give up? Don't worry, most other photographers don't know the answer to this either. In fact, normal – non-apo – lenses are technically called 'achromatic'. The key difference between the two is that achromats are corrected only in the blue-violet and yellow ranges of the spectrum, while apochromats are also corrected for the red wavelengths. `

What this means in practice is that apochromatic lenses give sharper results. The improvement in optical quality is recognizable at all focal lengths, but is most significant with telephoto lenses because the effects of chromatic aberration get worse as

focal length increases. Apo lenses are produced using optics made with fluorite, which is very expensive, or ultra-low dispersion (UD) glass, which has similar characteristics but is more reasonably priced.

Is it worth spending more to buy an apo lens? If you're just intending to take snapshots, probably not. You won't really see the difference in a colour enprint. But if you're serious about your photography, and either shooting transparencies or having big enlargements made, then an apo lens could prove a worthwhile investment.

LENS COATINGS

An important difference between older lenses and more modern ones – and this is something to bear

ARCHITECTURAL DETAIL
There are some things you just can't get close to, such as this sundial on the side of a building. That's when you need a telephoto lens – here the top end of a 70–200mm zoom was used to focus attention on a small detail.

GOING IN CLOSE
Medium telephoto settings in the region of 135mm enable you to pick out interesting details rather than including the whole of the scene.

WIDE-ANGLE LENS
The look and feel you get from an image taken on a 28mm may not be as exciting as lenses with a wider angle of view, but they're great when you don't want to get too much into the frame.

STANDARD LENS
Standard lens settings, around 50mm, are ideal when you want a natural, realistic perspective that concentrates attention on the subject rather than the photographic technique.

in mind if you're tempted to buy secondhand – is the coating that's now added to elements. When light hits an uncoated lens element not all of it passes through. Around 5–10 per cent is reflected back. And with a typical 70–210mm zoom containing 14 elements, that adds up to a lot of light sloshing around. The result is the loss of contrast and 'ghost' reflections that are referred to as 'flare'.

To maximize light transmission, lenses are now given multiple layers of coating, which reduce reflection to as little as 0.2 per cent, and so minimize the danger of flare. The coatings used can also control the precise colour characteristics of the lens, and ensure that all the lenses in a range are optically matched for colour.

Finally, coatings contain a hardener that helps protect the front and rear elements from physical damage. For all these reasons, it's preferable to use a modern, multi-coated lens, rather than an older, uncoated one.

MARQUE VS INDEPENDENTS

These days, the difference between marque lenses – those produced by the company that made your camera – and most independently made lenses tend to be slight. Marque lenses are optically top-notch and cosmetically matched to the camera and other lenses in the range. Indie lenses offer more choice and, because they can be made in a range of fittings, gain economies of scale that mean they are generally cheaper.

Some modern autofocus cameras have specific linkages that allow body and lens to communicate with each other, and when buying an independent lens you need to check that it's fully compatible. But for general picture-taking at normal degrees of enlargement, you'll struggle to tell whether a picture was taken with a marque or independent lens.

PRICE

Generally, you get what you pay for with lenses. Buying cheap lenses is a poor investment, since the optics are arguably the most important part of the system. It's always worth buying the best lenses you can afford. You spent a lot on your camera and you'll spend a lot more on film and processing over the five years or so that you use a lens, so it surely makes sense to pay the extra for one that will give you the results you want, even if you have to wait a month or two before you get it.

When comparing the prices of lenses, check what else is included in the package. Is there a lens hood? What about a pouch or case? How long does the guarantee last?

HANDLING

Don't just buy on specification. The way a zoom handles in practice is important. Always test-drive a lens before buying. Is it comfortable and easy to use? Check the action of the zoom mechanism – is it just right, or too stiff or too light? If it's an auto-focus lens, check the focusing ring in case you want to focus manually. Little niggles can grow into big ones when you use the lens a lot.

LENS DEFECTS

No lens is perfect, however well designed or made. Here are some of the most common optical aberrations and how to spot them.

Distortion

➡ The lens designer's aim is that the final picture represents the subject accurately. But the complexity of lens design, especially in wide-ranging zooms or fast-aperture lenses, means that this is not always possible. With subjects such as buildings or artwork, distortion may become apparent when straight lines fall near the edge of the picture. With barrel distortion, straight lines bend in at the corners of the frame; with pincushion distortion the effect is reversed, with straight lines bending in at the centre. Some lens defects can be minimized or even eliminated by means of aperture choice. Not so with barrel and pincushion distortion, which remain the same no matter what the f-stop.

Spherical aberration

➡ Light rays entering the edge of a lens element are bent more than those passing through the centre, and the spread of focus produced results in a soft, low-contrast image. All lenses are subject to some spherical aberration, and this is one reason why they tend to give sharper results as you close down the aperture – because less light from the edge is being used. Most lenses are at their optical best two stops in from maximum aperture. If the performance is significantly worse – with optimum quality four or five stops in – this is a sign of severe spherical aberration.

Coma, or comatic aberration

➡ Compensating for spherical aberration is not difficult, but one of the effects of overcompensating is coma, which causes blurring near the edges of the image, with circles reproduced as 'pear' or 'comet' shapes. Once again, opting for a smaller aperture will lead to a significant improvement in image quality.

Flare

➡ Flare is caused by non-image-forming light bouncing around inside the lens. Careful design, including multi-coating of elements and anti-reflection measures inside the lens barrel can help, but it can never be eliminated entirely, especially when the sun or some other powerful light source is included in the picture. For that reason it's always a good idea to use a lens hood. In extreme situations block the sun with either your hand or a proper 'scrim'.

Vignetting

➡ Less light finds its way into the corners of the picture, resulting in a darker 'frame' around the subject. This fall-off becomes greater as the angle of view increases, and is most often seen in lenses with a focal length of 24mm or less, though not all wide-angles suffer from the problem. Try setting a small aperture: the smaller the aperture the less the vignetting. With some lenses, especially wide-angles and those with large front elements, vignetting can occur if you fit a filter or too large a hood.

Lens focal lengths

20MM WIDE-ANGLE
Lenses in the 20/21mm range give a distinctive, striking wide-angle look to the subject, but need using with care to prevent everything looking as if it's far off in the distance.

So what do all these 'mm' numbers mean? Let's look at the range of focal lengths and how to use them.

STANDARD LENGTH

Until the 1980s, 50mm lenses were supplied with the majority of SLRs, and though most people now go for a standard zoom, standard prime lenses still have a lot going for them – and they're not that expensive to buy. They're called 'standard' because their focal length of 50mm and angle of view of 46° give a perspective that's very similar to the way we see the world with our eyes. The result is natural-looking pictures, and a 50mm lens is the ideal choice when you want to record things faithfully, without distortion. It's also small, lightweight and produces razor-sharp images. Most 50mm lenses have a maximum aperture around f/1.8, which allows you to take pictures in low light without resorting to flash – as well as making it easy to throw backgrounds completely out of focus.

Whether you're photographing people, land-scapes, still lifes or buildings, the standard lens can be extremely useful. But the pictures from a standard lens can sometimes lack impact, and you'll quickly find that although it's a jack-of-all-trades it's also master of none.

WIDE-ANGLE LENSES

Lenses that take in more of the scene than a 50mm lens are known as wide-angles. The most popular fixed focal length wide-angles are 28mm and 24mm, but the full range goes from 8mm fish-eye up to 35mm. The most obvious characteristic of a wide-angle lens is that it includes more of the subject in the frame. The wider the angle of view of the lens the more it will take in: a 21mm includes more than a 24mm, a 28mm more than a 35mm, and so on.

Wide-angle lenses also give a greater apparent depth of field, especially at small apertures such as f/11 and f/16. This ability of wide-angle lenses to keep everything sharp is legendary. If you set an aperture of f/22 and focus at 1m (39in), every-

thing from 0.5m (20in) to infinity will be in focus. Even at more modest apertures, depth of field is extensive. In fact, when using a wide-angle lens it can be difficult to throw the background out of focus when that is what you want to do.

Another useful aspect of a wide-angle lens is the dramatic perspective it can provide, with the parts of the scene that are closest to the camera looming large while elements further away seem to recede quickly into the distance. This effect will be exaggerated if you tip the camera backwards or forwards. Doing this creates what are called 'converging verticals', with the result that tall buildings appear to be falling over backwards.

There's always a danger when using a wide-angle lens that everything will end up looking a long way away. The wider the lens the greater is the risk of this happening. But by paying careful attention to your composition, and framing the subject so there is something of interest in the foreground, you can create a wonderful sense of depth and space in the picture. With a landscape, for instance, you might find a vantage point with a rock or a boat close to the camera. With a building, the foreground might include some brightly coloured flowers or a statue. Or you could look for some kind of natural frame, such as an overhanging tree or a bridge, to place in the foreground.

The two areas where wide-angles are most commonly used are landscape and architecture. Both involve large subjects that cannot be photographed satisfactorily with a standard lens, and it's often not possible to step back to include more in the frame. When photographing the interior of a building wide-angles can make rooms look much more spacious than they really are.

Wide-angle lenses are also useful when you are photographing a large group of people where space is restricted. In this situation, care should be taken that you don't place those at the edges of the group too close to the edge of the frame, or they can end up looking distorted.

• 35mm

Thirty years ago, 35mm was the most commonly used wide-angle. Hardly anybody buys it as a separate focal length now, apart from reportage photographers who work in close and want to include more than 50mm will allow. You usually get it 'free' as part of a standard zoom. But consider it if you want a fast, compact, moderate wide-angle, though 28mm is arguably a better choice.

• 28mm

Among wide-angle focal lengths, 28mm is the 'standard' lens, with an angle of view of 75°. Many photographers now choose a standard zoom that goes down to 28mm, because this is the first focal length at which wide-angle characteristics really become apparent. It lends itself to pretty much any kind of photography, and is capable of taking in a broad sweep of landscape or the interior of a building with little in the way of distortion. At one time, 28mm lenses were phenomenally popular, but now they're more commonly bought as part of the zoom, though prime lenses are still available. They're worth considering if your standard zoom goes down to just 35mm, though you'll see a more dramatic opening up of perspective if you go for a 24mm.

• 24mm

The 24mm lens marks the turning point between wide and ultra-wide. It's wide enough to give that distinctive and dramatic wide-angle sweep, but

24MM WIDE-ANGLE For general wide-angle use nothing beats a 24mm – especially if you go in close and fill the frame with a subject in the foreground and set as small an aperture as possible.

ULTRA-WIDE-ANGLE
Lenses such as the 17mm
used here not only get a
lot more into the picture,
they enable you to create
dramatic compositions
with eye-catching
perspective. Using an
aperture of f/16 keeps
everything sharp from
front to back.

TELEPHOTO
At a concert it's often
difficult to get close to a
performer, and you'll
need a reasonably
powerful lens if you're to
make much impact –
here a 300mm telephoto
was used.

without significant distortion – and at a sensible price. Depth of field is extensive, even at wide apertures, and creates an exaggerated scale and perspective. The extra 4mm of focal length increases the angle of view to 84°, and gives a much more noticeable wide-angle effect.

If you ever find yourself wanting to photograph big buildings, vast landscapes, cramped interiors or large groups of people, you'll discover that even a 28mm lens sometimes won't cope. But the 24mm, with its greater angle of view, covers more of the scene, and lets you cram a surprising amount more into your pictures.

• 20mm
For its great covering power and sweeping perspective, 20mm is a focal length beloved of landscape photographers. Although examples are not cheap, they're certainly worth considering, especially since most have a maximum aperture of f/2.8, which makes it possible to hand-hold even when light levels start to drop.

• 17mm
This classic ultra-wide-angle focal length swallows up an enormous amount of the world, and as soon as you tip it even a little, bends all the straight lines into curves. This is great where you really do want to cram everything in and produce dramatic results but, with care, by keeping the camera upright, you can minimize the distortion. The amazing perspec-

tive offered by ultra-wide-angle lenses makes it possible to create striking images from virtually nothing, simply by going in close. An ordinary road heading off into the distance can suddenly be transformed into an exciting composition by getting down low to the white lines.

• Wide-angle zooms
The advent of digital SLRs, some of which have a magnification factor of 1.4x or 1.6x as far as lenses are concerned, has prompted manufacturers to concentrate their efforts on producing high-quality wide-angle zooms at more affordable prices. As a result, you can now readily buy zooms that start from 15/16/17/18/19/20mm and go up to somewhere between 30mm and 40mm. Such lenses are pure wide-angle heaven. As with other zooms, there have been compromises in construction, and quality is not, in absolute terms, as good as prime lenses, but for most purposes it's more than sufficient. If you favour landscape, architectural or group work, a wide-angle zoom is well worth considering.

TELEPHOTO LENSES
By narrowing the angle of view to include just part of the scene, and then magnifying it, a telephoto lens allows you to fill the frame with small and distant subjects. When shopping for a telephoto lens, photographers often ask how much closer it will bring things. There's a simple relation between the focal length and the degree of magnification. It's all based upon the 50mm standard lens, with a 200mm lens giving a magnification of 4x and a 400mm a magnification of 8x.

Any lens above about 70mm is strictly a telephoto, but it's not really until you get up to 100mm that you start to see an obvious telephoto effect, which gets stronger as the focal length increases.

The main reason most photographers want a long telephoto lens is to bring distant subjects closer. Certainly, if you want to photograph subjects such as wildlife and birds or sport and action you won't make much impact without something reasonably powerful. But long teles are also excellent for the subjects that most photographers tackle with a wide-angle – such as architecture and landscape.

With buildings, for instance, standing some way back and using a 200mm or 300mm enables you to take shots in which the verticals are perfectly upright, avoiding the convergence you get if you use a standard or wide-angle in close. Landscapes also take on a different dimension, allowing you to turn much-photographed scenes into interesting and unusual abstracts. Telephoto lenses enable you to crop in tightly on just a small part of the vast panorama in front of you – such as a lonely white house set in a vast valley. Zoom lenses up to 300mm are particularly versatile for this kind of work, allowing you a wide range of framing options.

Even in portraiture, long teles have a part to play. Most magazines recommend the use of a lens with a focal length of around 100mm for flattering

pictures of people, but try shooting with a 200mm or even 300mm, and you can make the person stand out extremely powerfully, thanks to the limited depth of field such lenses give, especially when used at maximum aperture.

Long teles also have another characteristic that clever photographers can take advantage of: the way in which they compress perspective. When you use a 300mm or 400mm lens you'll find that sub-jects that are in reality a long way apart seem to

ZOOMING

If you've got a zoom lens, one of the most dramatic ways of conveying a sense of movement is to change its focal length while you're taking the picture. The result is an 'explosion' effect, in which everything seems to be blasting out from the centre of the picture. The technique can be used successfully for almost any kind of photography, but works best when the picture has plenty of colour in it and there's a strong central subject to act as a focal point. It doesn't matter whether you have a standard or telephoto zoom; both are perfectly suitable, although the results will be slightly different. Telezooms from 70–210mm tend to give a more 'concentrated' burst effect that's easier to predict.

↑ ZOOMING
Zooming the lens during the exposure can transform a mundane subject into something really exciting.

Because you have to zoom the lens while the picture's actually being taken, you should try to set as long an exposure as possible, which will give you time to twist or pull the zoom ring from one end of its range to the other. Ideally you want 1 sec or longer, so your best bet is to anchor the camera firmly to a tripod to avoid any unwanted camera-shake. This also frees you to operate the zoom control as smoothly and steadily as possible. To achieve that long shutter speed you'll need to load up with a slow film (around ISO 50), shoot on a relatively dull day, and stop down to a small aperture (f/16 or, if you have it, f/22).

If there is still too much light, you might have to resort to filters to cut it down further. What you really need are neutral density filters, which vary in strength but typically reduce the light by two or four stops. If you haven't any you can improvise with a polarizer, which will absorb around two stops of light. The resulting small aperture also has the advantage of ensuring that everything in the picture stays sharp, even if focus drifts a little during zooming.

If you have an autofocus camera, you'll need to switch it to manual focus. Start by focusing at the top end of the scale – for instance, 210mm on a 70–210mm lens and 80mm on a 28–80mm. This is because focusing is more critical at longer focal lengths. Before actually exposing any film have a few practice runs so that you learn how fast to zoom and get the knack of doing so smoothly. Having mastered the technique of zooming all through the exposure, you might also like to experiment with holding the focal length for part of the exposure and then zooming during the rest. This gives a sharp central image with streaks at the edges, but requires a shutter speed of 8 sec or more.

PORTRAITS
Lenses from around 75mm to 105mm are perfect for people pictures of all kind, because they flatter facial features.

CANDID SHOTS
Super-telephoto lenses such as the 600mm used here to capture this man from the other side of a road, are powerful enough to tackle most distant subjects.

'stack up' so that they look as if they're next to each other. This can be used to dramatic effect with a subject such as a row of trees or telegraph poles.

You do need to be aware, however, that long tele lenses will show up any weaknesses in your technique. With the depth of field so limited, you need to be bang-on with your focusing, because even the slightest error can lead to unsharp pictures. With an autofocus camera this shouldn't be a problem. Camera-shake, though, might be. When hand-holding a long tele, remember to set a shutter speed that's at least the reciprocal of the focal length – 1/250 sec with a 200mm, 1/500 sec with a 400mm – and preferably faster still. Even that may not be enough. Whenever possible you should use a tripod to stop it waggling about or, when shooting sport and action, a monopod, which combines stability with manoeuvrability.

And finally, you may not immediately think of your telephoto when it comes to shooting close-ups, but it may be the perfect choice. Most modern types have an excellent close-focusing capability, giving images up to a quarter life-size. The principal advantage of using a longer focal length lens is that you don't have to get so near to the subject, which means you're a lot less likely to block the light.

Twenty years ago photographers would buy separate 90mm, 135mm and 200mm lenses. It's now more common to take in these three popular focal lengths in one lens – a telephoto zoom – although as discussed above there are arguments for sticking with prime lenses.

• Short and medium telephotos

Telephoto lenses with a focal length between 70mm and 105mm are more commonly known as 'portrait' lenses, because the perspective they give is perfect for flattering pictures of people. Short telephotos are also excellent for a host of other subjects, from landscape to still life, where you want to crop in a little more tightly on a subject. The most common primes in this sector have focal lengths of 85mm, 90mm, 100mm or 105mm, and most camera makers offer one or two in their range, sometimes also with options in respect of maximum aperture.

• Medium telephoto lenses

With a focal length of 135mm or 200mm, medium telephoto lenses are slightly more powerful, making them ideal for situations where you can't get quite so close to your subject, such as candid shots, accessible sports, pets and architectural details. Prime 135mm and 200mm lenses are no longer popular – most people prefer to buy a telezoom – so no independents are available, although most camera companies offer at least one example of both of these focal lengths.

• Long telephoto lenses

Longer telephotos, from 300mm upwards, have extra pulling power that enables you to fill the frame with far-off subjects, making them perfect for wildlife and sports photographers. This is a sector that is particularly well served, both in terms of marque lenses and independents.

For general long telephoto photography a 400mm is probably the best choice. Slightly less powerful, but excellent if you have a zoom up to 200/210mm, there are 300mm lenses available,

while 500mm and 600mm telephotos are really only worth considering if you want to shoot difficult subjects such as wild birds and motorsport. These very long teles are bulky, heavy and expensive. A 1.4x or 2x converter (see 'Teleconverters', page 55) is another option when you need more pulling power. But for those who need something really powerful, there are focal lengths right up to 1,200mm – this has an angle of view of just 2°.

• Telephoto zooms

For many photographers a telezoom, from 70mm or 80mm to 200mm or 300mm, is the ideal second lens. This one reasonably priced lens will give you access to a wide range of popular subjects out of the reach of a standard zoom. If you feel you'll need the pulling power of a 300mm, it's a good idea to invest in a 75–300mm to complement your standard zoom, giving you coverage from 28mm right up to 300mm. There are telezooms up to 400mm and even 500mm, but while they sound appealing, they're not as portable and easy to use as those going to 200/300mm.

TELEZOOM
There's nothing to beat a telezoom – in just a couple of seconds you can go from an overall view to a frame-filling detail.

MIRROR LENS
A mirror lens creates characteristic doughnut-shaped out-of-focus highlights – but you have to get the distance right.

SPECIALIST LENSES

• Mirror lenses

A special kind of telephoto lens, a mirror lens is far more compact and lightweight than traditional telephoto designs, making it considerably easier to carry around and use.

Although this is an advantage, the lack of weight can lull you into a false sense of security as far as shutter speeds are concerned, and if you're hand-holding the camera you'll need to set a shutter speed that's at least equivalent to the focal length of the lens in use. So with a 500mm mirror, the minimum to be safe is 1/500 sec.

However, as all mirror lenses have a fixed aperture, typically f/8 on a 500mm, you have no direct control over the shutter speed. On a sunny day, using ISO 100 film, 1/500 sec is the best you'll get. It makes sense, then, either to load up with a faster film, say ISO 400, or preferably work on a tripod. Because of the fixed aperture, you need to work in aperture-priority or manual exposure modes.

If you want to take pictures with the characteristic mirror lens 'doughnut' effect on out-of-focus highlights you'll need to experiment with the distance between you and the subject and the subject and the background.

Finally, take care when shooting into the sun, as the large front element and mirror design makes these lenses prone to flare.

• Fisheye lenses

With an angle of view of 180°, these lenses are truly amazing and make all kinds of outlandish effects possible. However, they're items of equipment that can easily become overused. Uncorrected for distortion, all but the centrally placed lines in the image are noticeably curved. The full-frame fisheye, with a focal length that's

FULL-FRAME FISHEYE
Full-frame fisheye lenses, such as this 15mm, produce a standard 24 x 36mm image, but straight lines curve as soon as you tip the camera. Objects close to the camera look much larger than those further away.

typically 15mm to 18mm, produces an image over the entire frame. The circular fisheye, as its name suggests, produces a circular image with a black border. Its focal length is normally 6mm or 8mm. Because fisheye lenses offer a full 180° angle of view there's a constant danger of including your own fingers and feet in your pictures.

• Macro lenses

Designed for close-up photography, macro lenses are available in two main focal length ranges: 50/55mm and 90/100/105mm. The former doubles as a standard lens, and the latter makes an excellent portrait optic, and is the better choice. Some macro lenses give half life-size reproduction; on others the ratio is 1:1. When using a macro lens, accurate focusing is absolutely essential. The closer you go, the more limited the depth of field

becomes, and at its nearest setting the lens may offer you only a few millimetres leeway. For this reason, it's a good idea to focus manually, even if you have an autofocus camera.

• Soft-focus lenses

Most modern lenses, even budget-priced ones, are capable of taking high-quality pictures, with lots of detail and plenty of contrast. In fact, for certain subjects – such as a beautiful woman or a country cottage – they're sometimes too sharp. Most photographers soften the image by fitting a diffuser, but there is another way: you can buy a special soft-focus lens. This has a ring that allows you to dial in soft focus when you want it, or use it as a normal lens when you don't. Soft-focus lenses aren't offered by independents, but some camera manufacturers list them.

⬆ FISHEYE LENS
The characteristic circular image from a fisheye lens takes in a full 180° – so you need to be careful not to include your fingers or feet in the picture.

• Perspective control lenses

More commonly known as shift lenses, perspective control (PC) lenses make it possible to photograph tall buildings in confined circumstances without causing converging verticals – which make buildings appear to be falling over backwards. This is achieved by means of a sliding control on the lens that allows the elements to be shifted up or down (hence the name) to control the perspective.

Shift lenses are easy to use because you can see the effect they're having in the viewfinder. Start by making sure the camera back is absolutely vertical – ideally using a hot-shoe spirit level – then simply adjust the degree of shift until a clear upright on the subject lines up with the edge of the viewfinder frame. Because of the fine control needed, this is a lot easier if you work on a tripod, which will have the added benefit of allowing you to set a small aperture, ensuring maximum depth of field.

Care should always be taken on the metering front when using a perspective control lens, as the process of shifting can sometimes cause errors. The surest approach is to take your reading before changing the perspective.

While shift lenses are designed primarily as technical instruments to correct distortion, they can also be used creatively to introduce it. Shifting the lens the other way will have the effect of stretching the subject – producing extremely dramatic shots of people.

⬆ **PERSPECTIVE CONTROL**
Shot with a normal 24mm lens (top), the Grand Hotel, Brighton appears to be falling over backwards. But when a 24mm PC lens is used (above), it's possible to correct for the verticals.

➡ **TELECONVERTERS**
Using teleconverters is an inexpensive way of increasing the range of focal lengths. Fitting 2x and 3x converters to a 100mm lens (right) gives the equivalent of 200mm (centre right) and 300mm (far right) lenses.

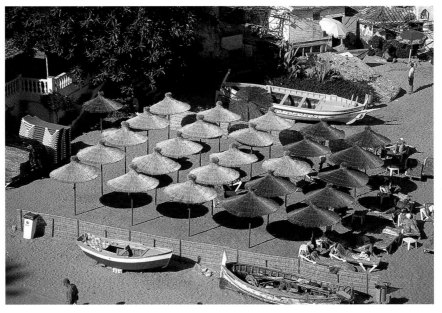

TELECONVERTERS

Teleconverters are optical devices that can be fitted between the lens and the camera body to increase the focal length of the lens by 1.4 or 2 or 3 times. They offer a simple and inexpensive alternative to buying another lens of a longer focal length. A 2x converter will turn 50mm into 100mm, 300mm into 600mm, and so on.

This applies in the same way to zoom lenses. So it's true that if you used a converter with your 28–105mm it would effectively become a 56–210mm zoom – but it's not recommended. The problem is that when you use a teleconverter the image quality is degraded, resulting in a picture with reduced sharpness and lower contrast. The amount it's degraded by depends primarily on the quality of the lens with which the teleconverter is used.

Prime lenses tend to be out of the top drawer optically, so they still manage to give good results when used with a converter – which is designed to be used with such lenses. Zooms, however, are often not as sharp to begin with, and the results when they're combined with a converter can be disappointing, especially if you are looking for pictures bigger than enprints.

A 2x converter also absorbs two stops of light, effectively turning a lens with a maximum aperture of f/4 into one with a maximum of f/8. To compensate for this loss you may need to move up to a faster film, further compromising quality.

BUY A LENS HOOD

Flare is a problem that's caused when stray light enters the lens and scatters inside it, fogging all or part of the image, and resulting in a picture that lacks contrast and definition. Your pictures are most likely to suffer flare when you're shooting directly into the sun on a bright day, and its strong light falls directly upon the front element of the lens. To avoid this happening you should try to find a shooting position in which the front element is shaded by something like a tree. Failing this, you could hold up one of your hands to block out the sun – although you must take care to ensure that it doesn't appear in the finished picture.

To minimize the risk of flare, you should fit hoods to the fronts of all of your lenses. Whenever possible, buy a hood made for your particular lens, as it will be perfectly matched to offer the maximum protection. As a general rule, wide-angle lenses, with their greater angle of view, require extremely shallow hoods, while telephotos, with their narrow view, benefit from far deeper types.

Which film?

Film plays an extremely important role in the life of a 35mm photographer. The type you choose, and how you use it, can make an extraordinary amount of difference to how your pictures come out. In fact it's no exaggeration to say that the whole look and feel of an image is determined by film choice. So you obviously don't want to pick up the first film that comes to hand. Nor should you accept whatever the shop assistant offers you, or use what your Uncle Fred recommends.

Film choice demands careful consideration, based upon the subject, the situation, what you want to do with the pictures and, most importantly, your personal approach to photography.

SLIDE OR PRINT

The first decision you need to make is whether you want to shoot prints or slides.

For most people, colour negative film is the preferred choice – and the right one. At reasonable cost you get a set of prints that you can pass around to family and friends or send to far-off relatives. You don't need any equipment to view your photographs, and prints are easy to carry around with you. And if you take a cracking shot and want a big blow-up to put over the mantelpiece

it won't break the bank. Also worth considering is the fact that colour negative film is straightforward to work with, and with high-quality modern emulsions it's hard to get bad results.

Slide films, on the other hand, are much more demanding. But if your technique is up to the mark, and your camera metering accurate enough, then you could reap the benefits. You may feel that slides are 'old hat' these days, because nobody can be bothered to set up projectors and screens any more. While it's certainly true that the giving of slide shows is a dying art, there's no denying the power of a pin-sharp and well-exposed transparency blown up to billboard-size proportions.

Shooting slides is also essential if you're looking to make money from your camera. Very few magazine, postcard and calendar publishers will consider prints, no matter how good they are, and slides are the only currency most picture libraries will deal in.

COLOUR OR BLACK AND WHITE

The next decision is whether to go for colour or black and white. Once again, for many photographers this is an easy choice to make. They prefer the natural, realistic look of colour, and wouldn't consider anything else. The rich, saturated colours of modern emulsions make it easy to get wonderfully true-to-life images.

Then there's the convenience factor to consider. Virtually wherever you live, you can drop a colour film into a local processing laboratory and get your photographs back within the hour. Or you can send it off in a readily available prepaid envelope and receive the prints a few days later.

Black-and-white photography has a lot going for it, however. If you want to go beyond merely capturing a memory, and are setting out to produce creative or artistic images, then monochrome emulsions – because of the way they reduce everything to a series of tones – can be a great medium to work with.

The good news is that getting black-and-white film processed is now a lot easier than it used to be, with most labs offering a quality processing service. In fact, some modern monochrome films, such as Ilford XP2 and Kodak T400CN, can be processed using standard C41 colour chemistry and turned around within the hour. The prints are made on colour paper, and do sometimes have a colour cast – but that can add to their charm. And you can always get the negatives printed on to proper black-and-white paper later if you wish.

Alternatively, if you fancy setting up your own darkroom, processing and printing black-and-white for yourself has the advantage of being a relatively low-cost option that is also extremely satisfying.

TUNGSTEN VS DAYLIGHT

Most films on the market are intended for use in daylight or with electronic flash – and they give neutral results if you use them in these conditions. Use them under tungsten light, though, such as a normal household lamp, and you'll get a nasty orange cast. This can be corrected by using a blue correction filter, but a better option is to use one of the tungsten-balanced films that are available.

SLOW FILM
Though you may need to use a tripod when light levels fall, slow film, such as the ISO 50 emulsion used here, offers superfine grain, excellent sharpness and rich, vivid colours.

BRAND VS OWN BRAND

Many photographers are uncertain about which brand of film to buy. Should they go for leading brands on the basis that they're probably the best? Or are cheaper own-brand films as good?

This is one area where it's hard to give definitive answers. If you're looking for the ultimate in quality, and regularly have enlargements made, then it's probably worth paying a premium price. But if you mostly shoot enprints, most brands should give acceptable results. Try a few different types and settle on one that gives you pictures that you like.

It's more important where you get the film processed than which film you use. Processing is often a case of 'you get what you pay for', and spending more to see the images you went to so much trouble to take well reproduced would seem to be a worthwhile investment.

↑ **MEDIUM-SPEED FILM**
For general use there's nothing to beat a film with an ISO rating of 100 or 200. It produces high-quality results in a wide range of situations and gives workable apertures and shutter speeds.

UPRATING AND DOWNRATING

⊛ In the bad old days, when there were few films with a rating above ISO 400, a technique called uprating was very popular. This involves deliberately underexposing the film and then increasing development to compensate. For technical reasons this is only possible with slide film and black-and-white – with colour print films all the colours are completely upset.

These days, you'd normally use uprating only for creative effect. It will generally increase grain and contrast significantly. The opposite technique – downrating – can be an effective way of reducing contrast when faced with a harshly lit subject.

↑ **UPRATING**
Although it's less necessary now with modern high-speed films, 'pushing' or uprating films is an excellent way to squeeze more sensitivity out of a film. Here an ISO 400 film was rated at ISO 1600 and push-processed to compensate.

FILM SPEEDS
• Slow (up to ISO 100)

When only the highest possible quality will do – for a big enlargement or publication – slow films are the first choice. Grain is virtually non-existent and colours extremely rich. The only problem is that the relative insensitivity of the film means you need to have very good light or use a tripod – possibly both.

• Medium (ISO 200)

For general purpose picture-taking, a medium-speed film is the one to go for. It will give you

excellent quality, and will enlarge well beyond 10 x 8in, while still being very usable. Recent improvements in the quality of ISO 200 film have led to it now being more popular than ISO 100. Certainly at enprint size it's impossible to detect any difference between the two, and the extra stop of speed offered by ISO 200 is helpful with today's wide-ranging zooms.

• Fast (ISO 400–800)

Switch to fast film, ISO 400–800, and you'll see a worsening of quality. The colours will be softer and the picture not as punchy. But these films are still very good – especially some of the recent colour print introductions. ISO 400 transparency films, however, lag significantly behind their ISO 100 and 200 stablemates. Use fast film only when you really need the speed – such as when shooting sport – not as your regular stock.

• Ultra-fast (ISO 800–3200)

Load up with ultra-fast film, with an ISO of 800 upwards, and you'll start to see the grain at even normal levels of enlargement. But these films can be useful tools in the right circumstances – such as taking pictures hand-held in really dire light, or

FAST FILM
As light levels start to fall, or when using a zoom lens with a limiting maximum aperture, you'll need a slightly faster film. ISO 400 should be your first choice – you'll get strong colour and good sharpness without excessive grain.

if you need fast shutter speeds in half-decent light. You can either regard them as 'get-you-out-of-trouble' films or use their pastel graininess to deliberate creative effect.

INFRARED FILM

Beyond the mainstream films are a host of other specialist emulsions that are well worth investigating. One of the most interesting is infrared, which is available in both black-and-white and colour forms. Kodak High Speed Infrared is a superb monochrome emulsion that's sensitive to infrared and red wavelengths. It gives extraordinary results, with pronounced grain, luminescent foliage and skin tones, and black skies. Rate the camera at ISO 400 and fit a red filter. The film must be loaded and processed in complete darkness. For colour, there's Kodak Ektachrome Infrared film, which gives different results depending on the filters you use. With all infrared films you need to make a small adjustment to your focusing. Do check that you can use infrared in your camera – some of the latest models have an infrared film counter that can fog the film.

ROLL YOUR OWN

If you shoot a lot of film you could soon find photography burning a hole in your pocket. A great way to cut your costs is to buy your film in bulk lengths and break it down into cassettes yourself. The savings can be considerable and it's easier than you might think. All you need is a daylight loader, some reloadable cassettes, a roll of masking tape, and some DX-coding stickers. The tricky bit is loading the bulk film into the loader. This has to be done in complete darkness, so invest in a changing bag if you don't have access to a darkroom. Once that's done, you can load your cassettes with film in broad daylight. The only drawbacks are that not all film types are available in bulk lengths, and that there is a very slight risk of scratching the film when you load it.

INFRARED FILM
The rich colours of this Mediterranean scene have been transformed through the use of infrared film and a yellow filter over the lens.

◀ INFRARED WITH FILTERS
The colours you get from infrared film depend to a large degree upon the filter you use over the lens. Yellow is the best choice, but others are worth trying. From top to bottom, the images are: original scene on regular slide film, infrared with yellow filter, no filter, and blue filter.

PROFESSIONAL FILMS

It's worth saying a word or two about films designated 'professional'. Many amateurs think that they will get better results by using such film – but in fact the opposite can be true. Professional films are designed to be used and processed in a particular way. Unlike amateur films, which 'mature' over time, professional films are ready to shoot when they leave the factory, so they have to be kept in a refrigerator until needed then shot and processed immediately. If you leave a roll of professional film in a camera for a couple of months before processing, the results will probably be inferior to those from an off-the-shelf amateur brand.

You also need to be aware that there may be tonal differences that may not suit your photography. ISO 160 professional films made for wedding and portrait photography, for instance, have muted colours and a soft tonality that don't bring out the best from many everyday subjects.

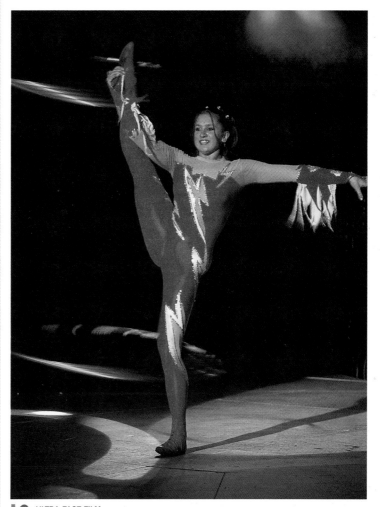

↑ ULTRA-FAST FILM
When light levels are so low that you need as much speed as possible, such as when visiting a circus, opt for an ultra-fast film with a rating of ISO 1600 or even 3200. The quality will be inferior, but at least you'll get the picture.

Flash photography

Typical accessory gun with bounce and twist head.

Hammerhead gun designed to fit alongside the camera on a bracket.

⊙ **BUILT-IN FLASH**
Built-in flashguns are fine for subjects relatively close to the camera, and while the quality of the light is not perfect they do produce crisp, sharp images.

Almost all 35mm compacts and SLRs now come with a flashgun built into the camera. Most are of low power, with a typical guide number (GN) of 12m/ISO 100. On some advanced SLRs, the flashgun zooms automatically with the lens, and may go up to a more powerful 17m/ISO 100.

As a rule of thumb, integral guns will give you a working distance up to 3–4m (10–13ft), making them good for pictures of people, domestic interiors and other relatively close subjects. However, because the gun is fixed in place, there's little you can do to improve the quality of light it gives out – except use the anti-red-eye facility if there is one.

If you're a wide-angle fan, do check the angle of coverage of the flash, which is often that of a 28mm lens. If you use a wider lens, you'll find the edges of your pictures come out dark. Take care also when using long lenses at close quarters. The lens barrel can obstruct light from the flash, as can Cokin filter holders or oversized hoods.

Sooner or later, though, having a built-in gun is going to start limiting your creativity, and you'll need

to think about investing in a more versatile and more powerful gun. Ideally you'll want something with a GN of around 36m/ISO 100, a bounce and twist head, and perhaps some other advanced features, such as trailing shutter curtain sync and multi-flash and slave flash facilities, to open up further possibilities and fire your creativity.

The gun will also offer a wide variety of working modes, some more automated than others. Which one you use will depend upon the circumstances.

MANUAL MODE

In manual, flashguns give out the same amount of light every time. To calculate the aperture you need, you have to divide the GN by the flash-to-subject distance. So, if your GN is 36m/ISO 100, and the flash-to-subject distance is 3m, the aperture will be f/11 (36 divided by 3 equals 12, closest aperture is f/11).

You can also work the other way round. If you want to use a particular aperture – say f/8 – then dividing it into the GN will give the flash-to-subject distance, in this case 4.5m (36 divided by 8).

AUTOMATIC MODE

Auto guns have a sensor on the front that measures the light reflected back from the subject and cuts off the output when enough has been given out. All you have to do is set the aperture indicated on the back of the flashgun and make sure your subject is within the range shown. Simple guns offer just one auto setting; others boast as many as seven. Some auto guns also have 'thyristor' circuitry, which saves unused power and so improves the recycle time considerably. Some guns can recycle in as little as one second at close distances.

TTL METERING

Through-the-lens flash metering offers a significant advance in exposure accuracy. A sensor inside the camera measures the light reflected back from the

subject, so the calculation is based only on what the lens sees, and is less likely to be affected by excessively light or dark areas around the subject. Some SLRs now boast more sophisticated systems. For example, Canon's A-TTL (advanced through-the-lens) EOS Speedlite system fires a pre-exposure flash to determine the flash-to-subject distance.

DEDICATION

Most SLRs now offer a dedicated flash facility, meaning that there's some interchange of information between the flashgun and the camera, but exactly what you get depends to a large degree upon which system you're using. Almost all set the flash sync speed automatically, and most offer some kind of TTL or more advanced metering – such as Canon's Evaluative metering and Nikon's 3-D Matrix metering – which uses information from the focusing system to improve flash accuracy.

FLASH TECHNIQUES

• Improving the light

Using your flashgun on top of the camera results in flat lighting and harsh shadows – and the danger of red-eye. But with a little imagination your flashgun can produce results every bit as good as a high-quality studio flash head.

A simple way of softening the light is to fasten some tracing paper or soft tissue over the flash tube. This will reduce the output, but any automatic or dedicated gun will make the necessary adjustments for you.

If your gun has a bounce and twist head, then reflecting the flash off a convenient ceiling or wall can improve things significantly. But check first that the surface you're intending to use is white – coloured ceilings and walls can add an unpleasant colour cast to your pictures. And don't get too close to your subject. You need to allow sufficient space for the light to bounce up and down at an angle that still illuminates the subject fully.

Sometimes ceilings are too high to allow the use of bounced flash – what then? Well the answer, if you have some cash to spare, is to invest in one of the many types of flash reflector or

FLASH MODES ON A 35MM COMPACT

Most good-quality compact cameras feature flashguns that fire automatically as and when required. This is extremely useful, as it saves you having to worry about whether extra light is needed or not. But there are times when you don't want the built-in flashgun to fire automatically, perhaps because you want to retain the mood of the ambient lighting or because the flash would be unwelcome – say at a wedding. For this reason many compacts have a 'flash off' option that's quick and easy to set.

The flashguns on some simple cameras give out the same amount of light every time, but some models are more intelligent and vary their output according to how far away the subject is. This gives a softer, more attractive flashlit picture. Some also have a specific 'fill-flash' setting.

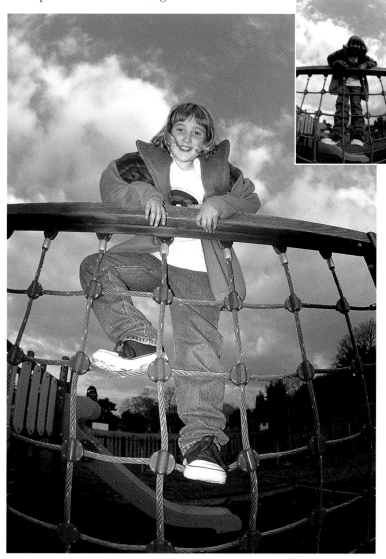

🔼 **FILL-IN FLASH**
When you're taking pictures towards the light it's a good idea to set the flashgun to fire so the subject is fully illuminated. Many 35mm cameras will automatically balance the flash and daylight exposure for you.

↑ BOUNCED FLASH
Bouncing flash from a white ceiling, wall or both produces a softer, more natural-looking illumination than pointing it directly at the subject.

→ LONG-RANGE FLASH
Add-on flashguns can be extremely powerful, especially when you use a faster film – as here, where a stage show over 10m (33ft) away was captured using a telephoto zoom on ISO 400 film.

modifier that are on the market. These spread the light, making the nature of the illumination much more attractive. They fit above the flash head, held in place either by Velcro or an elastic band, and provide you with the option of using a limited form of bounced flash whatever the circumstances. The light produced is not as soft as flash bounced from a ceiling, but it is a big improvement on direct flash.

The main problem with on-camera flash is that it's directly in line with the subject. But you can change all that by taking the flashgun off the camera. You'll need to buy a simple cable that will connect the flashgun to the camera, and depending on your camera you might also need an adapter to go on the hot shoe and another on the bottom of the gun. Some SLR systems offer a special lead that allows you to hold the flash in one hand or fit it on to a bracket for a much more angled light, with all the benefits of dedicated flash metering plus the full power output.

• Red-eye reduction

Photographing people using flash when light levels are low can easily result in pictures where the eyes glow red – a fault generally called red-eye. This common problem is caused by the flash reflecting off the blood vessels at the back of the eye, and it effectively ruins what might otherwise have been a first-class shot.

Fortunately, the majority of compact cameras now feature some kind of anti-red-eye facility. A pre-flash closes down the pupils of the subjects just before the picture is taken to minimize the risk of red-eye occurring. Some cameras have this feature as a separate push-button control, while on others it's part of the flash menu. In all cases it's reasonably easy to use. The only practical problem is that it takes a couple of seconds for any pre-flash to fire, so you may miss the moment in fast-changing situations.

• Fill-in flash

One of the essential techniques of photography is the use of fill-in flash. Master it and you'll see the quality of your pictures improve enormously. It involves using your flashgun in daylight to provide a controlled burst of low-powered flash to

illuminate, or 'fill in', areas of shadow on the subject and to soften harsh contrasts.

The intention is usually to maintain a natural-looking effect, so getting the right balance between flash and daylight is essential. If there's not enough flash, the effect won't be visible. If there's too much, it will be overpowering and appear unreal.

Fill-in flash is particularly valuable when photographing people on a bright sunny day, when the lighting can be very harsh and cast unpleasant shadows. The best way to avoid them is to put the sun behind your subjects, producing a glorious halo of light round their hair, and then use your flashgun to illuminate their faces. Fill-in flash is also good on days with flat, overcast light, when it lifts colours slightly and helps subjects stand out. Generally a lighting ratio of 1:4 – one quarter as much flash as daylight – works well.

Some SLRs and compacts provide fill-in flash automatically – and if your camera offers this facility, give it a try – but with many cameras the effect is a bit too strong. For the best and most repeatable results, you'll probably find it's better to take control yourself.

The flashgun is set up in the expectation that it will be the only source of light, so to use it for fill-in you need to trick it into giving out less light than it usually would. Start by taking an exposure reading from the subject based on your flash sync speed, which is typically 1/60 or 1/125 sec, with a handful of cameras offering 1/250 sec. On a sunny day you'll get an aperture of about f/8. Now set your gun to automatic at an aperture two stops greater than the metered reading. So if the camera reading is f/8, set f/4.

And that's it. When you take the picture, the daylight exposure will be correct, while the flash exposure will be two stops underexposed – giving the attractive 1:4 fill-in required.

ADVANCED FLASH TECHNIQUES

• Slow sync

Your camera's flash sync speed is not the only speed at which it will synchronize with flash – just the fastest. Any slower speed will work just as well. If your sync speed is 1/125 sec, you can also use

⬆ FILL-IN FLASH
Pictures of people can often look dull and lacking in impact on days when the weather is overcast. In these conditions using fill-in flash brings everything to life. Using the flash on full power, though, creates an unnatural, overlit effect. Typically the best results are obtained at one quarter to one eighth power, but what works best is, to a degree, a matter of preference.

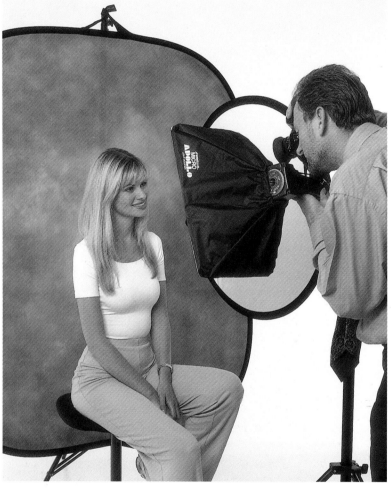

↑ USING A FLASH MODIFIER
One of the quickest and easiest ways of improving the quality of light from a flashgun is to fit a flash modifier over the front of the tube. Without it (top left) shadows are harsh; the results are softer and more attractive with it in place (top right).

1/60, 1/30, 1/15 sec, and so on. Why would you want to use a long shutter speed? Because one problem with a fast sync speed is that it freezes all movement, which is fine for static subjects but not for sport and action. Setting a long shutter speed, and combining it with flash, allows movement to be expressed more effectively.

On some cameras, the flash sync speed is set automatically, so you need to select a mode that lets you choose the shutter speed you'd like. The technique is easiest if you use an automatic gun,

and set an aperture of, say, f/8. Set a shutter speed that gives a correct daylight exposure at that aperture. The best time to take pictures using this technique is when light levels are low, giving a shutter speed of between 1 and 1/30 sec – in bright light you may not be able to get a long enough speed.

Take a picture with this set-up, and you'll get 1:1 daylight and flash. To make the flashlit main subject stand out more, you can effectively under-expose the background, which the flash doesn't reach, by setting a shutter speed one stop faster, for example, 1/15 sec rather than 1/8 sec.

To add to the effect, try panning along with the subject – firing the shutter as you track it with your camera. The result will be a sharp, flash-frozen subject and a streaked background.

Slow sync flash produces its most exciting pictures when used to photograph fast action. But you do have to be able to get within flash range of the main subject – so it's no good for sports such as cricket or football where the action is some way away. Some photographers also use the technique creatively for pictures of people, to give a sharp subject against a wacky, blurred background. The aim in this case is not to produce any sense of movement, so it's best to use a tripod or some other form of support to avoid any risk of camera-shake.

• Second curtain sync

On most SLR cameras the flash fires when the first curtain of the focal-plane shutter has just completed its travel. This is called 'first curtain sync'. Usually it works very well, but when it is used with a moving subject at a slow shutter speed, the result can look as if the subject is actually moving backwards.

To avoid this problem, an increasing number of advanced flashguns are offering the option of second curtain sync. In this case the flash fires as the second curtain is about to begin its travel. This results in any ambient light streaks appearing behind the flash-frozen image, instead of in front, conveying the correct direction of movement.

• Multiple flash

The multiple flash technique involves firing several

bursts of flash on to one frame of film, allowing you to show the same subject several times in different positions. If you have never tried it before, it's best to start simple, which means working in a darkened room with a black background. Secure the camera to a tripod, open the shutter on 'B', and fire your flashgun by hand, using the test button. Fire the flash twice, first with your subject on the left side of the picture, then on the right. Then close the shutter.

If you make sure the two subject positions don't overlap you can rely on the table on the flashgun for aperture information. With that shot safely under your belt you can start shooting more advanced sequences, where parts of the subject overlap. Here exposure is trickier. The general rule is that anything that is in the picture just once will need a full flash exposure, while anything else needs one stop less for every time it appears.

• Stroboscopic

The principle of stroboscopic photography is the same as multiple flash, but its a lot easier because the flashgun does most of the work for you. Many guns now boast a 'strobe' facility, and can fire a rapid succession of low-powered bursts that are perfect for capturing fast movement such as a golf swing. You can usually control the number of flash pulses to produce the effect you require.

As with multiple flash, you need a darkened room and a black background.

• Open flash

One of the most advanced of all flash techniques is open flash, which is sometimes also known as 'painting with light'. For this, the flash is fired by hand, often several times, to light parts of the picture selectively.

The origin of the technique lies in the photography of large buildings such as churches, where many flashes were required to give adequate and even illumination. While buildings still make good subjects for the technique, it can be used for almost anything. It even works with table-top subjects if you mask down the flash to give a controlled beam of light.

If you're working outside, start by taking an exposure reading from the background, and set it

on the camera. You need a subject where the exposure without flash will run into minutes – so low-light conditions such as dawn or dusk are ideal.

Mount your camera on a tripod, set at B, trip the shutter and lock it open. Then light whichever parts of your subject you want by running round (you won't register on the film if you keep moving) and firing the flashgun. The easiest way is to use an auto gun at the same aperture setting as the camera. To increase the mood, try fitting filter gels over the flashgun for all or part of the subject.

⬆ **FLASH AND DAYLIGHT** By allowing flash to illuminate the subject in the foreground and setting a correct exposure for the background daylight, interesting results can be obtained – especially if you move the camera during the exposure.

Close-ups

Looking for a new challenge? Then why not have a go at shooting some close-ups? Start thinking small and you'll soon find yourself immersed in a fascinating world. Many of the most beautiful things are tiny – think of the wings of a dragonfly or the petals of a flower – and for just a small investment you could start capturing their beauty on film.

To start with, it's important to be clear about the terminology, because the terms 'close-up' and 'macro' are often treated as interchangeable, when in fact they have very specific meanings. The key lies in understanding what 'life size' means.

A life-size photograph is one in which a subject is reproduced on film exactly the same size as it is in real life. If you were to take a life-size photograph of an object measuring 24 x 36 mm, it would completely fill the picture area. This is said to be a reproduction ratio of 1:1. If the same subject filled half of the picture area it would be half life size, or 1:2. And if only half of it could be fitted in, that would be twice life size, or 2:1.

Technically, close-up photography is concerned with pictures in the range 1:10 to 1:1. That is, from one tenth life size to actual life size. So suitable subjects include insects, coins, small flower heads, stamps, and so on. Macro photography covers life size to ten times life size, from 1:1 to 10:1. Larger magnifications, greater than 10:1, fall into the area known as micro photography.

To be able to shoot close-ups successfully you really do need an SLR, with its reflex viewing system that allows you to look through the taking lens. Compact cameras are wonderful for a great many subjects, but close-up photography is not one of them. The parallax errors caused by the separate viewing and lens systems mean it's impossible to frame the shot accurately. Nor can you see precisely the effect of any close-up accessory you may have added.

Many people think expensive specialist equipment is required to shoot close-ups, but nothing could be further from the truth. In fact you may already have all that you need to get started. The standard 50mm lens will focus down to around 0.5m (20in) and fill the frame with something the size of an A4 page. This makes it suitable for closing in on larger subjects such as flower heads. A telezoom will take you even closer. Specifications vary, but many telezooms allow you to produce quarter life-size images. However, if you want to magnify things more than this you'll need to invest in some accessories.

The great thing about close-up photography is that there's such a wide range of accessories available. You can dip your toe in the water by buying a simple screw-in filter and then, if you find you like shooting close-ups, dive into the deep end and invest in a macro lens.

CLOSE-UP FILTERS

Supplementary close-up lenses fit over the front of your lens like a filter. They are available both as screw-in types and as part of filter systems such as those made by Cokin.

Close-up filters increase the magnification achieved by reducing the focusing distance. They come in a range of different strengths, measured in diopters. The weakest is +1 diopter and the strongest +10 diopters. For general close-up work a +4 diopter lens is the best choice: this allows you to fill the frame with something the size of a butterfly.

The advantage of using close-up lenses is that there are no problems with exposure. You can rely on your camera's meter for accurate results. There is some slight loss of quality when working with these lenses, but this can be minimized by shooting at a small aperture of f/11–22. This also has the advantage of giving you plenty of depth of field to keep everything sharp.

REVERSING RING

A lens reversing ring is a simple adapter that allows you to reverse the lens so that the front element faces the camera body, producing an extremely

powerful and high-quality close-up accessory. The degree of magnification depends upon the lens in use: a 50mm lens will give 1:1 (life size), a 28mm delivers 2:1 (twice life size), while a 100mm produces 1:2 (half life size).

The versatility of this set-up improves if you use a reversing ring with a zoom lens. A 28–105mm zoom would enable you to vary the reproduction ratio from half life size to twice life size.

EXTENSION TUBES

Extension tubes are simply hollow tubes that increase magnification by extending the distance between the camera body and the lens. Independent manufacturers generally sell tubes in sets of three different sizes that can be combined to give a wide range of extensions. The degree of enlargement can be determined by dividing the amount of extension by the focal length of the lens in use. So a 50mm lens with 52mm of extension (21mm plus 31mm) will give you 1:1 (life size).

reproduction. Extension tubes also work well with telephoto lenses, giving smaller magnifications but greater camera-to-subject distances. The quality is top-notch, because no additional glass is introduced. Extension tubes are the best general accessory for close-up and macro work, but make sure you buy a set that maintains automatic linkages.

AUTO BELLOWS

The ultimate tool for macro enthusiasts is a set of bellows, which can be infinitely adjusted to produce the required magnification. Typically they can be extended up to 130mm, giving magnifications of up to 2.6:1 (2.6 x life size) with a 50mm lens. Such extension increases exposure considerably, though, and a tripod or flash is recommended if sharp results are to be obtained. Unless you're willing to get involved in a lot of complex calculation, auto bellows – which maintain metering connections – are essential, and it's useful to retain autofocus as well.

⬆ **SUPPLEMENTARY LENS**
Although inexpensive, supplementary close-up lenses produce high-quality images quickly and easily – here a +4 diopter lens was used on a 50mm standard lens.

⬆ **BELLOWS**
A set of bellows enables you to magnify tiny objects beyond life size for a dramatic new perspective on everyday items.

Filters

The first filters that most photographers acquire are the skylight or UV types used to absorb ultra-violet radiation. These can be left in place more or less permanently to protect the fronts of lenses from dust and damage. The only time you might want to take them off is when you need to clean them, or when you're using other filters that will serve the same purpose.

In general, it's a good idea to fit as few filters as possible at any one time, because every piece of glass or plastic you place in front of the lens risks degrading the quality of your final image. In practice, adding one filter will normally make no difference, and you may not be able to spot any difference using two, but adding three or more filters is definitely something to be avoided. You should also take great care when handling filters, as any finger marks or scratches can cause further loss of quality.

WARM-UP FILTERS

One useful range of filters is the 81 warm-up series. These come in a range of strengths from 81A (pale straw) to 81EF (rich orange).

As their name suggests, these filters give the picture an attractive glow, making them ideal for all kinds of subjects. In portraiture they add a healthy-looking suntan, while for landscape and travel they create a glorious sense of warmth. If you want to enhance the effect even further, try using two filters together.

Another orange filter, 85A, is required for colour correction when tungsten-balanced film is being used in daylight.

⊙ **GRADUATED FILTER**
The sky in this evening scene was grey and lifeless, but using a blue graduated filter has balanced the exposure and added richness to the shot.

⬆ **SUNSET FILTER**
Sunset filters are effectively graduated warm-up filters, and add overall warmth to an image and density to the sky area.

COOL-DOWN FILTERS

Sometimes, though, the warmth of the natural light might be too great, or you may want to produce a cool, melancholic feel in your picture. For these situations you should make use of the blue 82 series of filters.

When you want to take pictures under tungsten lighting using normal daylight-balanced film, you'll need to colour-correct using the much stronger 80A blue filter if you're to avoid a nasty orange cast. Like most filters, this will reduce the amount of light reaching the film, but TTL metering systems will automatically allow for the loss.

GRADUATED FILTERS

With some filters you need to be more careful with your metering, and this is particularly true of graduated filters. These are half-coloured filters that are used to add density or colour to bland skies in landscape, travel and architectural shots. The best way to get accurately exposed results when using grads is to tip the camera downwards and take a meter reading from the foreground with the sky excluded – before fitting the filter.

To produce a natural-looking effect you need to line the filter up so that the point at which it changes from clear to coloured lines up with the horizon. And this is where square filter systems come into their own, allowing you to slide the filter up and down in the mount until it's exactly where you want it. You can't do that with a round filter. Setting a large aperture, such as f/4 or f/5.6, will also help to make the line less obvious. This is especially important when you're using a wide-angle lens.

Which colour graduated filter you choose is largely a matter of personal choice. Some photographers favour the natural effect created by grey, or neutral density, grads, while others prefer to add drama with a tobacco or blue. It's also possible to use graduated filters together – with one upside down to colour the foreground.

If you want to enhance a sunset, or create the feeling of one in the middle of the day, there's a special kind of graduated filter called – you guessed it – a sunset filter.

SQUARE OR THREADED FILTERS?

➡ The decision to invest in one filter system over another should be based not so much on which filters that system contains – all the major brands include pretty much anything you're likely to need – but how versatile it is.

If you work exclusively with one format and a set range of lenses, life will be pretty straightforward, but chances are you use different formats for different jobs, so ideally you need a system that's suited to all of them.

➡ **Slot-in filter systems** manufactured by Lee, Hitech, Cokin, Pro 4, Cromatek and others score highly over traditional screw-in brands produced by the likes of Hoya, Heliopan, Rodenstock and B+W in this respect, because you can fit the square filters to different lenses simply by investing in another adapter ring.

If you do go for a slot-in system, make sure it's big enough to cope with all your lenses. The 84mm Cokin P size is about the smallest you should consider, but 100mm systems from Format, Cromatek and Lee, and the 134mm Cokin X-Pro are far more versatile, especially with wide-angle lenses.

➡ **Round filters** are designed to fit a specific thread size; this is fine if all your lenses share that same thread, but not so good if they don't as you will need to buy stepping rings to increase or reduce the thread. There's also a significant risk of vignetting if you use two or more screw-in filters together on wide-angle lenses, due to the combined depth of the filter mounts. Flare and reflections can be caused by the parallel glass surfaces being close together, and screw-in graduated filters offer no control over alignment.

That's not to say you should rule out round filters altogether. If you use only one filter at a time, or need a particular filter for a specific application, they're ideal. A larger number of glass filters are made with the round screw-in design, so optical quality and durability can be higher.

POLARIZING FILTER

Overall, one of the most useful filters you can buy is the polarizer – in fact it's pretty near indispensable in sunny weather. As well as deepening the blue of the sky, it also increases the overall saturation of the image. Add to that its ability to take away surface reflections from glass and water, and you have a filter that's worth its weight in gold.

The degree of polarization that is produced depends upon the position of the filter, and as you rotate it you'll see through the viewfinder the effect it's having – with the sky darkening and lightening as you turn it. You'll get the maximum polarization when you have the sun to the side of you, but you'll need to take care if you're using a wide-angle lens that one part of the sky doesn't end up darker than the other.

There are two types of polarizing filter – circular and linear. These descriptions have nothing to do with the shape of the filter, but refer to the alignment of the polarizing material. If you have an autofocus camera, or one with spot metering, you almost cer-

ⓒ EXPERIMENTING WITH SPECIAL EFFECTS
Special effects such as those produced by this multi-image filter are not to everyone's taste, but if you like to play around there are dozens of filters to choose from.

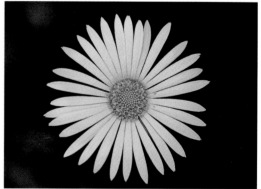

ⓐ POLARIZING FILTER
By deepening the blue of the sky and enhancing contrast, polarizing filters produce images with much more punch (second photograph).

ⓐ USING TWO POLARIZING FILTERS
Using two polarizing filters together allows you to explore stress patterns of plastic to create unusual and eye-catching photos.

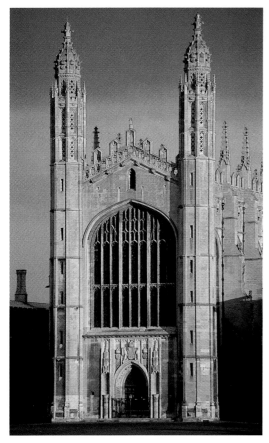

⬆ DIFFUSER
Soft-focus filters offer a quick and easy way to give an attractive, atmospheric feeling to images of all kinds.

tainly need the more expensive circular type. However, the good news is that because it absorbs around two stops of light, your polarizing filter can also double as a neutral density filter when you need to cut down on the amount of light hitting the film.

DIFFUSER

One filter that can be used equally well with colour and black-and-white film is the diffuser or soft-focus filter. It comes in various strengths to give an atmospheric mood to many subjects.

The filters mentioned here are arguably the most useful, and should be in every photographer's bag. But beyond them there are dozens of different types – from the wacky to the downright weird. Some are rather gimmicky and, while it's possible they'll become a regular part of your outfit, you may find that you'll use them just once and then put them away forever.

FILTERS FOR MONO PHOTOGRAPHY

⬥ When you take a black-and-white photograph the various colours in the subject are all recorded as shades of grey. But it is possible to manipulate the tonality and contrast of a scene – to a surprisingly large degree – with the use of plain coloured filters. Filters lighten their own and associated colours, and darken complementary colours.

⬥ The most widely used are **yellow**, **orange** and **red** filters, which lighten yellow, orange and red tones, while darkening blues and violets – making them great for progressively increasing contrast and deepening skies in landscape, architecture and travel photographs. Yellow improves things a little, but the best result is usually achieved using orange, producing white clouds against a dark sky and strong contrast. Red gives results that are very dramatic (see below), but sometimes a bit 'soot and whitewash', with black skies and bleached-out foliage. Red is also used in infrared photography.

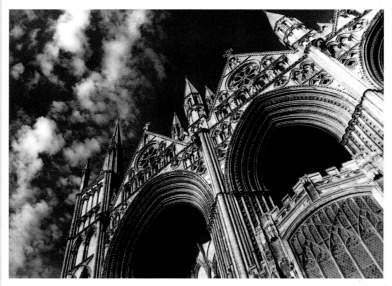

⬥ Less well known is the fact that yellow and orange filters are also excellent for portraits, lightening skin tone and blonde hair and helping to hide skin blemishes. A pale to medium yellow gives the most natural-looking effect. Orange lightens skin further but may also lighten lip colour and darken eye colour too much. Red won't give you flattering portraits, but is good for creative, experimental work.

⬥ Not many people use **green** filters these days, which is a shame. Unfiltered landscape shots can show little variation in foliage tone, but using a green filter helps differentiate them nicely, allowing you to produce prints with fine nuances. Green can also be good for portraits where you want to darken skin and lip tone, such as in character studies of wrinkled old men.

⬥ **Blue** is a useful filter when photographing under artificial light, which can muddy the tonality of the shot.

Supports

Mini-tripod

HOLDING IT STEADY

The reciprocal rule – that when hand-holding you should use a shutter speed equivalent to the focal length of the lens – is a useful guide, but in practice it's a good idea to play safe and set a speed one stop faster. So with 100mm go for 1/250 sec rather than 1/125 sec, and with 500mm go for 1/1,000 sec rather than 1/500 sec.

Of all the accessories you can spend your hard-earned cash on, none can so dramatically improve the quality and range of your picture-taking as a tripod. Why? Well, for a start, many photographers badly overestimate their ability to hand-hold a camera without shake – especially when they're using a zoom or telephoto lens. The well-known rule of thumb, which says it's safe to hand-hold as long as the shutter speed matches the focal length of the lens you're using, sounds highly scientific and plausible. But photographers vary enormously in their ability to hold a camera steady. Some are as steady as a rock and capable of shake-free results using a 300mm at 1/8 sec in a force nine gale, while others are so wobbly that they need 1/500 sec to get sharp shots from a 28mm wide-angle.

Mounting the camera on a tripod does away with any concerns regarding shake, because once it's firmly anchored you can safely use whatever shutter speed you want. Using a tripod also makes it possible for you to take pictures that are far more creative and interesting.

For instance, at the moment when it starts to get dark you may pack your camera away, load up with a faster film, or reach for the flashgun – none of which is the best solution. If you fix your camera to a tripod instead you can take advantage of the often atmospheric and moody illumination you get when the daylight level drops – such as the gorgeous colours of the early morning or fascinating night scenes.

Naturally you can also use a tripod to explore longer shutter speeds – perhaps by photographing a waterfall or a fairground ride. Yet other creative options include being able to zoom the lens during the exposure, for a dramatic 'explosion' effect, and trying your hand at advanced techniques such as 'painting with light' using a torch or flashgun with a long exposure.

And, of course, one of the most obvious advan-

tages of working with a tripod is that it gives you greater control over depth of field: you're free to choose the aperture you want for the effect you have in mind, not the one that is forced upon you by circumstances.

CHOOSING A TRIPOD

When buying a tripod you should go for a model that's stable but not too heavy – otherwise you'll be tempted to leave it at home. It should ideally extend to at least 1.5m (5ft), higher if possible, and have no more than three leg sections – the more joints there are the weaker it will be. An adjustable head is essential, and nice-to-haves include legs that can be splayed out for work close to the ground and a reversible centre column.

OTHER SUPPORTS

Also worth having is a mini-tripod that's small enough to slip into a gadget bag and light enough to carry around all day. The most stable models tend to extend to a height of 60cm (2ft) and have three- or four-section legs.

Monopods are essentially one leg of a tripod with an adjustable head on top. While they don't offer all the stability of a tripod, they're ideal when photographing subjects such as sport and wildlife, where you need more mobility. You can also use a monopod for general picture-taking in low light in situations where a tripod would get in the way.

A versatile support is a bean bag, filled with expanded polystyrene, that acts as a cushion for the camera and lens. You can rest it on a fence or a half-opened car window. If you don't have one, you can improvise with a rolled-up pullover, or – if you stretch out on the ground – a gadget bag.

Monopod

SHUTTER RELEASE

Finally, when using a tripod you'll need some way of operating the shutter without putting your finger directly on the release – which would obviously introduce camera-shake. Older cameras have a simple screw thread, allowing you to buy an inexpensive cable release. Modern SLRs and compacts require an electronic release that is designed for use with a specific camera. Also available are infrared remote control systems, which enable you to fire the camera from a distance. One simple option when photographing static subjects is to use the camera's self-timer.

GETTING THE BEST FROM YOUR TRIPOD: DOS AND DON'TS

DO

⇒ Spread the legs wide to give a low centre of gravity.

⇒ Make sure the locks on the legs are fully tightened, so there's no slippage.

⇒ Secure the camera tightly to the tripod platform.

⇒ Use the rubberized feet on slippery surfaces and the spiked feet on rough terrain.

⇒ Use a remote cable release to fire the shutter.

⇒ Hang your gadget bag around the point where the legs join if you need extra stability.

⇒ Invest in a proper carrying bag – you're more likely to take the tripod out with you if it's easy to carry.

DON'T

⇒ Hold on to the tripod as you're likely to cause vibration rather than stop it.

⇒ Extend the central column any more than you have to – it's certain to create unwanted wobble.

⇒ Put cameras with long or heavy lenses on to flimsy tripods meant for lightweight systems.

⇒ Fire the shutter release by hand.

Composition

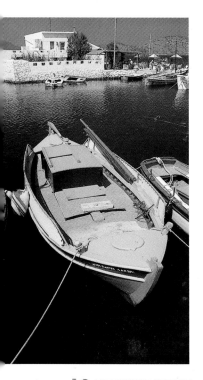

⬆ **FOREGROUND INTEREST**
To stop it looking as if everything is far away, arrange the shot so there's something of interest close to the camera. Fit a wide-angle, such as the 24mm used here, and set a small aperture – in this case f/16 – and you'll create a strong sense of depth.

➡ RULE OF THIRDS
If you follow the rule of thirds – placing your subject at the intersection of an imaginary grid dividing the frame into thirds vertically and horizontally – your pictures will always look perfectly balanced.

Composition is all about arranging the elements in a scene so they hold the attention of the viewer by soothing, captivating, surprising or even disturbing. It is, therefore, vitally important.

Of course, whenever you take a picture it has to be composed but, unless you pay conscious attention to what you're doing, you can end up with an image that's bland and boring. But once you start thinking about how best to frame the picture and trying different things, your photographs will quickly improve. Over time, these thought processes will become natural, and you'll instinctively know what works and what doesn't. In other words, you'll develop visual awareness – an eye for a picture.

THE 2:3 FORMAT

One of the great things about 35mm is the 2:3 format, which is not only pleasing to the eye but also allows you to compose pictures both horizontally and vertically. In fact, the majority of pictures are taken in the horizontal format, because that's the way in which it's most comfortable and convenient to hold the camera and, frankly, because many photographers never think of turning the camera on its side. Many subjects, though, benefit from being photographed in the upright format. So make it a habit to consider which format would work best every time you're sizing up a scene.

If you use the horizontal format for pictures of people, for instance, you'll include quite a lot of the background. This can be a good thing if it contributes to portraits by showing people in their environment. But with most portraits you want to concentrate attention on your subject, and the best way is to turn the camera on its side and frame tightly, ideally by using a telephoto lens. On the other hand, when you photograph two people together, or a group, it's more satisfactory to keep the camera horizontal.

When it comes to landscapes, many photographers automatically use the horizontal format in order to get all of the vast sprawling panorama before them into the frame. This approach can work extremely well but sometimes results in a weak picture in which everything seems to be far away – especially if a wide-angle lens is used. Turning the camera on its side, and including something of interest in the foreground, can often create a greater sense of depth.

In architectural photography, the format you choose will depend to a large degree upon the nature of the building itself and on how much of the surroundings you want to include. 'Ordinary' buildings, such as houses and bungalows, which are long and low, generally benefit from a horizontal treatment, while skyscrapers and other high-rise structures often require an upright treatment.

If in the end you can't decide which format is best, take both so you've got all options covered.

FOCAL POINT

If the picture is to hold the attention of the viewer it must have a focal point – a centre of attraction on which the eye can settle. That point can be any size, from a barely discernible dot in a landscape to a person filling most of the frame.

Many photographers simply place the most important part of the scene in the centre of the viewfinder. Although this often works very well, it can get rather boring. So if you want to add variety to your picture-taking, try putting the subject somewhere else. One of the best compositional techniques to follow is the rule of thirds. All you need to do is mentally divide the scene into nine equal sections, visualizing a grid that divides the picture into thirds vertically and horizontally, and place your subject at one of the four intersection points. This gives a strong sense of balance and harmony.

However, you can have too much of a good thing. It's not always harmony you want. Don't be afraid to break the rules and create a little discord by placing your focal point elsewhere.

With the subject at the top of the frame, for example, you get an unsettling and top-heavy image. The point of interest seems to hover in the air and the eye struggles to balance it against the space around it. The left-hand side of the frame is an excellent place for your subject. Because we read from left to right, the eye naturally starts with the main point of interest and uses it as a springboard to enter the rest of the picture. Images with the main point of interest at the bottom centre tend to feel grounded and stable, making for good and solid compositions.

Including more than one focal point is a sure-fire way to create tension, because the eye can't decide

where to settle, and wanders from point to point, taking in the whole of the picture as it goes.

FRAMES AND LINES

To add an extra dimension to your picture, exploit the many natural and man-made frames you'll find around you, such as overhanging branches, arches and window frames. They focus attention on your subject and may also help to fill out large areas of sky or obscure distracting details.

Frames are a great way of giving your pictures a strong sense of depth. If there's nothing suitable

DUAL FOCAL POINTS Having two points of interest at opposite ends of the frame creates a feeling of tension, making it difficult for the eye to settle in any one place in the photograph.

⬆ FOREGROUND INTEREST
Wherever you go you'll find there are naturally occurring structures which you can use to frame your main subject. Walking some way down the road from this building (top) produced a more interesting composition with the traffic light gantry in the foreground (above).

➡ STRONG SHAPES
Once your eyes become attuned you'll notice all sorts of naturally occurring shapes. The top of this marquee describes a strong triangular shape.

➡ STRONG COLOURS
Colour can be used in a conscious way to produce vibrant or harmonious compositions. Shooting primary colours in bright sunlight results in a shot that can't be ignored.

around, placing an object in the foreground can achieve the same effect. The foreground interest establishes a relationship between the front, middle and back of the scene, and is particularly valuable in landscape work.

You can do similar things with lines. Diagonal lines provide the most dynamic compositions, whether some element of the picture cuts it in half or several elements are arranged along a diagonal. Some diagonal lines are straight, while others are more meandering, such as a road or a river in a landscape.

Horizontal lines give a strong sense of stability, while vertical lines are vigorous and active, In circular compositions a line can sometimes seem to spiral down to the centre of the picture, taking the viewer's eye with it on a journey of discovery.

Converging lines draw the eyes very quickly from the foreground of the picture to something in the distance. The effect is easily achieved if you find a subject with strong parallel lines and tilt a wide-angle lens backwards.

THE HORIZON

Another important compositional issue in landscape work is where to position the horizon. Having it in the middle of the picture produces an extremely balanced composition, with both the subject and the sky given equal weight. However it can be rather static and lacking in interest, and is rarely the best approach.

THINK ABOUT SHAPES

It can be useful to see compositions in terms of shapes, which give structure to a picture and help lead the viewer's eye through it.

Triangles create dynamic compositions – with the eye flitting between the three different points. Squares are solid and stable shapes that are common in the man-made world, and you'll be able to make good use of them if you regularly photograph subjects such as buildings. Positioning squares full in the frame can produce strong, but occasionally rather dull compositions.

Semi-circles are more active than full circles, but both can be strong elements. Crosses create

pictures in which a lot seems to be going on, with the crossing lines intersecting the picture. Though not as prevalent as other shapes, they're worth looking out for because of the interest they bring to even the simplest of photographs.

Rectangles offer more interest than squares, because the sides are of irregular lengths. The effect is enhanced by choosing a subject that is long and thin, and matching it to the upright format.

EFFECTS OF COLOUR

Colour can be used as a compositional tool. Some colours, such as orange and yellow, blend well together and produce restful images. Others, such as red and blue, contrast, creating a visual clash.

VIEWPOINTS

Overall, the most effective compositional accessories you have at your disposal are your legs. When you come upon a photogenic subject, don't start snapping away immediately. Instead spend a few minutes wandering around it first, considering what the best angle might be. There's nothing more frustrating than eagerly rattling off several shots, only to walk on and find a far better viewpoint.

One of the best ways to improve many compositions is simply to step closer to the subject. Tightly framed images have impact and immediacy. Shooting from a viewpoint that's higher or lower than your normal eye-level will let you see things differently and bring a whole new dimension to your picture-taking. Climb a hill or a high building for a bird's-eye view, or crouch on the floor for a worm's-eye view. Either way, you'll find experimenting with camera height will pay great dividends in helping you to take a wider range of ineresting photographs.

◀ ▼ UNUSUAL VIEWPOINTS
A high vantage point will give you a different perspective from what you see at ground level. Climbing a tower at the Alhambra in Granada, Spain enabled both the tourists and the scenery to be included. Meanwhile, looking up at the roof of Ely cathedral and using a 16mm lens revealed the fantastic vaulted ceiling.

Understanding light

DIFFUSED LIGHT
The extremely soft light found on the shaded side of a building doesn't suit every subject, but works well for the pastel shades of this large pot.

USING SHADOWS
Pictures taken with the sun behind you can easily look dull, but by shooting late in the afternoon and incorporating the shadow from an adjacent building into the composition, interest has been added to this shot.

It's a common misconception among photographers that certain kinds of light are 'good' while others are 'bad'. They'll often glance out of the window, decide the weather isn't suitable, and pack their equipment away for another day.

But all light is useful in certain situations, and the secret of success in photography is simply a matter of matching the right subject to the right light. Even the flat, grey light of a rainy, overcast day has its uses, while the intense, contrasty light of a summer's day has as many disadvantages as it has advantages.

It's not an exaggeration to say that light is the single most important element in any picture. In many ways it's the photographer's raw material. You can have all the cameras, lenses and accessories in the world, but without light you won't get very far. And it's the way you use light that makes all the difference. It doesn't matter how attractive or interesting your subject is, if the lighting's not appropriate your picture won't work. Yet it's astonishing how few people pay any real attention to light; so eager are they to press the shutter release and get the picture in the bag they don't really think about how to make the light work for them.

The most fascinating thing about light is its sheer diversity. Contrast, intensity, colour and angle are the four attributes of most interest to photographers, and it's the ways in which they combine through the day and in different weather conditions that gives so much choice and control.

QUALITY OF LIGHT

One of the principle things to understand in relation to light is that quality is far more important than quantity. More doesn't mean better – in fact, the opposite is often true. More evocative results are achieved when the light is subtle and directional rather than intense and overwhelming.

While bright sunny days have a lot going for them – with the high levels of light giving the option of fast shutter speeds and small apertures – the fact that everything is fully lit means pictures will lack the shadows that can bring subjects to life. This is particularly true around noon, when the

shadows are not only short but also heavy. That's why, whenever possible, you should avoid the middle of the day, shooting instead early in the morning and late in the afternoon, when the lower angle of the sun produces longer, more photogenic shadows. In winter months, the sun sits low in the sky all through the day, producing a characteristic 'raking' light that's ideal for bringing textures and patterns to life. This is particularly true of buildings and architectural details, which are great subjects for winter photography, along with the barren landscapes you find at this time of year when there's little foliage around. The way in which the light strikes the subject is important: the narrower the angle the more detail is revealed.

Another point to bear in mind is that the colour of light around lunchtime, although generally neutral in tone, can sometimes suffer from an unpleasantly cool, blue tint, especially in the shade. The nearer you are to sunrise and sunset, the more orange, and more attractive, the light will be – helping subjects such as stonework look their best.

LIGHT IN PORTRAITS

In portraiture, the camera's position in relation to the light is extremely important. If you put the sun behind you your subjects will often end up squinting, while the shadows under their eyes, nose and chin will be rather unattractive. Placing them sideways to the sun is often not much better, as one side of the face will be in the shade. With either option, using some kind of reflective material to bounce light back into the shadows will give a more balanced result.

The most flattering light for taking pictures of people is directional but diffuse – the kind you get on a sunny day with wispy clouds or, indoors, through a large window covered with a sheer curtain. The subjects are fully illuminated but the shadows are soft.

However, the conditions under which we have to take photographs are seldom ideal. If the light is too harsh, one option is to find a shady area, perhaps under a tree or canopy, where pictures can

LIGHTING FACES
Soft lighting is best for portraits, and if the sun is shining it's a good idea to find a shady area.

STAINED GLASS
The best time to photograph stained glass windows is, surprisingly, when the weather outside is overcast – so the contrast between exterior and interior conditions is reduced.

INTO THE LIGHT
Contre-jour photography can produce unpredictable results. Shooting into the light on a city street late in the day creates an enigmatic image.

SOFT LIGHTING
Hazy sunlight is the perfect time to photograph subjects such as gardens, where you want to record the maximum amount of detail.

SHADOWS AS SUBJECT
Shadows are extremely important in photography, and can sometimes be the whole point of the picture.

be taken. If it's not convenient to move into the shade, another option is to is to improvise a little overhead cover by getting someone else to hold a blanket or sheet of card over the subject for a short while. A further possibility, not quite as good but still effective, is to find a building or wall behind which you can shoot.

Because the illumination in each case is indirect, it's wonderfully soft and gentle, and ideal for most kinds of portraits. Cutting out the toplight means you don't end up with shadows under the eyes, nose and chin. All the light comes in from the front and side, producing a really attractive effect, although if you want a 'masculine' character portrait a more contrasty treatment will be necessary.

DIFFUSED LIGHT

For close-ups, where you want to preserve the maximum amount of detail, diffused lighting is great. Garden photographers, for instance, tend to avoid sunny days in favour of more overcast conditions. Some even like to shoot when it's raining.

This is also a great time to improvise some still lifes by gathering together a number of related or contrasting items. Items of food – such as bread, fruit or vegetables – can make up an appealing theme, or you could have a go with anything from

tools to crockery to jewellery. Simply find a suitable spot outdoors, spread out a piece of fabric or a sheet of card, and arrange your subjects on it in an interesting way.

When it rains, of course, or the mercury in the thermometer starts to drop, there are fewer subjects that work well – though generally those with bright, strong colours do. The key thing to bear in

THE KELVIN SCALE

Saying that light is a bit blue or slightly orange is a rather vague way of describing it, which is why a more scientific method has been developed – the Kelvin Scale. This is based on noon daylight, which has a colour temperature of 5,500K (Kelvins). Daylight film is designed for use in this light. As the blue content of the light increases, so the temperature rises. On a bright summer's day with vivid blue sky, or at high altitudes in mountainous regions, the colour temperature may be as high as 10,000K. Photographs taken in such conditions can exhibit a strong blue cast, requiring an orange filter to correct the balance. At sunset the colour temperature falls to around 3,000K, when theoretically you should use a blue filter for a 'natural' result. But who in their right mind would want to colour correct a sunset?

The colour temperature of household tungsten lighting is similar, but in this case it is a good idea to use a correction filter, as the strong orange cast that otherwise results usually looks wrong.

Kelvin	Source	Kelvin	Source
10,000K	Blue sky	4,500K	Afternoon sunlight
7,500K	Shade under blue sky	4,000K	Fluorescent tube
7,000K	Shade under cloudy sky	3,5000K	Morning/evening sunlight
6,500K	Deep shade in daylight	3,000K	Sunset
6,000K	Overcast weather	2,500K	Tungsten household lamps
5,500K	Noon daylight/ electronic flash	1,900K	Candlelight

THE RIGHT CONDITIONS
Light makes all the difference. On a grey day with a washed out sky (above left), the Spanish coastal town of Nerja looks pretty unappealing. But under a blue sky in the early morning sun it's completely transformed (above right).

mind is that successful photographers aren't successful because they own masses of equipment or have the latest technology at their disposal. It's because they understand light and know how to use it. Landscape photography is all about light, portrait photography is all about light. In fact, photography is all about light – full stop.

Portraiture

From the invention of photography over 160 years ago right through to the present day, its most popular subject – by a long, long way – has always been people. While a relatively small band of enthusiasts pursue specialist interests such as landscape, still life or natural history, the vast majority of pictures taken are of family and friends. Whether we're out having a wonderful time or simply relaxing at home, we like nothing more than to record the occasion for posterity.

But all too often the results disappoint – failing to capture the magic of the moment or the personalities of those present. Even people you know really well can get tense and nervous when a camera is pointed at them, resulting in awkward poses and cheesy grins that ruin the shot. Images can also be let down by technical considerations such as poor composition, ghoulish red-eye, inaccurate focus, incorrect exposure or unflattering lighting.

At the heart of the problem is the fact that many photographers just pick up the camera and snap away without thinking what they are trying to achieve or how to get the best from the situation. However, with the right approach, a picture can be a true and lasting portrait that reveals something of the real people, or a treasured memento of a precious moment – not just a superficial snapshot.

LIGHTING

Of all the kinds of lighting available to the photographer, top lighting is probably the least satisfactory. You get it in the middle of the day when the sun is at its highest. Because shadows are downward-pointing and relatively dense, it's best avoided whenever possible. The best times for portrait photography outside are morning and afternoon, when the sun is closer to the horizon. Place the sun behind you and your subjects will be evenly lit, with a catchlight – a point of light that's a reflection of the sun – in their eyes, bringing them to life.

Whenever possible, though, portraits are better shot on cloudy days, when the shadows are softer and more flattering, minimizing lines and wrinkles.

BACKGROUNDS

The lens setting and the subject's position in relation to the background are also important factors. If you want people to stand out, putting the emphasis on them rather than the surroundings, you should use the top end of your zoom range and get them to stand well away from the background.

When you want to shoot portraits showing people in their surroundings you should do the opposite. Go for a wide-angle setting and position the person close to the background.

SHOOTING CANDIDS

Whether you shoot indoors or out, getting your subjects to relax while you're photographing them can sometimes be a challenge. As soon as you pick up your camera and point it in their direction many people get tense and nervous, and their stiff body

🡱 INDOORS
Windowlight indoors can produce wonderfully flattering portraits, as here, where the light was streaming in through a large window behind the photographer.

🡲 OUTDOORS
If you want attractively illuminated pictures on a bright, sunny day, ask your subject to stand under a large tree. This will cut out most of the top light, so there's little in the way of shadows under the eyes, nose and chin. A 100mm portrait lens and aperture of f/2.8 help throw the background out of focus.

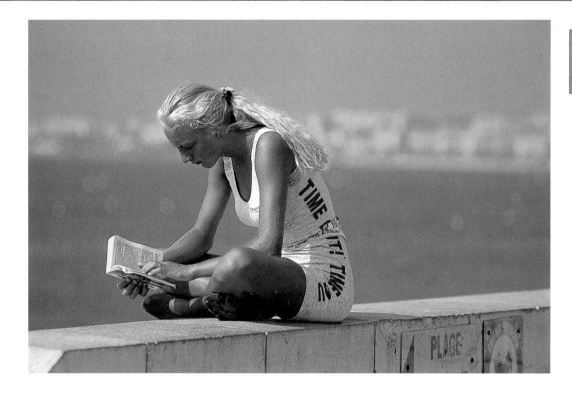

CANDID SHOT
A 300mm lens was used to photograph this girl on the seafront at Nice, France.

language and frozen smiles can ruin the shots. Or worse, they start acting up and pulling silly faces.

There's a simple way to avoid these problems – by shooting candids. Instead of asking people to pose, you photograph them when they're unaware of you. This allows you capture them as they really are, at their most natural, allowing you to get a glimpse of their real character.

Shooting this way isn't hard; you simply have to develop a different way of working. Instead of getting people to 'Say cheese', stand at a distance using a telephoto lens setting, and wait for the right moment to release the shutter. People's expressions change in a fleeting second, and opportunities can arise and be gone before you know it – blink and you miss them. So you need to concentrate on your subject completely, anticipating the right moment and acting decisively when everything falls into place.

Of course, if you're indoors using flash, the first picture you take will give the game away. Outside, though, you may be able to take a sequence of pictures, especially if the subject is immersed in some kind of activity or chatting to someone else.

The obvious downside of candid shots is that you have little control over aspects such as lighting or background, so there will almost certainly be times when you cannot use this approach.

POSED PORTRAITS

When you do follow the posed route, be prepared to offer direction rather than leaving people to their own devices. The more you tell them what to do, within reason, the more confident they will be in your abilities. So have some idea how you would like to begin, in terms of location, pose, lighting and composition, then make changes as you go along.

The best way of putting people at their ease is to chat to them about things that interest them, such as their hobbies or work – taking pictures as they grow more animated and lost in the conversation.

COMPOSITION

As with other areas of photography, composition plays an important part in portraiture. How big you make the person in the frame, and where you place them, is to a large degree a matter of personal preference. Even if you are intending to enhance images in the computer, you don't want to lose quality by throwing too many pixels away at the outset, so it's a good idea to get your composition as right as possible in the first place.

One option is to include all of the person. This works well if you want to show them in a particular context, but can lack impact, as they often seem

POSED AND UNPOSED
The results you get when you ask people to pose are different from those produced by taking a candid approach.

PORTRAIT SEQUENCE
Expression can change in the space of a second, and sometimes you just want to keep your finger on the shutter release to give yourself plenty of choice.

SETTING THE SUBJECT IN CONTEXT
Including props that throw some light on what a person does for a living or what their interests are can make a portrait more interesting.

far away. For general picture-taking a three-quarters crop, typically from just above the knees, is a good choice – the face isn't too small in the frame but you can still see the background. For maximum impact, try framing more tightly, to show just head and shoulders. You get lots of eye contact, and the only real downside is that you don't see anything of the setting.

It's better to use a telephoto lens to fill the frame with the subject, rather than moving physically closer with a standard or wide-angle lens – the distortion that results is far from flattering. As you go closer you need to make sure you focus on the eyes, as the depth of field is greatly reduced, and if the eyes are unsharp it tends to make the whole picture look wrong.

When photographing one person, you'll often want to place them at the centre of the frame – though it's worth experimenting with other positions, such as to one side, or even with dynamic compositions such as tilting the camera to get a diagonal. With two people together, you should aim to capture something of the relationship between them. If they're related in some way, getting them to put their arms around each other or tip their heads together is a simple way of creating a sense of intimacy. It also avoids the common problem of the focusing sensor going between the heads and focusing on the background – with the people ending up out of focus.

With groups, try to avoid lining them up like a firing squad. The key to success lies in making sure you can see everyone's face and there's some kind of shape or structure. One simple technique is to create a 'triangle', with the tallest person in the middle, and others slightly in front and to the side.

WHAT GEAR?

The most flattering focal length for portraiture is short telephoto – in the range 75mm to 105mm. Standard and wide-angle lenses tend to distort facial features, but are usually fine for full-figure and environmental compositions. Longer telephoto lenses, 200mm and above, are ideal for candid shots, as they allow you to stay far enough from the subject to avoid being noticed.

USE A REFLECTOR

» One simple way of making the light even more appealing for portraits is to improvise a reflector of the type widely used by professional photographers. Any white or reflective material will do – such as a piece of white card, an old sheet or a square of polystyrene. Simply ask the person to hold it at waist height, so it's not seen in the picture, and you'll be astonished at how much it improves the lighting.

» If you have a friend on hand who can act as an 'assistant', try positioning your subject so they're lit from the side, with the reflector held vertically on the opposite side to bounce light back into the shaded areas.

» Reflectors are also valuable when taking pictures into the sun. The backlighting from this arrangement can be extremely attractive, because of the glow it gives around hair and body.

⬆ USING A REFLECTOR
Hazy sunlight is great for portraits outdoors, especially if you use a reflector to bounce light back into the areas of shadow.

Landscape photography

HIGH VIEWPOINT
Finding a vantage point that looks down gives an outstanding view of this landscape. Adding two filters – an 81B warm-up and a polarizer – has helped the clouds stand out and increased the saturation.

CREATING DEPTH
Strong foreground interest creates a sense of depth, especially, as here, where the foreground is lit by the sun and the distant view is in shade. A 24mm lens was used on a tripod at an aperture of f/16 to maximize depth of field.

What could be easier than landscape photography? All you have to do is find yourself a photogenic location, step out of the car, lift the camera to your eye and capture your masterpiece. If only! As you may have discovered, it's not as simple as that. The sprawling panorama that's spread out before you may take your breath away, but how can you capture it in a picture that will do the same?

How do you retain all the excitement of a vast three-dimensional scene when it's reduced to the two dimensions of a print or slide? Through the clever use of light, viewpoint, lens choice and composition – that's how.

LOCATION

It's pretty obvious, but well worth saying anyway, that life for the landscape photographer is a lot easier when you start with an outstanding location. While it's possible to create striking images in unlikely places, it's true that you can't make a silk purse out of a sow's ear. So if you want to give yourself a head start on the landscape photography front it makes good sense to visit a location that will offer you plenty of exciting views, with sweeping wooded slopes, dramatic peaks, tumbling streams or placid lakes.

It's also a good idea to choose a single area and then get to know it like the back of your hand – going back time and again at different times of day and in different seasons. Invest in one or two good guidebooks that will help you find the best vantage points. You should also get a detailed map, which will be worth its weight in gold.

Having chosen a location, where do you begin? By walking round it. Of all the tools that you have at your disposal in landscape photography, your legs are easily the most important. As you do this, you'll almost certainly discover that high vantage points are often ideal places from which to shoot – because they give you a commanding view across the whole scene, as far as the eye can see. Sometimes, though, the opposite is true, and by crouching down at the lowest point of a valley you can make a small hill seem to rise up into a mighty crag above you.

COMPOSITION

It won't be long before you realize that viewpoint and composition are inextricably bound up with the kind of lens you're using, and can't be considered in isolation.

It's a commonly held belief, for instance, that wide-angles are the 'right lenses' for landscape photography. Most 35mm photographers rely on a 28mm or 24mm, and some even use an ultra-wide-angle, such as 20mm or 17mm. Of course such lenses can be excellent for scenic subjects – but only if they're used correctly.

The danger with wide-angles is that because they take in so much, everything can end up looking small and far away. The three-dimensional quality of the scene is lost, with the result that the shot lacks any kind of impact. So to create the sense of depth you're looking for, you need to look

for ways of making the viewer's eye read 'through' the picture. One excellent option is to include foreground interest by choosing a viewpoint where something at the front of the picture helps to give a sense of near and far. Your foreground interest could be a bush, a rock, a boat – in fact anything at all – but it's worth actively seeking one out.

Another approach is to frame the shot so that a natural element, such as a river, dyke, road, wall or fence, threads through the picture. Try to get in as close to it as possible, so that it looms large in the front of the shot and rapidly diminishes in size as it leads away. The effect works best when the direction of travel is from the bottom left of the picture up towards the top right – and if the ground over which it runs is uneven, this will help enormously to convey the shape of the land. With water, you can deliberately select a long shutter speed of 1 sec plus, which will blur it into a photogenic froth.

MOVING WATER
Waterfalls are always wonderful to photograph, no matter whether you go in close, or as here, shoot from a distance to show them in context. If you want the water to blur, attach the camera to a tripod and use a shutter speed between 1 and 1/8 sec.

EVENING LIGHT
A broad definition of landscapes includes seascapes, and a great time to photograph them is towards the end of the day. To open up the perspective, a 17mm lens was used.

THE RIGHT LENS

When you're including foreground interest it's essential to get the picture sharp from front to back. To achieve this you'll need to set as small an aperture as you're able – certainly f/16 and even f/22 if that's possible. This is one of the reasons why a tripod is so useful for landscape work, because it allows you to set small apertures without fear of camera-shake.

Wide-angles may take in a lot, but telephotos also have much to offer the landscape photographer, because sometimes picking out and isolating a small element from the landscape can be a lot more dramatic than including everything. Because

they crop into the scene, telephotos tend to give a rather more 'abstract' landscape effect. The more powerful the lens the more abstract the image will be, often ending up as attractive textures and patterns that are barely identifiable.

While prime lenses can be used, telezooms from around 70mm or 80mm up to 200mm or even 300mm will give maximum framing flexibility. As with wide-angles, a high viewpoint will often help with telephoto landscape photography, allowing you to look down and select the part of the scene that's most interesting.

Subjects to look out for that benefit from this treatment are ploughed land, rows of trees, fields of crops and cracked mud. Going even closer, you might make a superb image from a close-up of the rough surface of a wall or fence.

With telephoto lenses it's also possible to limit the depth of field to make particular elements stand out. This 'differential focus' involves setting a large aperture, such as f/4 or f/5.6, to pick out a single aspect of the view, such as a lone tree, which will then appear to be projected forward from an out-of-focus background.

LIGHT

So far we haven't considered what is arguably the most important element in emphasizing shape and form in a landscape photograph. This is, of course, light, which in turn is affected by the time of year, time of day and the weather.

If you want to reveal all the curves and contours of a scene, shadows are essential, and this means that the sun really has to be shining for landscape photography to be worthwhile. The flat, shadowless light you get on an overcast day is generally the kiss of death to scenic work – although in stormy weather the dramatic skies can sometimes compensate for lack of excitement on the ground.

The position of the sun in relation to the camera is also crucial. You certainly don't want it behind you, as the shadows will fall away and be hidden, producing bland, uninspiring pictures. The best place for the sun is 90° to the left or right, so that it casts shadows that fall right across the picture, giving a strong sense of shape and depth. In the

⊙ HORIZON POSITION
Pictures look more dynamic if you don't put the horizon in the middle. Here the great expanse of sky produces a really interesting composition.

↑ **ISOLATING DETAIL**
Telephoto lenses are great for isolating details in the landscape such as this farmhouse in France; a 200mm lens was used here.

→ **SMALL SCALE**
Intimate landscape shots can be every bit as appealing as broad panoramas. This shot was taken with a 50mm lens in hazy sunlight.

right circumstances, shooting into the sun can be effective, with the shadows falling towards the camera, but care must be taken to expose correctly and to avoid flare.

The longer the shadows, the more dramatic the effect, which is why the best summer landscapes are often those that are taken early in the morning or late in the evening, with the sun very low in the sky. That's where a map comes in handy, and you may also sometimes find a compass useful: by planning ahead and anticipating the position of the sun in relation to a particular location, you can make sure you're there at the right time to catch it in the best light.

In autumn and winter, since the sun doesn't rise so high, as long as it's shining it's possible to create evocative landscapes pretty much all through the day – although dawn and dusk remain the best times, because then the light is softer and also warmer in tone.

Animals and birds

Many photographers are drawn to taking pictures of animals and birds, and the 35mm system is uniquely versatile in that it will allow you to tackle pretty much any subject that interests you. Of course, if you want to go on safari in Africa or take pictures of rare, exotic birds, you'll need some fancy, expensive equipment, but many subjects are accessible and can be photographed with the gear you have already.

PETS

Household pets are a great starting point for any aspiring animal photographer. The techniques required are similar to those used when taking portraits of people. The main difference is that because pets tend to be smaller, you'll need a longer focal length in order to fill the frame. The top end of a telephoto zoom is usually more than sufficient for medium-sized animals such as cats and dogs, and may even work for some smaller creatures such as hamsters if you get close enough.

⊙ PEOPLE AND PETS
Photographing a pet with its owner always makes for an interesting and attractive photograph.

Most of the best pictures are taken with the animals in a natural setting, outside, using daylight. Whenever possible avoid using flash with animals, as you can easily find that your shots are ruined by the animal equivalent of red-eye.

The best time to work is on a bright day, avoiding midday so there's plenty of soft, attractive light. If you choose a time when the animal is resting, perhaps just after a meal, it's more likely to stay in one place rather than chasing after you for attention. You can also use 'bribes' to get pets to stay where you want them.

The key points are to make sure you place your subject so the light is falling on it from the best direction and there's an attractive background behind. Then get down to the animal's level, lying flat on the floor if necessary. As with children, there's nothing worse than a shot in which you're looking down on the subject from a height.

If you've got a pet that might try to run away, such as a rabbit, try fencing off a large area so it can't escape, and then frame the shot so the enclosure can't be seen.

With a lively pet such as a dog, you could have a go at taking an action shot – perhaps of it leaping into the air to catch a ball. You may need a faster film speed, around ISO 400, to give you a shutter speed fast enough to freeze the action. You'll also need to take care with your focusing, especially if you have an autofocus camera.

Of course, you may prefer to photograph the pet with its owner, and this can work extremely well, especially if you capture the warmth that exists between the two. If the pet is your own, you could set the camera up on a tripod and use the self-timer. Simply frame the shot, pre-focus, fire the shutter, get into position, and smile. The hard bit is getting your pet to smile, too.

ZOOS

Unless you can afford to go on safari, zoos offer your best opportunity of taking good pictures of wild animals. But few creatures are allowed to

roam free, and the enclosures used to house them present a challenge to the photographer wanting to produce pictures that look as natural as possible. The techniques required depend to a large degree upon what method has been used to separate the animals from the public.

• Cages

A cage is the traditional way of enclosing an animal, and the main difficulty lies in throwing its bars sufficiently out of focus for them not to be visible. Those in the foreground can usually be lost by going in close enough to poke the lens partially between two bars. Those in the background can be minimized by setting as large an aperture as possible, around f/4 to f/5.6, to restrict the depth of field, and using a zoom lens, ideally up to 300m, to frame the subject tightly.

• Moats or pits

Some animals are allowed to roam free on a moated 'island', and here the problem is principally one of distance. With large species, you may be

🔼 MAKING IT LOOK NATURAL
When taking pictures at safari parks, you can make it look as if the animals are in the wild if you choose your viewpoint carefully.

🔄 ANIMAL CLOSE-UPS
A zoom lens up to 300mm will enable you to capture masses of different subjects on a visit to the zoo.

⬆ SHOOTING THROUGH GLASS
Excellent pictures can be taken of animals kept in glass enclosures, providing you go in close to avoid any reflections.

➡ CREATIVE WILDLIFE
Wildlife images don't always have to be simple record shots – be on the lookout for ways of coming up with something more creative.

able to fill the frame with a medium-power tele-zoom, but with others you may need a lens of 400mm or even more. Choose your viewpoint carefully, and you should be able to give the impression of an animal in the wild.

• Behind glass

Creatures behind glass are the hardest to photo-graph. Start by going in close, and resting the front of your lens against the glass to avoid reflections. With a poorly lit enclosure you may be able to get away with fast film, but if not you'll need flash, and this can also reflect off the glass, causing a 'hot spot'. The best solution is, wherever possible, to use the flashgun off the camera, so the light hits the glass at an angle and passes through, rather than reflecting back.

ANIMALS IN THE WILD

Taking pictures of animals in the wild offers a far greater challenge. It can be hard getting close to your subjects, and if you're to stand any chance you'll need to avoid strong scents, wear discreet clothing

and move around quietly. In fact, the best bet is to hire or buy a hide, but even then really long lenses will be required. You'll also need to learn as much as you possibly can about your chosen subjects, so that you know when and where best to photograph them.

Unlike most humans who, given half a chance, will have a lie-in until lunchtime, the majority of animals are up with the sun – and that's the best time to photograph them, as they are active and often playful. So you'll need to be an early riser yourself. For the first couple of hours after sunrise the light is soft, warm and flattering, throwing long, evocative shadows.

Some animals, such as foxes and badgers, are normally active at night, and photographing them successfully is demanding. For a start, you can't just wander around in the hope of finding them, because most nocturnal species have a heightened sense of hearing to make up for the fact that they can't see too well in the twilight hours. The best thing is either to go to a location you know they frequent and wait, or to put out food over a number of nights in the hope of attracting them. Whichever approach you take, you'll need a lot of patience. Whether you are out in the wild or at home in your garden, it's always best to set up your camera on a tripod, because your arms can get mighty tired waiting.

Flash is obviously required, and a separate gun is pretty much essential. The best approach is to anchor the camera to a tripod, and connect it to a gun mounted close to the food, which you may want to hide out of sight of the lens. An alternative is to fire a second flash by means of the built-in gun using a 'slave'. If you don't have a lens that's long enough, you can set the whole thing up near the lure, then retreat and trigger both the shutter and the flash by lead or infrared remote control when the animal appears.

For the ultimate experience in wildlife photography, nothing beats a genuine African safari. Imagine rumbling across the Serengeti plains in an open-topped jeep, searching for lions, elephants, rhinos, giraffes, wildebeest and zebras. Obviously we're talking big money – and big lenses. But with a skilled guide you should be able to get some cracking shots with a zoom up to 300mm. A lens in the range 400mm to 600mm, though, will be necessary for some situations.

PHOTOGRAPHING BIRDS
At a falconry centre it's possible to get sufficiently close to exotic birds of prey to fill the frame using a telephoto zoom lens.

BIRDS

Birds are not the easiest subjects to photograph. Most telephoto zoom lenses are nowhere near powerful enough, and you really need a lens of at least 400mm to be able to reproduce a bird in your garden at a reasonable size in the frame. The situation is even more challenging in the wild, where you can't get as close, and super-telephotos are the order of the day.

One excellent option, though, while you're building up your equipment and expertise, is to visit a captive collection of birds of prey, where you can get up close to exotic and photogenic species such as owls, condors, hawks, eagles and falcons. This will allow you to produce powerful wildlife portraits, and if you go in close and frame tightly, you can exclude anything in the background that shows the bird wasn't in its natural habitat. You may also want to try to photograph such birds when they're on the wing, but fast reflexes will be necessary as well as, once again, long lenses. A shutter speed of 1/500 sec should be sufficient, which may require an increase in ISO speed if conditions are overcast – but watch your exposure when the bird is against the sky.

Travel and holidays

Holidays provide the perfect opportunity for you to make the most of your 35mm camera, and whether you're spending a week in Bognor or a month in Barbados, you'll want to take lots of memorable pictures.

As well as being able to spend time relaxing and having fun with your family, free from the routines and chores of daily life, you can also explore all the exciting places in or around your holiday destination. Stunning sunsets, fabulous cities, beautiful scenery, famous monuments – everywhere you look there will be chances to capture the colour and character of the place.

When faced with all those new sights and sounds it's tempting to snap away at anything that looks remotely interesting. Think carefully about each picture, otherwise you could be disappointed when you return home.

FILM CHOICE

It's surprising how much film you can get through during a one- or two-week holiday, so buy plenty before you go. If you're shooting prints, ISO 200 is an ideal speed for summer holidays. If you intend taking lots of pictures indoors, or outdoors during the evening, pack a few rolls of ISO 400 film as well. Those who favour transparencies may want to major on ISO 100, with a few rolls of higher speed ISO 200 and 400 emulsions. Don't wait until you reach your destination before buying film, as you may find it's more expensive – and that your favourite brand isn't available.

Most 35mm cameras are now dependent on batteries, so remember to pack a couple of spares, as it may be difficult to find the type you need while you're away.

SUN, SEA AND SAND

Although there are many different options these days, with some people preferring to spend a couple of weeks getting off the beaten track or exploring a city, a beach holiday is still something most of us look forward to in summer. And even if your budget doesn't extend to jetting off somewhere exotic, chances are you'll spend some time at the coast when the weather's at its best.

Most of the pictures you take on the beach will be of family and friends, but while the circumstances may not seem conducive to creative photography, that doesn't mean you have to end up with bland snapshots. Certainly the odds are

> **ACTION SHOTS**
> If it's a family break, you'll obviously want to record everyone having a good time. But don't go into 'snapshot' mode, just because you're on holiday.

> **TIGHT FRAMING**
> Bold colours abound in the Mediterranean, and the only problem is how to make the most of them. A tight crop was chosen for this shot of a boat in the Portuguese coastal resort of Albufeira, angling the composition for more impact and dynamism.

stacked against you. The sun is often bright and harsh, the sand is reflecting light all over the place, and it's not unusual for backgrounds to be busy and messy. But where there's a will there's a way, and with a little thought it's possible to overcome such challenges.

The problem with photographing people on the beach is that once the sun's high in the sky you get dark shadows under brows, noses and chins. These are unflattering in the extreme, but can be avoided. The easiest way is to take pictures at the start and end of the day, when the sun is closer to the horizon, and the light is much softer and warmer. If you must capture images in the middle of the day, try using a white towel or shirt as a reflector to bounce light back into the shadow areas, or switch the camera to the 'fill-flash' setting, which will give a low-powered burst of light to balance exposure. Alternatively, position people so the sun is behind them, with no direct sun falling on their faces, or find a place under a parasol to take out all the top light.

The harshness of the light and the reflectivity of the sand and sea mean that you also need to take care on the exposure front – if you're not careful your camera's meter will be fooled into thinking there's more light than there really is, and you can end up with muddy, underexposed images.

One more word of warning: sand and salt water can damage cameras very easily, so take care when shooting near the water's edge and never leave your camera uncovered on the beach.

If your hotel or apartment has a swimming pool then you've got the perfect opportunity to take even more exciting pictures. Try photographing kids

splashing around in the water, floating on an airbed or jumping off the diving board. With a bit of luck you'll be able to freeze their frenzied activity completely, but if not, a little blur in a picture can sometimes make it even more effective.

FINDING A VIEWPOINT

When you're visiting popular tourist sights, avoid snapping away as if your life depended on it and spend a little time exploring first. Look out for interesting viewpoints where you don't have to shoot over the heads of other visitors, or sit in the shade and wait until the crowds disperse. Wander around and consider the scene from different angles – try shooting from ground level, or from a higher viewpoint. Whether it's the Pyramids or the Tower of London, even at world-famous

FINDING AN ANGLE
Every city has its famous sights and tourist spots, and when you visit them you'll obviously want to photograph them. Try and think of ways to be as original as possible.

OFFBEAT SUBJECTS
Always be on the lookout for something unusual that seems to evoke the character of the place you're visiting. These masks were spotted in a window in New Orleans and photographed with a standard lens.

monuments you can still produce unusual and original pictures – instead of the same old snaps from the same old angles.

HANDLING PEOPLE

One of the best ways of capturing the character of a place is to photograph some of the people who live and work there. Wherever you go, for example, there will be a flourishing local craft industry, such as leatherworking in Spain or ceramics and gold-smithing in Crete. Often the finished goods, set out on attractive stalls run by their makers, provide opportunities for appealing pictures that will bring it all back to you in an instant.

But should you ask first or shoot candid pictures? What if your subject pesters you for payment, or worse, suddenly turns nasty? §As a general rule, it's courteous to let people know

you'd like to photograph them. How would you feel if you were outside your house or in your local market and someone started taking pictures of you without asking? Many amateurs are shy and that leads them to behave in a furtive way. They use long lenses from the other side of the street and that comes across as intrusive. The worst that can happen if you ask is that people will say 'no'. If you can, strike up a conversation, then when you ask to take some pictures it will seem a lot more natural.

Another successful approach, if language is a problem, is to make it obvious you're planning to take a picture that includes someone – and then allow time to elapse so they have the choice to be in it or not. Most of the time people will stay where they are and let you take the picture.

For pictures of this kind a standard zoom is ideal. The wide-angle end is useful if you want to show people in their environment, perhaps with a well-known landmark behind, and the telephoto end helps if you need to crop out other tourists.

Sometimes you'll be pestered for money, especially in poorer parts of the world, and whether you pay is entirely up to you and your conscience. Many photographers, rather paradoxically, will only offer payment when they're not asked, because they don't want to encourage begging. But remember, a relatively small sum could easily make a big difference to someone in poverty.

GLORIOUS SUNSETS

Finally, no summer holiday would be complete without a set of stunning sunset pictures. But what is it about a sunset shot that makes it 'stunning'? To an extent it's the sunset itself – you obviously need rich, vivid colours – but there's more to it than that. First, you need to get the exposure right: if the picture is overexposed everything will look washed out; if it's underexposed, it will be muddy and indistinct. Take a reading from a bright area of the sky just to one side of the sun.

You also need a clean, uncluttered viewpoint. A row of parked cars in the foreground or a line of pylons in the distance means your sunset will never be a masterpiece. When you sense in late afternoon that the sunset is going to be spectacular, start thinking about a good place to shoot from.

LOCAL PEOPLE
This saxophone player was busking early in the morning down by the Mississippi, and the photographer engaged him in conversation, shooting around 40 pictures over the course of half an hour. At one point a paddle steamer passed by in the distance, completing the composition.

Photographs in which the sun is going down over water often have a special quality to them – but obviously you have to be facing west. A flat area of landscape can work equally well.

That doesn't mean you should avoid having other things in the picture. Anything in the foreground will record as a silhouette, so by finding something with a graphic shape – such as a palm tree – you can add interest and variety to your sunsets, to stop them all looking the same.

Finally, if you plan to include the sun itself in the pictures, wait until it's weak enough to look at, otherwise it will cause flare.

WHAT GEAR?

Going on holiday poses something of a dilemma for the keen photographer. Since there's the maximum opportunity to get out and take lots of pictures, ideally you want every item of equipment with you. At the same time you want to travel light. One compromise is to take a reasonably complete outfit with you, and then choose what you actually need to take out each day. Certainly a selection of lenses will be useful, covering the range from wide-angle to telephoto, along with a flashgun for inside shots and balancing daylight exposures, and a small, portable tripod.

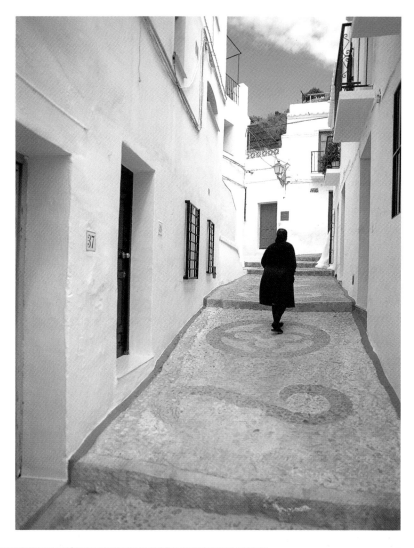

WHITE BUILDINGS
When photographing white buildings take care with your exposure. All the light bouncing around can easily fool your meter into underexposure. If in doubt, bracket exposures to ensure you get at least one photograph that's right.

SUNDOWNER
With nothing that has to be done and no work the next day, holidays provide a great opportunity to photograph some wonderful sunsets.

Children and babies

BABIES
Tiny babies are easy to photograph. Here, daylight was streaming in through a large window and the photograph was taken standing on the bed looking down.

CANDID PICTURES
Kids can be extremely mischievous, and all you really have to do is follow them around and capture that magic on film in a candid style. The top end of a 70–300mm zoom was used to catch this boy as he stayed still for a brief moment.

If you're a parent you'll need no urging to photograph your offspring. Inevitably you'll want to catalogue every aspect of their growing up – from cradle to college and everything in between – and that means burning masses of film.

If you don't have kids of your own, then you'll almost certainly find relatives, friends or neighbours willing to let you take pictures of their brood in return for a few prints. And be assured you'll find it worth the effort. Children are a fascinating and challenging subject for photography, initially frustrating yet ultimately rewarding. They don't have all the inhibitions displayed by adults, and their spontaneous and natural actions give you the chance to take some first-class photographs.

BABIES

Generally the first few months of a baby's life are a frenzy of photographic activity, with the camera being used almost every day. And you'll need to shoot that often if you're to keep up with the newborn's rate of development, because a week in the life of a baby can make a huge difference.

It all starts, of course, at the birth, and that all-important picture of mum holding the baby for the first time is one that will always be treasured. If the baby has been born in hospital you may need to use flash to get decent results, as delivery rooms usually have fluorescent lights. Don't worry about damaging the baby's eyes – you won't, although you may notice a little jump of surprise at the sudden brightness.

Once the baby is at home you should try to make photography part of your daily life, rather than something you do only on special occasions. Keep the camera handy and photograph everyday things, such as crying, feeding and crawling, as well as the historic first smile and first step.

As well as such spontaneous shots, remember to take time out to produce some more formal, posed pictures, with mum and dad with their hair done and the baby beautifully dressed.

Be sure to take some really embarrassing pictures of your little one as well – being sick, on the potty, breast-feeding, in the bath – so you can bring them out in 15 years' time to show to future boyfriends and girlfriends.

TODDLERS

Photographing babies is easy – they stay where you put them, and as long as you feed them and change them and cuddle them now and again, they should be willing little models. But once they start to crawl, and then walk, you've got your work cut out. They're here, there and everywhere, and even with an autofocus camera you can find yourself beaten as they rush headlong towards you whenever they see you pick up the camera.

One thing's for sure: if you want to be successful at photographing children – whether they're your own or those of family and friends – you need to get down to their level.

On a physical level that means bending your knees and crouching so you're not towering over children and making them look up at you. But on a mental level it means treating them as equals, and not talking down to them. It means playing with them, chatting to them and entering their world. It's important to make children feel at ease, and if they're yours, or you know them already, then there should be no problem.

If you know the children only a little, or not at all, then try to visit them before the session and get to know them and their parents better. That will also give you a chance to talk about the kind of pictures you want to take.

INFORMAL SHOTS

There are two basic approaches to photographing children – informal and posed – which yield very different results. If you adopt the informal approach, you need to stand back and capture moments as they pass and events as they happen. Essentially,

ACTION SHOTS
Pictures of children playing are always appealing – especially when you catch boys pushing prams or girls with trucks.

PORTRAITS
Using a telephoto lens at maximum aperture throws the background – and in this case even the back of the hair – out of focus.

RECORDING EVENTS
The first day at school is an important event in any child's life – and like all such events needs to be recorded for posterity. The soft light in the front of the door helps this boy stand out beautifully.

outside, allowing you to take advantage of daylight and giving you fast shutter speeds capable of freezing most everyday movement.

POSED PORTRAITS

If you want more control, you'll get it by setting up a formal portrait with the child posing. Such pictures don't have to be taken in a studio, just in an environment in which you can manipulate such things as lighting, background and pose. Some kids are shy and find this intimidating, while others like being the centre of attention and lap it all up.

Generally, lighting for child portraits should be soft, so use light from a large window, diffused flash, or an umbrella or softbox – plus plenty of reflectors. If light levels are low, you may need to use a tripod to get a workable shutter speed. But avoid shooting in normal household lighting – the tungsten will produce an unpleasant orange cast unless you fit a filter. If you fit a flashgun you can completely override the existing light, and so avoid the problem of colour casts. But direct flash, although powerful, can be harsh and unflattering. It's better to bounce, if your gun has the facility, but if the flash head is fixed try putting some tracing paper over it to soften it slightly.

It's very easy to get carried away in the excitement of the picture-taking and concentrate so much on the subject that you pay no attention to the background – only to find when the pictures come back that it's distracting. So check out what's behind the child before you trip the shutter. Go for unfussy backgrounds that will help your subject stand out, and think about clothes in relation to the background. It's also essential, unless you are going for a 'little rascal' look, that the hair is neat and tidy and the face is clean.

Kids have an incredibly short attention span, and before too long will start fidgeting, so it's important to set everything up for a formal portrait in advance. In fact, whenever you're photographing kids you should be sensitive to their moods. If you sense that they're getting bored, either change tack or call a halt to proceedings. Keep on pushing and you'll just waste your film. Try not to be bossy even if – especially if! – they're your own kids, or you'll end up with folded arms and miserable

you take pictures of the children's life as it is, without setting things up too much. So you'd take shots of them in the garden, at the park, playing with friends or at a party. You might want to introduce a pet or a toy to stimulate some action, but that would be as far as your intervention would go.

In informal photography you may not have control over all of the elements of the picture, but you still need to think carefully about where to stand to take the shot, how to compose it, and when the light is best. Such pictures can generally be taken

ZOOMING IN
A 400mm lens was needed to capture the competitiveness of these youngsters racing in brightly coloured cars at Legoland in England. The light, from midday sun, was not ideal, but from this angle the cars and boys were reasonably well illuminated.

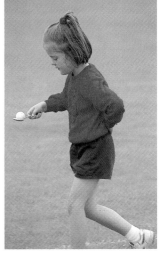

ADAPTABILITY
You need to be versatile to record the many different events, both outdoors and indoors, in the school calendar. Fast reactions are needed for sports day.

BUILT-IN FLASH
Sometimes you have no choice but to use on-camera flash – and in fact often the results are perfectly acceptable, if a little flat. While props should not be over-used, they do help give a picture interest and atmosphere.

expressions. Talking to children about whatever interests them, or telling them a few jokes, can work wonders in terms of getting them to relax.

One sure-fire way of getting good shots of kids is to give them something to do, because once they're engrossed in some activity they'll forget all about you and your camera, and you can snap away to your heart's content.

WHAT GEAR?

The ideal outfit for photographing children is a 35mm SLR with a selection of lenses and accessories – though a 35mm compact will let you tackle a wide range of situations.

A standard zoom will do fine for a start, but pretty soon you'll need a telephoto lens for longer distance and candid shots. Remember that children, especially younger ones, are much smaller than adults, so you either need to go in closer or use a stronger lens than you would for an adult in the same situation. A telezoom, from 80mm to 200mm or 300mm, should work well.

Other useful accessories include a flashgun, for low-light work and fill-in, together with perhaps a couple of filters, such as soft-focus and warm-up.

Architecture and cityscapes

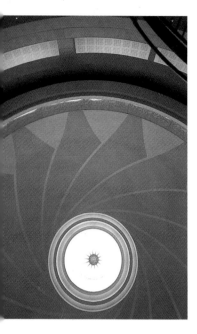

ABSTRACT SHAPES
Modern buildings are full of wonderful designs just waiting to be photographed. This composition was spotted on the ceiling of a modern shopping mall, and photographed with a standard lens.

LARGE INTERIORS
Interiors demand wide-angle lenses if their spaciousness is to be conveyed. As ever, it's a good idea to include something in the foreground to give a sense of depth.

From stately homes to urban skyscrapers, buildings make fascinating subjects for photography. Wherever you live, you're bound to be within reach of plenty of examples of architecture with photographic potential. Your own humble abode could even be a source of images with bags of impact if you tackle it with fresh eyes, imagination and style.

Any metropolis or built-up area will certainly offer a multitude of picture-taking opportunities. Buildings are constructed from a wide range of materials, and contemporary designs often have dramatic and eye-catching features that make the life of the photographer relatively easy. Even the front of an office or shop can be worth committing to film when viewed from the right angle.

If you don't live in a big city, don't worry – there are plenty of buildings every bit as attractive in the country. Obvious examples are churches and cottages, which sometimes look as if they're just sitting there begging to be photographed.

TIME OF DAY

Wherever you find yourself photographing them, buildings, more than any other subject, depend upon good light to bring them to life. In fact it's generally a waste of time and film taking architectural studies on an overcast day. What you really need is sunlight, although you don't want it too strong, or you'll find the harsh shadows result in pictures that are unacceptably contrasty.

So avoid the middle of the day, and try to take your photographs either early in the day, soon after dawn, or in the late afternoon. At these times the light is far softer and the longer shadows help to emphasize the texture of the walls. The light is also much warmer in tone, which can help you make the most of buildings that are made of stone. With some buildings, you have a limited choice of lighting conditions because of the direction they face – although only north-facing buildings will see no sun during the course of a day.

COMPOSITION

Creative composition is particularly important, as pictures of buildings often lack a sense of scale – with everything looking far off in the distance. You can get around the problem by finding something to act as a frame around the subject. This could be a natural object such as the overhanging branch of a tree, or might be a convenient arch. If you can't find a frame, a statue or plant in the foreground could be used to add depth. The technique works best with the lens at its widest setting, but you must make sure it's the distant subject you focus on, using the focus lock if necessary.

Generally in architectural photography you want verticals to appear upright, and this is only possible when the camera back itself is upright. With a tall building, however, you may have to tip the camera back to get all of it in. This creates the effect known as converging verticals, with the building appearing to fall over backwards in the image. Converging verticals can be used creatively: by

TAKING UNUSUAL VIEWS To stop your architectural pictures getting boring, experiment with different compositions and unusual angles.

AVOIDING DISTORTION Whenever possible you should aim to keep the uprights of a building really upright. That may mean, as here, standing further back and using a telephoto lens, but the truth of the results makes it worth it.

● REFLECTIONS
Chicago is a city full of the most fabulous skyscrapers, but sometimes the most intriguing architectural images are the least obvious, as this reflection in the windows of a building in the shade demonstrates.

● NIGHT CITYSCAPE
Try find a vantage point that gives you a commanding view. This picture was taken from the 14th floor of a skyscraper in Tokyo, Japan.

getting really close to the building and choosing a low viewpoint you can deliberately exaggerate the effect – so it looks intentional rather than a mistake. Get it right and everything seems to zoom off dramatically to a point in the distance.

Of course, you won't always want to include the whole of the building, so converging verticals may not be an issue. Often you'll spot some architectural detail that's particularly appealing, and that will be what you'll want to focus in on – especially when the building as a whole is not very interesting. To some extent it will be whatever catches your eye, but elements such as gargoyles, plaques, sun-dials, door knockers and even house numbers can all make great pictures in their own right.

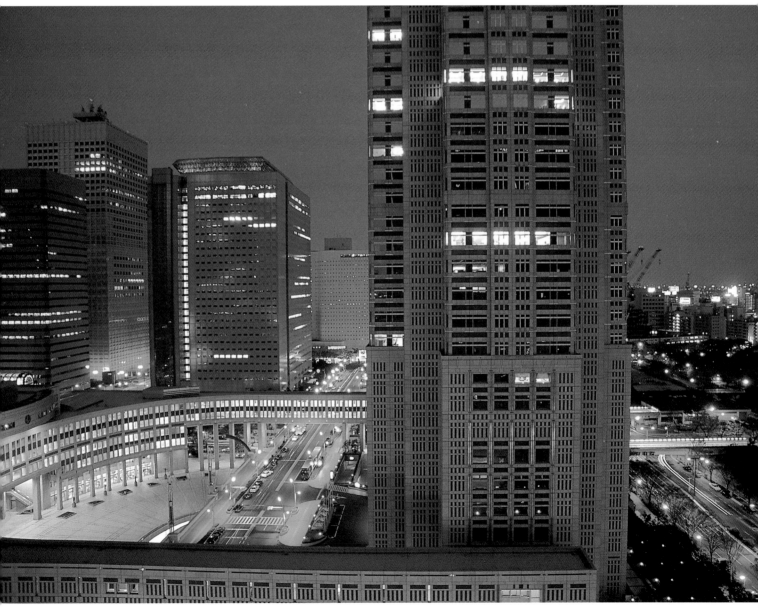

INTERIORS

If you go to a stately home or prestige office you'll often find a sumptuous interior full of fascinating architectural detail. Don't try to photograph it using flash, because even the flashguns used by professional photographers aren't usually powerful enough to illuminate such large areas. Of course there may not be enough daylight for a hand-held exposure without the risk of camera-shake, even if you have loaded up with a fast film. In this case you'll need to use a support. Mount the camera on a tripod or, if this is not allowed, try resting it on any convenient flat surface.

NIGHT LIFE

Some buildings that you wouldn't look at twice during the day – and certainly wouldn't consider photographing – are completely transformed into photogenic subjects when night falls, floodlighting comes on and neon signs light up. In fact, the best time to take night pictures is not actually at night but just before darkness falls, when there's still plenty of blue in the sky. The contrast between buildings and sky is then not too great, and a better balanced photograph is the result.

If you are shooting early enough in the evening you may get away with hand-holding the camera, as light levels can still be surprisingly high at twilight, but with buildings that are less brightly lit, you'll need to use the B setting featured on most SLRs and some compacts. This allows you to set exposures running into many seconds or even minutes. Simply press down on the shutter release, and the shutter stays open until you take your finger away. Of course, you'll need a tripod if you're to avoid camera-shake, and a cable release is advisable. Experiment with a range of different times, such as 10, 20, 40 and 60 sec, to see which one works best.

Anticipating what colour illuminated buildings will turn out in the finished picture is largely a matter of experience. Tungsten lighting is often used for floodlighting, and the results will therefore be orange. This is generally attractive, but if you prefer a more neutral rendition you should use an 80A blue filter.

WHAT YOU NEED

» When you think of photographing buildings, it's wide-angle lenses that come to mind first. Many of the most photogenic architectural constructions either tower above you or stretch out to the side, and getting them into the frame can be a problem – especially if you're in a cramped area where there's not enough room to step back, as is often the case in urban locations.

Most 35mm compact cameras feature wide-angle coverage down to 38mm, 35mm, 32mm or even 28mm, which is fine for many buildings, but if you're serious about the subject you'll need an SLR with something wider, such as 24mm or even 20mm. A 15–30mm or 17–35mm zoom lens will literally open up your horizons and composition options.

» Serious architectural photographers get round the problem of converging verticals by investing in a perspective control (PC) lens. This is more commonly known as a 'shift' lens, because the elements can be shifted up and down, magically eliminating the effect.

» Surprisingly, some of the best results are achieved using a telephoto zoom from a viewpoint some distance from the building. A lens starting from 70/75/80mm and going up to 200mm plus gives you lots of options. You can start by photographing the whole place with the lens at its widest setting, and then zoom in to capture interesting details.

» Filters are also useful in architectural photography. Old stone buildings such as castles, country houses and cathedrals often benefit from a warming filter, such as 81A or 81B, to enhance the colour of the stonework. With more modern buildings, such as skyscrapers, there's nothing to beat a polarizer, which gives the image a lot more punch and saturation. Bland, washed-out skies can kill the impact of a good architectural picture, so it's also worth using graduated filters to add density and, where appropriate, more colour. Grey graduates will let you darken the sky naturally, while blue will give more interest. Other, more 'dramatic' colours should be used with care.

↑ SIDE LIGHTING
Keep your eyes peeled for details that are often more absorbing than the buildings they're on, such as this statue (top) and a pair of hands (above) spotted on a door down a side street in Portugal. The relief of such details is best brought to life under hard side lighting.

Action photography

⬆ DIRECTION OF TRAVEL
It's easy to photograph action when it's moving away from you, but faster shutter speeds are required when the movement is across your field of view.

➡ CREATING BLUR
Everyday situations offer opportunities for interesting action pictures. At a shutter speed of just 1/15 sec with a 50mm lens these hurrying commuters blurred nicely.

Think of action photography, and you probably think first of sport. There's no denying that runners sprinting home, boxers slugging it out and surfers riding a wave are the stuff of breath-taking images. But there's more to action photography than sport. Any event in which people and things move has potential that you can exploit – even everyday situations such as children playing in the garden or washing blowing on a line.

SHUTTER SPEED

Action may take many different forms, but essentially you have two options when recording it in a photograph: you can either use a fast shutter speed to freeze the movement, or a long shutter speed to create blur.

In practice, however, shutter speeds don't have to be that fast to freeze most action. Surprising as it might seem, 1/500 sec or 1/1,000 sec will cope perfectly well with the majority of situations, depending on the pace the subject is setting. The direction of travel is also important. Movement

towards the camera is relatively easy to freeze, and you may even be able to get away with shutter speeds as low as 1/250 sec, although 1/500 sec would be safer. Movement at 45° to the camera is more difficult, requiring a minimum of 1/500 sec, and 1/1,000 sec to be sure. Hardest of all is movement at 90° to the camera: here 1/1,000 sec is often necessary and 1/2,000 sec is sensible for high-speed subjects such as sports cars. You also need to take account of the distance of the action from the camera. The above speeds apply when the subject is 10m (33ft) or more away, but if it is closer, even if it's moving relatively slowly, 1/1,000 sec may be required.

However, it's all too easy to freeze things so completely that you totally kill any sensation of movement – producing an effect that is quite the opposite of what was intended. Your dramatic shot that was supposed to show Formula 1 drivers battling it out may end up looking just like a row of parked cars. For this reason it's a good idea to try to set a shutter speed that renders most of the subject pin-sharp but allows part of it to blur in a

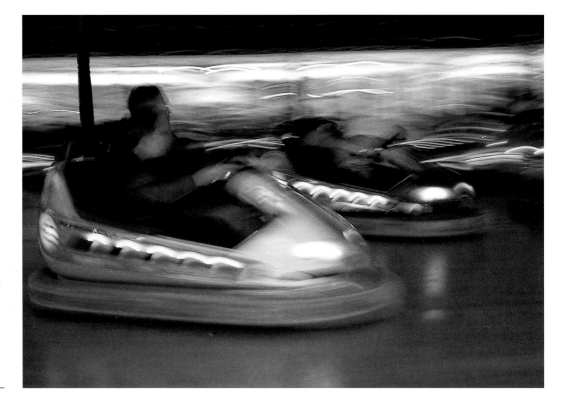

➡ FLASH AND DAYLIGHT
One effective way of capturing action is to mix flash and natural light. Simply set a longish shutter speed, say 1/15 sec, to introduce some blur, then use flash to freeze part of the action.

controlled way. For instance, you might aim to freeze the body of a speeding car but let the wheels blur to show that they're spinning fast.

TIMING

One of the key skills of sport and action photography is timing: anticipating the decisive moment when the movement reaches its peak. Shoot too early and there's nothing happening; shoot too late and you've missed it. Usually there's a split second when everything's perfect. That's why it's good, when you're starting out in the field, to choose an activity you know well. That will give you an edge, because you know the rhythm of the action. So if you're into football, try that, or go for athletics if that's your passion.

But you don't have to wait for special events. Action is all around you. On your way to work try photographing commuters streaming off a train, or cars speeding down a motorway. Or take a break and head out into the countryside, where you'll find fields of grain blowing in the wind, or people on cycles passing by.

EQUIPMENT

For everyday action photography you can use pretty much any lens, but for sports subjects a telephoto lens is usually required. With closer, more accessible subjects, a telezoom up to 200mm or 300mm will be sufficient, but with major events where the action is happening on a track, pitch, field or arena some distance away from you, you'll need to think about a 400mm, 500mm or even 600mm lens to fill the frame with action.

PANNING

If you want your action pictures to convey a strong sense of movement, panning is the technique you should use. It involves swinging the camera horizontally in the same direction as your moving subject – and firing the shutter while both are moving. This will produce a picture in which the subject is sharp but the background streaked. Here's how to do it:

- Choose a position in which your subject will go straight by you and which gives you a clear view.

- Pre-focus on a point directly in front of you that you know the subject will pass. If you have an autofocus camera, switch over to manual focus.

- Choose a shutter speed that matches the speed of your subject. For fast subjects, such as cars, skiers and motorbikes, experiment with speeds from 1/125 sec to 1/30 sec. For slower action, such as running or cycling, try speeds from 1/60 sec to 1/15 sec.

- Tuck your arms in tight to your body and prepare for the subject to appear. As it comes into sight, follow its movement with the camera, swinging the top half of your body round in a smooth and steady arc. Don't change focus.

- As the subject passes the point you focused on, fire the shutter release.

- Continue to follow the subject with your panning movement – as you'd follow through a swing in golf or a stroke in tennis.

- Repeat. And repeat again. Panning is an unpredictable art, and you never know whether you've achieved success until you get your pictures back from processing. So the more you take, the more winners you're likely to end up with.

PANNING
Panning produces characteristic streaks behind a sharp subject. The secret of success lies in getting the shutter speed right and practising a smooth panning action.

Night and low light

TWILIGHT
Just before night comes down the sky is often a clear, pure blue that's extremely photogenic – but light levels are low and you'll need either a fast film or a tripod to be sure of shake-free results.

ILLUMINATED STREETS
Night completely transforms a scene, as buildings, streets and cars are all lit up.

As daylight fades and lights go on, a whole different landscape of light appears, with its own challenges when it comes to photography – and the potential to create fascinating studies after dark.

All but the simplest 35mm cameras now have a wide range of shutter speeds and apertures that make it possible to take pictures at night and in low-light situations. Most SLRs offer a 'B' setting that allows you to set exposures running into seconds or even minutes.

Many buildings and street scenes you wouldn't look at twice during the day come alive at night, as spotlights and illuminations are switched on. Ideal subjects include historic buildings such as cathedrals and neon-signed nightlife such as clubs and bars.

The term 'night photography', though, is misleading. The best time to take pictures of street scenes and buildings is actually at dusk, just after the sun's gone down and while there's still plenty of blue in the sky. If you leave it any later the sky will be recorded as a dense black with the lights as burnt-out highlights. As a rule of thumb, an hour before it gets dark is when you should begin shooting for the best results.

THE RIGHT EXPOSURE

When you're shooting on film, night photography is, well, a nightmare – the enormous contrast range means getting the exposure right can be tricky and unpredictable, and it's not until you pick up the prints you find out whether you've been successful or – more commonly – not.

What makes night photography appealing is the bright, vivid lights. While you can use filters to compensate for them, the resulting pictures will be flat and uninspiring. If you have a choice, set the controls for daylight balance, and you'll capture the vibrant warmth that mercury vapour and tungsten illumination gives to these subjects.

In bright street lighting you might just get away with hand-holding, especially if you increase the ISO setting or go for a faster film, but the risk of camera-shake is always present. Bracing yourself against a lamp-post or resting the camera on a wall can help, but if you're serious about night-time shooting a tripod is virtually essential. Once the camera is firmly anchored you can take pictures in conditions where there's very little light at all, and with no fear of them

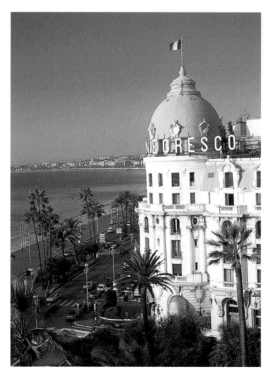

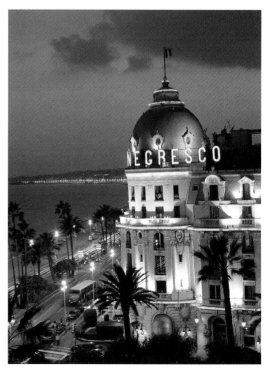

⬆ FLASHING LIGHTS
Neon lights always looks great but are sometimes hard to photograph if they're flashing on and off. If you spend a minute or two getting to know the sequence you can usually time things to get a complete message.

coming out blurred. A cable release avoids the need to touch the camera when firing the shutter, but a good alternative is to use the self-timer.

If you want to add animation to your low-light shots try including moving cars, whose front and rear lights will streak across the picture during long exposures. In fact, you can make this the whole point of a wonderful special effects picture by finding a good vantage point on a bridge looking down on a busy road and shooting as traffic passes below. Wait until a burst of traffic comes along, and then fire the shutter for a period of around 15 seconds. Once again, twilight is the best time to shoot. Christmas markets and funfairs are other wonderful hunting grounds.

SHOOT THE MOON

The nights are often exceptionally clear in winter, which makes it a great time to take photographs of the moon. While it looks big when viewed by the human eye, once you point a camera at it you'll realize how little of the frame it fills, so a decent zoom lens is essential. There will be less light pollution outside towns and cities, but if you have to shoot from an urban area, try doing so after midnight, when most people have gone to bed and switched off their lights. For something completely different you can also take pictures by the light of the moon. With their lack of colour and unusual lighting, moonlit images give familiar views the appearance of a totally alien landscape.

⬆ FIREWORKS
To capture fireworks, secure the camera to a tripod, and when a volley of fireworks goes up open the shutter on 'B' for about 10–15 seconds.

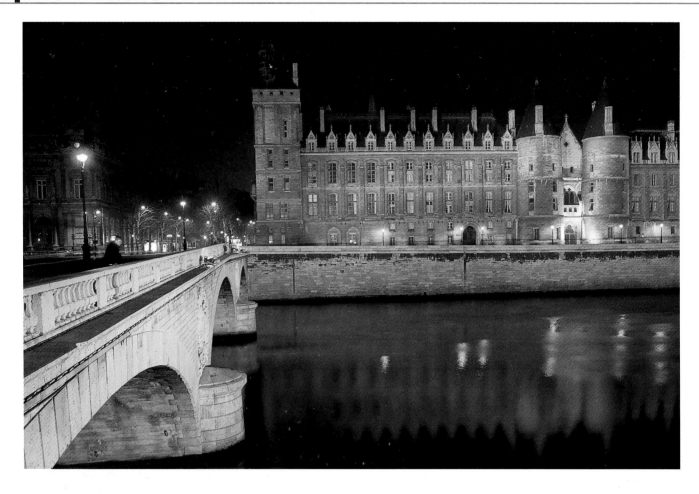

↑ TUNGSTEN FLOODLIGHTING
Unless you use blue filters to compensate, or a tungsten-balanced film, floodlit buildings will come out orange. Generally this is at least acceptable and often works well. Removing the warm colour would leave the picture neutral in tone and lacking in mood.

NIGHT EXPOSURE GUIDE

The main difficulty with taking pictures at night is calculating the exposure. So to help you here's a guide to some of the more common subjects you'll want to tackle. Please note that these exposures are only suggestions, and that it's sensible to bracket widely when taking pictures at night. All assume that you're using an ISO 100 film setting.

Subject	Exposure
Buildings with blue still in the sky	1/15 sec at f/5.6
Buildings against dark sky	4 sec at f/5.6
Funfairs/amusement parks	1/4 sec at f/5.6
Brightly lit buildings	1/4 sec to 1/15 sec at f/4
Floodlit buildings and monuments	1 sec at f/4
Neon signs	1/4 sec f/4
Illuminations	1 sec f/5.6
Traffic trails	15 sec at f/11
Fireworks/lightning	15 sec at f/16

One thing you won't want to do when photographing the moon is use flash. Though you do often see people at concerts trying to illuminate the stars on stage from their seats in the 83rd row, their efforts are futile. In fact, the range of most built-in flashguns is about 4m (13ft) at standard ISO settings.

SUNSET AND SUNRISE

Twilight is also a great time to head off to the countryside and capture some atmospheric images as the sun goes down. Shadows play a big part in creating a sense of depth in photographs, and at the end of the day they're at their longest and most photogenic. The secret is to find a vantage point such as a hill where you can get an elevated view of the shadows as they stride out purposefully across the landscape.

Another option worth considering if you want pictures with bags of impact is to have a go at creating some silhouettes. This couldn't be easier. All you have to do is find a scene in which the background

is much brighter than the main subject. Shooting into the setting sun is a sure-fire way of achieving that – but you'll need to take care to avoid flare. When you're aiming for a silhouette it's important that your main subject has a strong graphic shape – such as the human body, a leafless tree, a derelict machine or a statue. Some silhouettes can be a bit bland, and adding a coloured background in the computer can be an effective way of adding interest.

↑ SILHOUETTE
Twilight is a wonderful time. Just after the sun has set and before it gets dark colours are often magical. This lone fisherman had waded out into Rutland Water, Lincolnshire, and was silhouetted against the last rays of the light.

The reason that sunsets are far more popular than sunrises as photographic subjects is because you don't have to drag yourself out of bed at an unreasonable hour to record them. But it really is true that the early bird catches the worm when it comes to taking pictures outdoors, and those willing and able to rise with the lark will be rewarded with absolutely magical light that can turn even the most mundane subject into a masterpiece. In fact, successful photographers aren't just up at dawn – they're up before it, waiting for the first rays that herald a new day to peep tentatively over the horizon, often burning atmospherically through early morning mist. However, it's not just at the extremes

of the day when the light can be photogenic – or frustratingly low in intensity. Fog cuts light levels dramatically, but changes the landscape completely, with only objects close to the camera seen clearly, and those further away receding into invisibility.

Frost, too, transforms the landscape in startling ways, and also gives you the chance to go in close and capture interesting details of foliage that would look dull without a dusting of white.

PERSONAL SAFETY AT NIGHT

Taking pictures at night is obviously more risky than doing so during daylight hours. Follow these simple rules to avoid problems:

➤ Whenever possible go out early in the evening, when the streets are still bustling and busy. Don't go out alone unless you have to – persuade a fellow photographer to come with you, or just take a friend. Two people make a less easy target for crime than someone on their own.

➤ If you're taking pictures from the edge of a road, make sure you wear something reflective so drivers can see where you are.

➤ Take the minimum of equipment with you – a camera body and just one or two lenses – so if the worst happens you don't lose everything. It's a good idea to take out all-risks insurance to cover all your photographic equipment.

➤ Take particular care when shooting night scenes overseas, especially in big cities and when you don't know the area.

↑ THE MAGIC HOUR
The best time to take night pictures like this view of the Moulin Rouge in Paris is about an hour before it gets dark, so the sky is reproduced blue rather than black.

Still life

collection of objects to produce a composition that's pleasing to the eye, and then lighting it to perfection. Easy-to-assemble subjects include collections of vegetables, silverware, a bunch of flowers, or even single items such as a bulb of garlic, a tankard or a sunflower head.

COMPOSITION

Good still lifes tend to be tightly composed, and benefit from being organized into regular shapes such as triangles, circles or straight lines, to create a sense of movement through the picture.

Many of the compositional rules of general photography hold good here too. Diagonals are dynamic, especially if they start at the bottom left of the picture and thread their way through. By placing elements at the side of the image you frame it to create a sense of depth. Use the 'rule of thirds' to help you create balanced compositions: visualize a grid dividing the image vertically and horizontally into three and position important

⬆ SINGLE SUBJECTS
What could be simpler? A collection of melons may not sound very interesting, but pretty much any fruit or vegetable can make an appealing subject for still-life work.

➔ COMPOSITION
Careful arrangement of the elements and the choice of the camera angle are crucial in creating satisfying still-life images.

Since painting began, still life has been a perennially popular subject, with superb examples taking pride of place in museums around the world. And it's also a great subject for photography, though for some reason many people seem to prefer scenic work and portraiture. There's great fascination and enjoyment to be had in arranging a

parts of the arrangement at the intersections of the grid. You can also use colour, either contrasting or harmonious, to evoke the mood you want.

The background is extremely important in still life, and needs to be sympathetic to the subject matter: you might choose a bread board for a collection of different loaves, or sacking for an arrangement of fruit or vegetables.

DEPTH OF FIELD

With many still lifes you'll want to keep everything in the frame sharp, so you'll set a small aperture of f/11 or f/16 to give you maximum depth of field. But occasionally you may want to isolate a particular object from an out-of-focus background, and in this case you should go for a larger aperture of f/4 or f/5.6.

Lighting should also, of course, be appropriate to the kind of subject you're photographing. Windowlight indoors is extremely versatile: this could be virtually shadowless coming through a patio door on an overcast day, or sharp and evocative streaming in through a small south-facing window on a sunny summer's day. A reflector or two will allow you to balance the light to your satisfaction. Of course, if you have studio lighting you can adjust it to give you exactly the result you're after. But avoid on-camera flash, because it will kill the mood stone dead.

FOUND STILL LIFE

If all that sounds too much like hard work, there's another way of tackling still life – and that's by 'finding' subjects that are already set up. Where? Everywhere. Still-life arrangements are all around you, just sitting there waiting to be photographed. All you have to do is become aware of them and point your camera in the right direction.

Look around you now. If you're at home you'll be spoilt for choice. How about a shot of some of the objects on your mantelpiece, a collection of ornaments, an interesting clock, writing implements on a desk or books on a shelf? If you're at work – in an office or a factory or wherever – take a fresh look at all the items around you that are organized in attractive and interesting ways. Step

outside, and a whole new world of opportunity opens up. Seek out flea markets, car boot sales, jumble sales and places selling bric-a-brac. Pop into an auction or visit a craft fair or museum, and instead of lots of miscellaneous items all mixed in together, you'll find things catalogued and organized and laid out for you.

Nature also provides plenty of found still lifes – such as a pile of shells or pebbles on the beach or a tangle of branches or fallen roots in a wood.

WHAT GEAR?

You don't need any sophisticated equipment. For many still-life compositions a standard zoom will be ideal; if the subject is further away a telezoom is excellent. The most useful tool is a tripod, allowing you to anchor the camera while you arrange things to your satisfaction, popping back every now and again to check through the viewfinder how it's going.

Generally you'll want to record everything in sharp detail, so you should load up with as slow a film as possible, nothing faster than ISO 100, and ideally slower. Another option would be to go for a grainy effect, exploiting the coarseness of fast films of ISO 1000 plus.

⬆ FOUND STILL LIFE
At an auction of old cameras and lenses there were plenty of 'found' still-life images to be taken.

⬇ USING NATURAL LIGHT
You don't need fancy light for a lot of still-life work, just windowlight – as here – and a tripod to ensure sharp results should light levels be low.

Studio lighting

↑ **PERFECT PORTRAITURE**
Windowlight from the right, supplemented by a large white reflector to the left, produces a directional but soft light that's perfect for portraiture.

→ **MOODS OF DAYLIGHT**
Nothing beats daylight when it comes to creating appealing interiors – though you do need to think about the best time of day to shoot.

What do you think of when you hear the word 'studio'? Does it conjure up in your mind's eye an image of a large, airy room full of expensive lighting equipment? And does the thought of setting up a studio yourself send a shiver down your wallet?

If so, you might be surprised to learn that many studios, even those used by leading professional photographers, are in reality small, gloomy and sparsely equipped. In fact, some studios are only temporary – created as and when required by pushing all the furniture in a room up against the wall. You don't need a great deal of space to photograph people or even groups; and with subjects such as still life and close-ups you can work on the dining table. Nor do you need to shell out for an expensive lighting set-up. With a bit of ingenuity and imagination you can produce excellent results with what you already have.

DAYLIGHT STUDIO

One option that might not come immediately to mind is to light your studio entirely by daylight. This sounds odd but it's perfectly feasible. All you need is a room with windows and you're on your way. Consider the advantages: the light you get is completely natural, you can see exactly what you're getting, it costs nothing to buy and nothing to run, and it can't blow a fuse.

Professionals who work with daylight often choose a room with north-facing windows. Because no sunlight ever shines in, the light remains pretty much constant throughout the day. It may be a little cool for colour work, however, giving your shots a bluish cast. If so, simply fit a pale orange colour-correction filter over the lens to warm things up – an 81A or 81B should do fine.

Rooms facing other directions will see changes of light colour, intensity and contrast through the day. When the sun shines in, you'll get plenty of warm-toned light that will cast distinct shadows. With no sun, light levels will be lower, shadows softer, and colour temperature more neutral. The

size of the windows will also determine how harsh or diffuse the light in the room will be. Having at least one big window, or perhaps a glass patio door, will make available a soft and even light.

The effective size of windows can easily be reduced by means of curtains or black card, for a sharper, more focused light. Conversely, light from small windows can be softened by covering them with sheer curtains or tracing paper. The ideal room would also feature a skylight, adding a soft, downward light. Whatever subject you're shooting, you'll need a number of reflectors to help you make the most of your daylight studio, allowing you to bounce the light around and fill in shadow areas to reduce contrast.

In short, daylight studios are great, but they do have obvious disadvantages: you can't use them when it's dark, and you can't turn the power up

when you need more light. Nor can you move windows around – although you can change the position of your subjects in relation to them.

TUNGSTEN TIPS

Sooner or later you really need something more controllable – and the good news is that you probably already have a range of portable lighting units in the shape of the reading, anglepoise and table lamps you have dotted around your home. All can be pressed into useful service, and if you can muster two or three lamps you have the makings of a versatile set-up. However, you'll encounter two complications with these light sources.

The first problem is light output. The exposure you get with a 60w lamp is just 1/8 sec at f/4 using ISO 100 film. This makes the use of a tripod virtually essential. An alternative is to use a faster film: ISO 1600 would give you a potentially hand-holdable exposure of around 1/125 sec at f/4, but the resulting golf-ball grain and pastel colours may not suit every subject.

The second problem is the colour of the light, which, like that from all tungsten sources, has a strong orange cast. The exact colour of the light depends upon the wattage of the bulb and its age, but a deep blue 80B filter will remove most of the orange, while adding a pale blue 82C as well will more or less neutralize the colour cast. Another option is to use specially designed 'tungsten-balanced' films. These are not widely stocked, but any good photographic retailer will be able to order them for you.

Of course, you might prefer to retain the orange colour. Although it's technically 'wrong', the warmth it adds to an image can sometimes be very effective – especially when combined with fast film and a hint of overexposure.

One way of avoiding the problem completely is to shoot on black-and-white film. With a monochrome emulsion loaded you don't have to worry about the light source at all. You could even shoot under fluorescent lighting, which would produce a horrible green cast with normal colour film.

One of the great advantages of tungsten, like daylight, is that what you see is what you get. Which is why, when you start thinking about buying

some proper studio lighting you might be tempted to go the tungsten route. Heads running 500w bulbs are available at extremely reasonable prices. But as well as the issues of filtration and light levels, tungsten lamps also give out an enormous amount of heat, making them uncomfortable when you're taking pictures of people at close quarters. In such conditions you'll need to take regular breaks so your subjects can cool down.

FLASH HEADS

For all these reasons, it's much better to set up your studio using flash. In the short term you can improve the use of your flashgun – by fitting diffusers and modifiers, taking it to one side of the

⬆ DIRECTIONAL LIGHT
One studio light fired into a large softbox from the right is all that was used for this beauty picture.

camera or firing it into an umbrella. Ultimately, though, if you're interested in studio photography, you should buy flash heads.

Even the cheapest studio flash units will give you an aperture of at least f/8 at your flash synchronization speed of around 1/125 sec. The light is perfectly balanced for the daylight film you're using. The built-in modelling lamps will allow you to gauge the effect each light has on the subject. And other features such as variable power output and a built-in slave unit make operation simple.

If your budget is limited, you can start quite happily with just one head (plus a stand, leads and so on). In fact, even if you do buy a complete home studio outfit with two or three heads, it's a good idea to work with just one for a while. That way you'll get to know what can be done with it, and how moving it around your subject can drastically alter the mood of your pictures.

USING AN UMBRELLA

The illumination you get from studio flash heads on their own is too strong and direct for many subjects, and one of the quickest, cheapest and easiest ways of improving it is by using an umbrella or 'brolly'. Firing the flash head inside the umbrella, so that it reflects back on to the subject, results in light that is much softer because the effective source is a lot bigger. For even more control, umbrellas are available in different sizes. An average model is around 1m (3ft) across, but you can also get smaller versions, which give a punchier light, and larger sizes, for greater diffusion.

The choice of reflective coating on the inside of the umbrella also affects the quality of light. Silver is the most popular, as it delivers light that is well defined while still being soft. Alternatively, you can

⟳ LIGHTING FOR PORTRAITS
(From top to bottom) One studio head above the camera with no diffusion results in hard shadows; taking the light and umbrella to the side makes the shot contrasty but can be effective for a character study; fitting a white umbrella produces more attractive lighting – though the face is rather flat and there's still a shadow behind; placing the light and umbrella at 45° produces the most pleasing result, with one side of the face a little darker than the other and no shadow on the background.

use plain white, which is not as reflective, or gold, which warms up the light. Translucent white umbrellas are also available. While the output is lower using these, because only part of the light is reflected, they allow you to point a flash head directly at the subject and fire through the brolly.

The great advantage of umbrellas is that they can be set up quickly on location, at home or in a studio. If you don't have a place where lighting can be left permanently, it takes just a few seconds to open a brolly, fix it to the head and put it on a stand – and you're ready to start taking pictures.

Where you position the light and brolly depends, as ever, upon what you are trying to achieve. There are three main variables: the distance between the brolly/head and the subject, its height and its angle.

As a rule of thumb, the further the light is from the subject, the softer the illumination will be. A typical distance for portraiture is 1m (3ft), but it may vary for subjects such as still life. Generally when photographing people the umbrella is placed just above the height of the head, though once again there are no rules and the best approach is to experiment to see what works.

Placing the combination directly in front of the subject gives a flat, even lighting, with few shadows, that is not very exciting. Moving it slightly to one side, at around 45°, is usually better because it introduces a little shadow, but without harshness. Moving it further to one side produces a much more contrasty light that doesn't suit every subject.

TWO LIGHTS TOGETHER

Once you've got the hang of using one light and a reflector, you can introduce a second light to give a more polished, professional result. Using the second light at a lower power, to fill in the shadows in place of a reflector, will give an attractive, flattering effect. As a starting point, set the second light to half or one quarter the power of the main light.

After that it's simply a matter of experimenting with other set-ups and finding out what works and what doesn't. The great thing about studio heads is that you can see immediately what's happening, thanks to the modelling lights.

ACCESSORIES

To improve the quality of light further, and enhance the versatility of the heads, you can add a variety of different accessories. Arguably the most useful is a softbox, which is a square or rectangular panel that fits over the head to give a much softer light. Softboxes range in size from around 0.5m (20in) across to 3m (10ft) or more. For general use a softbox 1m (3ft) across will work well.

Also useful are barn doors, which feature four adjustable flaps that can be moved in and out to restrict the spread of light, and a snoot, a small conical attachment that provides a spotlight effect.

FLASH METER

When you set up studio flash lighting you'll need to budget for a flash meter, no matter how many heads you're buying. Flash meters – like incident light meters – measure the light falling on the subject, rather than that reflected from it. Most now feature a digital readout that indicates the aperture required for any given lighting set-up, normally to within one tenth of a stop.

⬆ IN THE STUDIO
One you become skilled with lighting you can produce high-quality pictures of just about any subject.

BACKGROUND STORY

⏩ If you want to add the finishing touch to your studio shots, whether they're taken with daylight or flash, it's a good idea to invest in a custom-made background support system. This will allow you to use every kind of background, from paper rolls to canvas sheets and specially painted designs, to make your pictures look really professional. Most support systems are modular, and can be assembled and broken down in just a couple of minutes.

⏩ Paper background rolls come in widths of 2.75m (9ft) and 1.35m (4ft 6in) and in every colour of the rainbow. Everything from bright, vivid colours to subtle, pastel tones is available. Dipping your brush into this enormous palette will allow you to create pictures with a lot more impact. You can also change the colour and shade of a background by the way in which you light it. Or you can transform it completely by fitting gels over any lights on the background.

⏩ Beyond paper rolls there's the wonderful world of dyed and painted backgrounds to explore. A cheaper and more original option is to buy off-cuts of fabric, which can be sometimes be had for next to nothing, or create some designs yourself.

➡ CHANGING THE BACKGROUND
It's amazing how much difference the background has on the mood and feel of a picture. Here the lighting is exactly the same in each case – only the colour of the backdrop has been changed.

Shooting a photo essay

When you've been taking pictures for a while, you may find yourself running short of new ideas about what to photograph – and as a result running short of enthusiasm. You've photographed all the obvious things: anywhere remotely interesting within reasonable reach of home, every member of the family, all your colleagues, friends and even strangers; all the places you've been on holiday.

What you need is something to get your creative juices flowing again, and one option is to start thinking in terms of shooting a photo essay. Instead of creating individual images, this involves setting out to shoot a series of photographs that tells a story. It could be about a place, an event, a person, or anything that interests you. All that matters is that it's a collection of images built around a theme. Setting yourself an assignment in this way will test your photographic abilities to the full, as you'll need to use a variety of lenses, accessories and techniques if you're to make the most of the opportunities available.

Once you've completed the first essay you will almost certainly want to go on and do others. You may regard some as 'work in progress', continuing to add images over time. Eventually, you might have enough pictures to think about organizing an exhibition, or approaching a publisher with a suggestion for a book. Whatever subject or theme you go for, it will help sustain your interest in taking photographs when there aren't enough trips to the Caribbean on the horizon.

A SAMPLE ESSAY

Historial re-enactments offer plenty of scope for testing your photographic skills. There are hundreds of historical societies whose members enjoy

dressing up in costume and getting together to re-enact a particular battle or other historical event. These provide wonderful subject matter for a photo essay, with lots of interesting characters around.

Don't be afraid to ask people to pose. The sort of folk who dress up as Cavaliers or Viking warriors are rarely shy and retiring. Make sure, though, that you're all set up ready to take the pictures. Sort out exposure first, and shoot on program or whatever mode you're most familiar with. Concentrate attention on the person by using the lower to middle focal lengths (80–120mm) of a telezoom. Or, if there's a backdrop that helps to set your portrait in the context of the event, ask them if they'd mind posing in front of that.

When the battle starts, be alert and capture the action as it unfolds. Here you'll be standing further back, and will need the full range of your telephoto, allowing you to shift from broad scenes to individual details in just a couple of seconds.

Patterns and textures

⬆ ➡ GEOMETRIC SHAPES Regular shapes are all around us: sometimes strongly defined, such as the roof of this wooden building, and sometimes more subtle, as in the planting arrangement above. Such shapes give structure to images and help make them more satisfying.

If you're looking for a new challenge, you could set yourself a project shooting textures and patterns. This exercise will give you a whole new way of thinking about potential subjects. Instead of paying attention to what things are, you need to concentrate on how they look. Content and identity become totally unimportant because you're shooting an abstract picture whose appeal lies in its visual strength, composition and colour. Not only will you pep up your picture-taking with this approach, you'll also find yourself coming up with some fresh and striking images.

Choose a theme – which can be whatever you like – to help focus your attention. It could be a very general idea, such as textures in nature or in buildings, or it could be very specific, such as walls or tree bark.

To get yourself started, try to set a time-scale, and stick to it, or you'll keep putting it off. For

instance, you might decide to photograph 20 textures and patterns within the next two weeks. Don't be too ambitious: the simple fact is that most photographers have to fit their picture-taking around earning a crust, family commitments and other interests, and never have as much time as they'd like – so aim to keep your plan achievable.

SEEING PATTERNS

Patterns can be found anywhere and everywhere, though it's not quite as straightforward as that. At first you may find it hard to see patterns even though they're right in front of your eyes.

A pattern is nothing more than a repetition of some visual element – such as a shape, line or colour. But because we're so used to looking at things in terms of what they are, rather than in terms of their visual content, it can be hard to recognize the many patterns all around us. You can't break the habit of a lifetime in just five minutes, but with a little perseverance you'll find you suddenly start 'tuning in' to patterns, and then you won't even need to look for them actively.

The shapes that make up a satisfying pattern can be actual – such as squares, triangles, circles or a succession of lines – or can be implied by the position of key elements within the frame. Subjects that work very effectively in this way are rows of things, either side by side, such as cars in a car park, or stretching out into the distance, such as a succession of electricity pylons. Any subject with a strong vanishing point, such as a spiral staircase winding down into nothingness, also works well.

The most effective way to emphasize pattern is to create an abstract picture, by cropping out all unnecessary detail and creating a clear visual relationship between the key elements in the picture.

Lens choice is crucial, because to some extent with pattern pictures you make them as much as take them, according to the focal length you choose. A wide-angle lens will let you create a relationship between the foreground and background of a picture, while a telephoto will 'compress' perspective and make objects seem closer together than they really are. Rows of trees or a succession of mountain peaks can be stacked together in this way to create a very satisfying picture.

SHOOTING TEXTURE

The two key factors in shooting successful texture pictures are going in close and lighting the subject effectively. As a general rule, the closer you get to a subject the more its texture becomes visible.

At first sight, for instance, the average brick wall may look about as photogenic as a caravan site. But if you go in close it suddenly ceases to be a wall and becomes a criss-cross of lines. Go in closer still, with just a handful of bricks in the frame, and you'll see the rough surface texture start to emerge.

The best way to focus on texture is with a tele-zoom, which is great for isolating parts of the subject and usually gives a good degree of enlargement. Many telezooms also have a handy close-focusing facility, which may even let you close in on the surface of just one brick.

But why stop there? If you really want to bring textures to life try investing in an inexpensive close-up accessory, such as a screw-in close-up lens or, for the more serious enthusiast, a set of extension tubes or bellows. If you've never used one of these accessories before you'll be astonished at the wealth of micro-detail they bring to life. Quite ordinary objects are suddenly revealed as a mass of intricate surface texture – just look closely at the carpet under your feet, that cork noticeboard on the wall.

⬆ **ABSTRACT PATTERNS** Can you guess what these are? It's not obvious – which is part of the fun of spotting subjects that create patterns. In fact, they're tip-up seats on a boat on the Seine in Paris, photographed with a 300mm lens.

⬇ **PATTERNS OF LIGHT** Shooting through textured glass, available from any DIY store, is a simple way of making the mundane more interesting.

OBLIQUE LIGHTING

To see texture at its best you need each tiny feature of a surface to cast a shadow, and to produce shadows you need the light in the right place. The worst kind of illumination for textures is a frontal light, such as the sun at its zenith in the middle of a bright summer's day. There may be lots of light but the shadows are shallow – and you'll never achieve a decent texture shot in these conditions.

FLOWER POWER
Whether they're individual heads or arranged in groups, flowers provide excellent raw material for images concentrating on texture and pattern.

To bring textures to life you need light to rake down at an angle. As it glances across the surface it throws long and photogenic shadows. So when hunting for texture shots outdoors you should aim to be out early in the morning, soon after the sun has risen, or late in the day, just before it sets.

Indoors you can easily create oblique lighting situations. Place a table in front of a small window and you've got the perfect conditions for throwing texture into sharp relief. After dark, use an angle-poise lamp, bent low to a table-top. For a more focused beam, a slide projector can be pressed into service. Finally, if you have a flashgun that can be taken off the top of the camera and connected by a lead, try using it from an angle of around 30°.

FINDING TEXTURES

Given that everything has texture, there's really no shortage of material – although the most obviously fruitful areas will be things with a rough and very evident surface texture. Here's a shopping list of ideas to help you start thinking along the right kind of lines.

fences, lamp-posts – the list of subjects is endless. Machinery of any kind is rich in potential, whether it's an earthmover or the family car. Have a rummage in your tool shed, and you're bound to find some interesting items: how about a sheet of sandpaper as an interesting background?

• Wet, wet, wet

Water may not seem an obvious subject for texture photography, but in fact it's superb, with a surface that's ever-changing, depending upon the time of day, the weather and the light. Stop and think for a moment about water: splashing over a sea defence at the beach, lapping gently at the edges of a lake, shimmering in a swimming pool, or crashing down over a waterfall.

ROUGH TEXTURE
Raking light brings life to stone walls like this, and it's then a simple matter of keeping the camera square so that everything is rendered sharp.

CROP IN ON DETAIL
Details like these ropes are often far more interesting than the whole of the subject – and tight framing lets you focus attention on the shape and form of the subject

WATER DROPLETS
Wax your car well and when it rains you will be rewarded with clear water droplets like this. The picture was taken using a 50mm lens at its closest focusing distance.

• Natural beauty

Nature is full of textures. Put on your hiking boots, toss a rucksack over your shoulder, and head out into nature and you'll be rewarded with hundreds of superb texture shots. Too energetic? Then take a leisurely stroll down the garden and see what you find. The earth itself is a good place to start – focus on a ploughed field or the humble lawn. Or, looking up, there's the sky, full of changing clouds. Trees are rich in textural possibilities, from the bark of the trunk to the veins in the leaves, as are flowers of all descriptions. A trip to the zoo or a wildlife reserve will open up even more possibilities.

• Man-made world

The built environment offers opportunities every bit as diverse as the natural world. Wander around your house or take a trip down any street and you'll have a film finished before you know it. Buildings in particular are full of possibilities: the walls, made from bricks, stone or flint, the roofs from red clay tiles or smooth blue slate, and a multitude of different kinds of doors and windows. Road surfaces,

BRINGING IT ALL HOME

Sometimes the circumstances in which you find smaller items may not be ideal for photography – perhaps the location or the lighting is wrong. But you don't have to pass that gorgeous leaf by, or miss out on the fascinating bag of nuts and bolts you saw in the hardware store. What you can do is bring small subjects back into a controlled environment to take your pictures.

That doesn't need to be a 'studio' – a word that conjures up images of fancy lights and expensive backgrounds – because you don't need all that stuff. If you've got it then of course it's very helpful, but you can get along just as well with windowlight plus a home-made reflector and some improvised backgrounds. With the camera mounted on a sturdy tripod, you can spend many happy hours playing around with the bits and pieces you find on your travels.

Creative processes

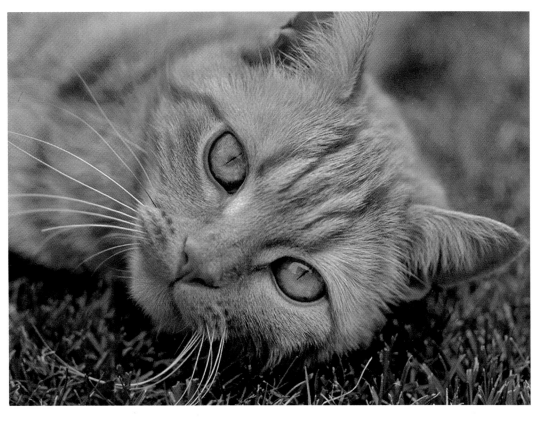

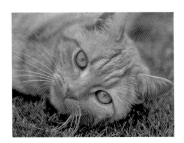

➔ HAND COLOURING
Hand colouring using dyes allows you to selectively colour just part of a black-and-white print.

➔➔ DOUBLE EXPOSURE
For double and multiple exposures to work well, you have to choose your subjects carefully. Noticing these backlit cobbles in the area around the church, the photographer decided to try and combine them in a single image, which he did with some success.

Once you've been seized with enthusiasm for using your camera creatively, there are many techniques you can try. Here are some suggestions to help you extend your photographic repertoire and spark new ideas.

COPYING A PRINT

Print copying used to be the backbone of many creative processes, such as copying and restoring old photographs, making slides of black-and-white or hand-coloured prints, and photographing 'joiners'. These days copies are more often made using a scanner. But sometimes the original is too large, so it's worth knowing how to do it well.

The first thing is to make sure that your lighting is even. One option is to photograph your print outdoors under overcast lighting, secured temporarily to a wall. If light levels are low, you may need to use a tripod. This works well when shooting black-and-white and usually colour negative, but with colour transparency film you may end up with a slight blue cast. While you can compensate for this by using a warm-up filter such as an 81A or 81B, the results are rather unpredictable.

To get even lighting without any hot spots, the best approach is to use two flashguns or studio lights set at 45° to the print, which can be either on a wall or on the floor. You need to make sure the print is completely flat, and that the camera is precisely square to the print.

HAND COLOURING

Photographs don't have to be black and white or colour – you can have a bit of both. Having produced a stunning monochrome image, you might want to enhance it by applying a little colour selectively. While these days it's often done in the computer, there's still a lot of pleasure to be had doing it the traditional way, by applying dyes to the surface of the print. Care should be taken with ordinary paints, because they may not absorb very well. The best choice are special colouring

materials available from photographic shops. If you dilute them carefully, and apply them steadily using a '00' brush, you can build up a strong depth of colour with the dye fully absorbed into the print.

MULTIPLE EXPOSURES

Many cameras now feature a multiple-exposure facility, and it can be fun combining two or more images in a single frame, though it's arguably much easier to do it in the computer if you're into digital imaging, because you have lot more control.

The challenge of in-camera work lies in positioning the elements where you want them, though simple compositions, such as a double exposure with someone sitting on both sides of a room, should present no serious problem. You just need to take care over your exposure. Try to avoid having parts of the image overlapping or they'll be overexposed.

If you're combining two images of different subjects, you may need to reduce the exposure for each by up to one stop. When shooting multiple exposures it's worth bracketing because the results can be rather unpredictable. You should also tell your processing lab that the multiple exposures are intentional, as they may think there's been a mistake, and not print the images.

The trick with multi-exposure work lies in getting two subjects that will work well together,. Generally what you're looking for is to have one dominant image and a second that adds atmosphere. For instance, you might take a cityscape at night and then put on a long telephoto lens and place a close-up of the moon in the sky. Another possibility would be to combine a shot of a computer circuit board with one of some kind of related hi-tech appliance such as a digital camera, mobile phone or PDA.

SLIDE DUPLICATING

Another option for combining images is to use a slide duplicator. These are designed to fit most types of 35mm SLRs by means of a simple T-mount. Although nowhere near as versatile as working digitally, slide duplicators allow you to bring together images you've already taken, so you're a lot more likely to produce successful pictures. Simply tape the slides together in a mount, put them in the duplicator, and copy them.

The quality of the results will depend to a large degree upon the quality of the originals. Contrast is the main problem you'll encounter, and you'll get the best results if the contrast of the originals isn't too high, and the film stock used for copying isn't too contrasty. This is one time you should avoid vivid emulsions such as Fuji's Velvia. Special slide duplicating films – which are low in contrast – are available. They're not widely stocked, but you should be able to track them down.

Once you get a little more experienced in terms of what works and what doesn't, you can start shooting subjects specifically for sandwiching. Pictures of the sea, clouds, textures, the sun and the moon will always come in handy.

Slide duplicators can also be used to make copies of slides or to copy a slide on to colour print or black-and-white film. As well as 1:1 duplicators you can buy 2.5x zoom models that allow you to blow up part of the image. This way you can improve the composition as you copy, though you should expect some loss of quality.

Overall, producing a copy transparency that looks anywhere near as good as the original requires a lot of time, effort and patience. Flash is the ideal lighting source because it's of consistent output and colour, though diffused daylight can also be employed.

◉ SLIDE DUPLICATING
The original transparency in this series, shot on a grainy ISO 1000 film stock, showed promise, but was flat in tone and had a magenta cast. It was copied using a zoom slide duplicator, but the image still left something to be desired. Copying it a second time with an orange filter in front of the diffusion screen, and at a higher zoom setting, has produced a more graphic photograph with pronounced grain.

CROSS PROCESSING

There are two main colour film processes. Colour negative films go through C41 chemistry and colour slide films take a bath in E6 chemistry. In each case the time and temperature parameters are reasonably fixed. But one creative option is to break all the rules and put films through the wrong process – E6 for a colour negative film and C41 for a colour transparency film. For obvious reasons this is called cross processing, and the results can be extremely dramatic, if rather difficult to predict. Contrast increases and colours change, producing an often hyper-realistic image that's really unusual. No wonder advertising and editorial photographers like to use it.

Initially it's a good idea to shoot a test film at various ISO ratings above and below that suggested by the manufacturer, to find out which gives the best results, and then use that in the future – although you will still find bracketing worthwhile.

You will also need either to process the film yourself or find a friendly lab willing to do it. The large chains will probably be reluctant to try but a small, local lab may be willing to help you.

LIGHTING WITH A SLIDE PROJECTOR

Got a slide projector? Have you ever thought of using it for more than giving slide shows? In fact, you can press it into service as an out-of-the-ordinary and original light source. Instead of plain light you get whatever image you put into the holder – which can produce some startling and artistic images depending upon what you project it. If you have a slide of a face or a figure, for instance, you could project it on to something curved, such as a vase, or use plain paper, twisted out of shape. Re-photograph the result and you'll end up with something unique.

TAKING PICTURES OFF THE TELEVISION

Taking pictures of a television screen is easy: all you need is a darkened room and a tripod. The darkened room is essential to avoid reflections from the screen, so shoot at night with the lights switched off and wear black clothes The tripod is required as the shutter speed you'll be using is 1/15 sec. This is because the image on the screen is built at the rate of 25 frames per second. If you set a faster speed you'll get an incomplete picture, with a black band across the screen; anything slower will give you two images superimposed, as one shot fades to another.

For the best results, position the camera square to the television and use the top end of a telezoom (200mm or 300mm), shooting from across the room. If you follow the indicated exposure you shouldn't go too far wrong, especially if you're using colour print film. With slide film you might want to bracket up to one and a half stops above and below, in half stops, to be safe. You might also find it useful to reduce the contrast of the television picture slightly.

⬆ CROSS PROCESSING
The startling colours and vivid contrasts of this image were created by cross processing the transparency in C41 chemistry designed for colour negative film, and then making a print with the negative.

Setting up and using a darkroom

If you like the idea of having complete control over your photography then doing your own processing and printing may be for you. While darkroom work is no longer as popular as it once was, it's still worth considering so that you can have the satisfaction of being able to hand round a print and say 'This is all my own work'.

Many photographers fancy the idea of processing their films and making prints at home, but don't pursue the thought any further because they don't think they've got anywhere to put a darkroom. And that problem arises because of a fundamental misunderstanding of the term 'darkroom'. In many minds it conjures up images of a specially designed room, perfectly blacked out, with worktops immaculately laid out with 'dry' and 'wet' areas.

Most of the time it's not like that. Even for professionals there can be a lot of 'making do' in setting up a darkroom. Many photographers have produced masterpieces in makeshift darkrooms. And no matter how humble your abode, there's bound to be a corner of it that can be converted, even if it's only on a temporary basis.

If all you want to do is process film, you don't actually need a darkroom at all. The only part of film processing that requires absolute darkness is when you take the film out of its cassette, and that can be done in a changing bag, or even, at a pinch, under the covers of a bed.

But assuming you want to go further and make your own prints, then you're going to need somewhere to do it. The space needs to be big enough to stand up in, and offer sufficient space to house an enlarger and either a set of trays or some kind of processor. It needs electricity, of course, to power the enlarger, safelight, and electronic timer if you have one. Water is essential – although running water is not. Processed prints can always be stored in a bucket or bowl, and then transferred later to be thoroughly washed with water from the tap.

Having considered the general requirements, let's take a look at some possible locations around the average home:

Under-stair cupboard: check that you won't be forced to stoop for long periods.

Bathroom: running water makes it convenient, but getting electricity into the bathroom safely may pose a problem, and you may inconvenience others who need to use it. To make a working space to hold the equipment you could build a plywood platform to fit over the bath.

Basement or loft: if you have a basement, ensure that the darkroom is protected against damp, especially if materials are to be left in it. A loft tends to offer the reverse problem, being too hot in summer and too cold in winter. If you convert it properly, it can be excellent.

Garage: being able to control the temperature is crucial to the viability of using a garage.

Spare bedroom: ideally you'll want to convert it permanently, and get it fully kitted out so you can go in and use it whenever you want. You're more likely to have to use it on a temporary basis, setting up your kit and blacking out for every session.

If you don't have any available space at home, you may be able to hire the use of a darkroom in a local college, photographic club or arts centre for a reasonable fee.

BLACKING OUT

Your darkroom must be completely light-tight. That means blacking out effectively, but with a little bit of do-it-yourself, you can probably get by. Where blacking out is likely to be needed is at the doors and windows. Try using thick card together with black insulation tape for a quick but effective fix.

If you're going to use the room reasonably often, it's worth spending a bit of cash to save yourself a lot of time. There's nothing like knowing it'll take you ages to get blacked out to dampen your desire to dash off a couple of quick prints. For effective blocking of light you can buy special blackout material, sold by many photo retailers by the metre. Another option is to make some plywood covers, paint them black, and then lock them securely in place. Arguably the best solution, if funds allow, is to have a set of blinds custom made – and it's worth tracking down a company that offers this service.

Developing film

There's not a great deal of difference between the basic procedures required to produce quality black-and-white negatives, colour negatives or colour slides, although the temperatures needed, the chemicals used and the time taken all vary.

Only a small part of the process – when the film is taken out of its cassette, loaded on to a spiral and then put into a light-tight tank – has to take place in darkness. The rest of the operation can be carried out in daylight. Once you know what you're doing, processing a film takes less than an hour, and if you buy a multi-tank, which takes several spirals at once, you can process up to eight 35mm films at a time.

Film processing is easy and straightforward – once you've mastered the art of taking the film out of the cassette and loading it on to the spiral. Before you try it in darkness with an important film, you'll need to practise several times in the light using an old film. Once you've got the hang of that, you should learn to do it with your eyes closed, then you're ready to do it for real.

After that, it's just a matter of following the processing times and dilution rates provided by the chemical manufacturer. Be meticulous, because a small difference can have a big effect on the results. Allow for the time required to pour solutions in and out. Pay strict attention to the temperature as well, and if it varies from the recommended temperature by even one degree adjust the processing time accordingly. The thing to remember is that consistency really counts.

Don't skimp on the washing in your eagerness to get your negatives into the enlarger. If you don't wash off all the fixer, in a few years – or even months – your precious negative will self-destruct.

Finally, soak the film in a wetting agent and hang it up to dry somewhere that's dust-free.

◖ GRAINY IMAGE
Processing and printing your own pictures gives you full control over the finished results. Here, push-processing was used to produce an image with prominent grain.

BLACK-AND-WHITE FILM

The starting point for many darkroom workers, black-and-white films are easier to handle than colour emulsions because processing is carried out at around room temperature and there's slightly greater tolerance in respect of timing and temperature. You also need a little less equipment. Three chemicals are used in black-and-white processing: developer, stop-bath and fixer. As a starting point use the chemicals and times recommended by the film manufacturer, and then as you gain experience you can start experimenting.

• What you need to develop a black-and-white film

Here's a list of items you'll need to do your own black-and-white developing, graded according to whether they're essential or merely useful.

ESSENTIAL	USEFUL
Developing tank	Accordion bottles
Spool	Stirring rods
Graduates	Film squeegee
Thermometer	Timer
Film clips	Drying cabinet
Storage bottles	Water filter
Funnel	
Force film washer	
Developer	
Stop bath	
Fixer	
Wetting agent	

COLOUR NEGATIVE FILM

Producing colour negatives that are consistent is imperative if you want to make life easy for yourself at the printing stage. Getting the colour balance right is a challenge at the best of times, but if your negatives vary from film to film, it can be a complete nightmare. For that reason it's a good idea to standardize on a particular film type and just one set of chemicals. Because the processing temperature is higher with colour negative processing than with black-and-white, a thermostatically controlled process is recommended, especially when ambient temperatures are low.

• What you need to develop a colour negative film

ESSENTIAL	USEFUL
Accurate thermometer	Drying cabinet
Bowl or bucket of	Process timer
water for waterbath	Thermostatically
Darkroom clock	controlled processor
Developing tank	
Film squeegee	
Force film washer	
Kit of chemicals	
Rubber gloves	
Set of measuring	
cylinders	
Wetting agent	

COLOUR SLIDE FILM

The higher processing temperature – 38°C (100°F) – required for colour slide films means that a thermostatically controlled processor is virtually essential. Without one you need to mess around with waterbaths to ensure the temperature of the processing solutions doesn't drop.

The chemicals are sold in kits, and it's a relatively easy three-bath process. While processing your colour slides won't save you much in the way of cash, you can have the pictures in your hands within an hour of having taken them.

• What you need to process a colour slide film

ESSENTIAL	USEFUL
Developing tank	Drying cabinet
Accurate thermometer	Waterbath
Set of measuring	Process timer
cylinders	Thermostatically
Wetting agent	controlled processor
Darkroom clock	
Rubber gloves	
Film squeegee	
Force film washer	
Kit of chemicals	

Making prints

Once you get used to working under the dim and slightly eerie glow of a safelight, you'll find knocking out prints a doddle.

The key points are to start with a clean negative, to do a test strip to ascertain optimum exposure, and to develop and fix for the recommended times. You should always think creatively when you come to make an enlargement, asking yourself whether you can improve the picture by cropping it differently. Beyond that, you can make a print to fulfil your own vision: by varying exposure and type of paper you can print light or dark, contrasty or soft in tone. By 'dodging' and 'burning' some areas you can lighten and darken specific parts of the print.

MAKING A BLACK-AND-WHITE PRINT

The equipment required for printing is relatively modest. Simple, open dishes allow you to see the image emerge on the paper under the safelighting, and processing is carried out at 20°C (68°F).

The main area of expense is the enlarger. If you can afford it, buy a model with a colour head. This may sound strange if you plan to do only mono work, but having a colour light source means you can work with variable-contrast 'multigrade' printing papers. This makes it easy to boost or soften the contrast in your images. It also means you don't have to buy lots of boxes of papers of different grades.

Try to remember to replace the lid on your paper before you switch the room light back on or you'll fog all the sheets and ruin them. It's a mistake that everyone makes once, but rarely twice.

Here's the whole process described step-by-step: the first two stages can be carried out in daylight or under safelight conditions.

1 Preparing the enlarger

Place your negative in the negative carrier of the enlarger, making sure it's clean and dust-free. Switch on the enlarger and adjust the height of the column until the image on the baseboard is the size that you want, with the image roughly focused.

2 Framing and focusing

Set up your enlarging easel so that the picture is framed and cropped exactly as you want it. Then focus precisely, preferably with the aid of a special magnifying 'focus-finder' that allows you to focus on the individual grains in the image.

SWITCH OFF ANY ROOM LIGHTS THAT MAY BE ON: FROM NOW ON, WORK ONLY UNDER SAFELIGHT CONDITIONS

3 Putting paper in place

Remove a single sheet of paper from its pack, remembering to reseal the pack fully. Place the paper in the easel, if you have one, or on the baseboard if not. Swing across the red filter under the enlarger head, select an aperture of f/8 or f/11, and switch on the enlarger.

4 Making a test exposure

To make a test strip to determine the correct exposure time, swing the red filter aside, but use a sheet of black card to block the light. Then move the black card at 3-second intervals to expose more of the paper, producing eight strips with exposures from 3–24 seconds.

↑ TONED SERIES
Having produced a black-and-white print, you can quickly and easily tone it using one of the wide range of toners commercially available.

5 Developing the test print

Put the exposed print in the first of your three trays of chemicals – the developer. Agitate continuously for the first 20 seconds by tipping the tray up and down, and thereafter occasionally to ensure that it's always covered by developer. Keep agitating.

6 Fixing the test print

Remove the print with print tongs and place it in the second tray – the stop-bath. After 20 seconds, move it with print tongs to the third tray – the fixer. Follow the manufacturer's recommendation for fixing time, and then transfer, using print tongs, to a tray of wash water.

7 Inpecting the print

Switch the room light on and inspect the print. Which of the various exposures used gives the best density? Repeat the whole process as above using that as the exposure time for the whole print.

8 Washing

For prints to last, the fixer has to be completely removed by effective washing. This means changing the wash water frequently, or, ideally, using a custom-made print washing unit for at least 30 minutes – more if archival permanence is required.

9 Drying

Use your fingers as a squeegee to remove excess water. Resin-coated paper can then be stood on edge on a sheet of kitchen roll to drain. Fibre-based papers can be dried on their back on photographic blotting paper. Both types are best dried in hot-air or hot-bed dryers.

MAKING A CONTACT SHEET

Even experienced photographers find it hard to 'read' negatives – to see by looking at them exactly what the finished print will look like. Facial expressions can be particularly difficult, and it's often hard to see whether someone is smiling or frowning when you examine the negative. For that reason, many photographers like to make a 'contact sheet' of every film before they start to make enlargements from it.

So-called because they're produced by putting negatives in direct contact with the paper they're printed on, contact sheets show actual-size positive images of all the shots on a film. Usually 10 x 8in paper is used, as it will accommodate a 36-exposure 35mm film in six rows of six negatives per row. Developed and fixed in the normal way, these sheets allow you to assess the viability of each shot and help stop you wasting paper. Filed alongside the negatives, a contact sheet provides a useful quick reference when you're looking for a shot in the future.

ALL STAGES MUST BE CARRIED OUT UNDER SAFELIGHT CONDITIONS

1 Using a contact printer

If you have a contact printing frame, slip your negatives into it – the right way round, in order, when viewed from the top. Place a sheet of 10 x 8in paper behind the negatives, glossy side facing them. Close the lid and clip it firmly in place.

2 No contact printer

If you don't have a contact printer, place a sheet of

● CONTACT SHEET
The quickest way of identifying which negatives to enlarge is to produce a contact sheet by printing them actual size on to a sheet of 10 x 8in paper. This can then be punched and stored in a binder along with the negatives for easy reference.

10 x 8in paper on the enlarger baseboard with the negative strips on top of it – the right way round, in order – and a plain, clean sheet of glass on top. Some negative filing sheets are transparent enough for you to print directly through them.

3 Setting up the enlarger

Switch on the enlarger, having first put in position the red swing filter that shields the paper from exposure. Set the enlarger column to a height at which the light covers an area slightly larger than that of the paper. Select an aperture of f/8 or f/11.

4 Making and evaluating a test exposure

Follow the instructions for making a print, above, beginning with the text exposure. If you have a set of negatives of varying density (which is often the case) some will inevitably be too light or too dark on the contact sheet, and choosing the right printing exposure will be something of a juggling act.

PRINTING FROM SLIDES

If you are new to colour work, printing from colour slides is the easiest option for several reasons. First, any colour cast you get on your prints can be eliminated by removing the same colour from the filters set in the colour head of the enlarger. Second, the fact that the original is on hand to compare with the print makes life easier. And once a filter pack has been set for a particular type of film, little correction is normally needed when printing different slides.

ESSENTIAL	USEFUL
Accurate thermometer	Colour safelight
Blower brush	Dodging tools
Chemical kit	Print dryer
Darkroom clock	Process timer
Enlarger	Thermostatically
Enlarger easel	controlled processor
Focus finder	
Measuring cylinders	
Processor – simple drum, deep tank or dishes	

COLOUR NEGATIVE PRINTING

Making your own prints from colour negatives requires more equipment than printing from slides or black-and-white negatives. It's also technically more demanding and more time-consuming, but great quality prints are possible if you work patiently, carefully and deliberately.

ESSENTIAL	USEFUL
Enlarger easel	Focus finder
Blower brush	Enlarger timer
Darkroom clock	Colour safelight
Enlarger	Print dryer
Measuring cylinders	
Processor kit	
Thermostatically controlled processor	

Determining the correct enlarger exposure is accomplished in the same way as when printing black-and-white, but with the added problem of getting the colour balance right. However, once you get used to dealing with colours in a way that's the reverse of the usual principles – a colour cast is removed by dialling more of that colour into the enlarger – things become much easier.

Digitizing 35mm originals

Many 35mm photographers have invested a lot of money in a comprehensive system of lenses and accessories, and although they're drawn to digital photography they're not about to trade it all in and start again.

Buying a digital SLR body is one option, and as quality continues to increase and prices to fall, it becomes ever more viable. But in fact it's possible to keep your existing gear and get into electronic imaging at minimal cost. The answer is to buy a scanner and digitize the images you produce with your current 35mm camera. Instead of capturing images digitally, you take your pictures and have them processed normally using film, then scan them to produce digital images.

For many photographers this route offers the best of all worlds. You still have your negatives and prints, but you also have high-quality digital images, opening up whole new worlds of imaging opportunities. Once an image is in digital form it can be enhanced, copied and manipulated to your heart's content. Your computer can literally become a digital darkroom – without the horrible smell and the need to black out the windows that used to be the norm in the days of chemical processing. Having let your creative juices flow, you then have the option of emailing your masterpieces around the world at a moment's notice, printing them out as hard copies, or incorporating them into reports, newsletters or other publications.

COMPUTERS

It goes without saying that to get into digital imaging you need a computer, and it's essential that you choose the right one, as it will be the beating heart of your digital darkroom. This need not mean spending a fortune. In fact, the majority of computers bought 'off the shelf' over the last few years are more than capable of getting you started in digital imaging, and it's quite likely that the one you already own will be just fine.

If, however, you want to do more advanced manipulation, or work on high-resolution images,

⊙ INCREASING CONTRAST
As a result of hazy weather conditions, this image of Prague was flat and soft. Simply increasing the contrast gives it a lot more 'bite'.

you need to specify your requirements carefully. If necessary, it may be possible to upgrade your existing machine.

If you're looking to start from scratch, the first thing to consider is whether you want a Mac or a PC. Apple Macs have a number of advantages: most people find them easier to use, they're more complete, in that you don't have to buy sound or video cards for them later on, and they're standard issue in creative and publishing communities. On the downside, Macs represent less than 10 per cent of the computer market, they tend to cost more, there's not such a wide range of models on the market and the software available is slightly more limited. For most home users, who want the computer for general use and whose kids want to be able to play games on it, a PC is the right choice. But for those who are serious about digital imaging, the Mac is arguably the better option.

There are many things to consider when buying a computer, but three factors are key: the microprocessor speed, the amount of RAM (Random Access Memory) and the size of the hard disk.

The microprocessor is like the engine of a car: the faster it runs the quicker you'll get there. There's no benefit, though, in buying absolutely the fastest microprocessor available: most are now more than fast enough for amateur use. Your money is better spent on increasing the amount of RAM you have. RAM is effectively the power that runs the computer's operating system. If you starve an image manipulation program – such as Photoshop – of RAM it will limp along and make your imaging sessions far from pleasurable, so 128Mb is pretty much the minimum amount of RAM that's workable.

The size of your hard disk is crucial because digital images can take up a lot of computer memory – especially if they're of high resolution. Choose the largest you can afford, but be aware that whatever size hard disk you specify you'll fill it up sooner than you expect, and may need to buy additional storage at some point.

The size of your computer monitor is important too, as it's literally your window on a digital world. The minimum that's viable is 17in – and a 20in screen is even better if your funds run to one. Make sure also that your monitor displays at least

1024 x 768 pixels in 24-bit depth for maximum colour fidelity. Flat screens offer no real advantage when it comes to digital imaging, but take up less space on a desk and look more stylish.

CD/DVD WRITERS

All but the cheapest modern computers feature a CD writer, and some also record to DVD. Such a facility is valuable because if you digitize a lot of your pictures, and then start to manipulate them, your hard drive will soon be full.

A CD holds 650Mb of data, and a DVD 4.7Gb, allowing you to archive images on a regular basis. CDs can also be used to submit images to potential picture buyers if you are interested in selling your work.

SCANNERS

Your doorway to digital imaging is a scanner, which takes the analogue information in a negative, slide or print and turns it into digital form, which can then be enhanced, printed, emailed and so on. There are two different types of scanner: flatbed scanners and film scanners.

Flatbed scanners are similar to photocopiers, and are designed to digitize flat artwork such as prints and drawings. For amateur use a model that scans originals up to A4 at a resolution of 600dpi (dots per inch) or greater will be sufficient – and these are now extremely affordable. Higher resolution flatbeds, typically 1,200dpi and 2,400dpi, are available at a higher price. They produce significantly larger file sizes, and are really only of benefit if you want to enlarge the original you're scanning from. A3 models are available but it's only worth paying the extra if you plan to use it professionally.

What if you shoot slides, or prefer to work directly from your negatives? You can get what's known as a transparency hood for most flatbed scanners. This shines a light through the image rather than reflecting back from it. However, the quality isn't really good enough for serious digital imaging, and the ideal solution is to invest in a dedicated 'film' scanner. Happily, these too have come down in price in recent years, and there's plenty of choice, though prices are higher

72dpi

200dpi

300dpi

RESOLUTIONS
Scan at the resolution you need: 72dpi for the Internet; 200dpi for output on an ink-jet printer; and 300 dpi for reproduction in a book.

image. Values between 3.0 and 3.6D (with higher values better) are typical of professional-grade scanners. Note, however, that there is no absolute standard for measuring dynamic range, so it's unwise automatically to assume that a scanner offering a dynamic range of 3.6D offers a better range than one offering, say, 3.4D – unless you are shown results to justify it.

Bit depth is another important factor and one that is subject to misinterpretation. Though you will eventually output your work in 24-bit colour, capturing images on the scanner at 36-bit or even 42-bit will theoretically provide more detail and record more colour variations. But actual performance will depend on the quality of the software conversion process and scanner driver and, as before, it is worth comparing real scans before making the assumption that a 42-bit scanner offers better quality than a 24-bit.

A good scan also depends on good scanning software. Great efforts have been made in recent years to make the scanning process more user-friendly, and with many models you can initially leave it to the software to handle everything for you, gradually taking more control as your knowledge and confidence grows.

You'll also need some software to enhance and manipulate your images once they're in the computer, and the good news is that most companies 'bundle' suitable programs with their scanners to get you started.

SAVING SCANS

Once you have made your scan, whether on a film or flatbed scanner, you need to save it to your computer's hard disk. There are a number of formats you can use. The best is TIFF/TIF, which involves no loss of qualiaty but produces a large file. You could instead save images as JPEG/JPG files. This has the advantage of reducing the file size considerably, allowing more images to be stored on a disk. But some image data is lost using this format, and the quality is reduced as a result. The best option is to work in TIFF format, and then make JPEG copies when there is a specific need for a smaller file size – such as when you want to email a file or upload an image to a website.

than for flatbed models. Because you're starting with a very small original, just 24 x 36mm, the optical resolution needs to be high. Some models operate at 2,700dpi, but if you can afford it go for a film scanner that delivers 4,000dpi. This represents a practical limit for both 35mm and larger scanners; a resolution any higher merely resolves the film grain.

UNDERSTANDING SCANNERS

The scanner's dynamic range, expressed in density levels (and denoted by 'D'), represents its ability to record variance in shades in the darker parts of an

PRINTERS

Unless you plan just to view your images on screen, you'll want some way of making prints. One option is to email your pictures to a digital lab, accompanied by your credit card details, and receive a package of prints through the post. Another is to write the images to CD and take them into a local processor, where you may be able to make the prints on the spot.

However, for many amateur photographers part of the appeal of going digital is being able to print their own images at home. Choosing the right kind of printer is crucial, and here technology has come on in leaps and bounds in recent years. Affordable A4 desktop colour printers are now capable of producing images that are virtually indistinguishable from a photograph. Spending a little more will take you up to A3 format – which is great if you want to produce exhibition-sized enlargements.

PRINT QUALITY

Printers lay down dots of ink on paper to make a digital photograph. The more dots the printer lays down per inch the higher the possible image quality, colour accuracy and resolution. A high-quality photo printer is capable of dropping over 1,400 dots per inch (dpi), but this doesn't always mean it offers the highest resolution. Many of the latest photo-realistic printers use six inks to ensure maximum colour and it may take a combined cluster of dots of all six inks to give the appearance of a single colour. Therefore, even though the printer's specification may quote 1,440dpi, it may in fact print at a true resolution of only one-sixth of that figure – or 240dpi.

The manufacturer's specification will indicate the speed at which the printer can output pages, but be careful: this will often refer to a document that has only a small amount of colour ink coverage, rather than a photographic print with high colour coverage. In all cases you will have to sacrifice speed for image quality.

Most ink-jet printers have a separate black cartridge to ensure maximum depth when printing. Most also have all three colours – cyan, magenta

and yellow – contained in one cartridge. This can be wasteful if you print a run of pictures with, say, a lot of yellow, as the other two colours will be useless when the yellow runs out. Some models, such as those from Canon and Epson, use individual colour cartridges so that each colour ink can be replaced as it runs out.

The pictures produced by ink-jet printers will generally last a number of years if stored in optimum conditions of low light, but they will fade fairly rapidly if they are subjected to bright light. Some companies are making big claims about the longevity of their latest materials, but these are often dependent on ideal lab conditions. If you're producing work to sell, make sure your customers are aware that the prints may fade. Alternatively, invest in one of the latest printers that promise prints with a much longer life – usually in conjunction with specific media.

◀ CROPPING FOR IMPACT
Digital manipulation makes it easy to strengthen a picture by cropping out extraneous detail – as here, where removing some of the background makes the girls the centre of attention.

▲ PAINTING THE IMAGE
Although the mottled background of this portrait was out of focus, it was still distracting. So the 'paintbrush' function of an image-editing program was carefully used to turn it black.

Image enhancement

↑ **CLONING**
This attractive daylight portrait was spoilt by the edge of a picture frame behind the head. Using the clone/rubber stamp tool, it was possible to remove it by copying a section of the background wall.

Many of the images you get from your scanner will be excellent, and you'll be able to use them straight away. Some, though, will require some attention, usually to improve the exposure, contrast or colour balance. Even scans that are good usually benefit from some tweaking to maximize the potential of the shot, perhaps by adding sharpness or selectively lightening or darkening specific parts of the picture. The software supplied with the scanner will certainly handle all these areas and more, but after a while you may become more ambitious, and there are then plenty of options for you to consider, from the popular MGI PhotoSuite and JASC Paintshop Pro to the professional standard Adobe Photoshop, which will allow you to create any image you can imagine.

UNIVERSAL TOOLS

While every image enhancement/manipulation program has a unique mix of features and its own way of doing things, there are some tools and controls that are common to all software packages.

• Selection tool

While sometimes you'll want to work on the whole image, you'll often want to select just part of it. All programs offer a range of methods for making a selection, often using a 'marquee' tool that allows you to create a box around the area you want.

• Colour, brightness and contrast

Controls for adjusting these vital elements (see below) usually offer a range of options, some fully automated, others more complex.

• Copy and paste

This simple system, which will be familiar to anyone who has used a word program, allows you to copy the whole or part of an image to a clipboard. You can then paste it elsewhere in the image or into a new or separate image.

• Layers

Not found on some older programs, the layers facility allows you to 'stack' different parts of an

↗ **LEVELS**
Using the levels control it was possible to brighten this underexposed arable landscape.

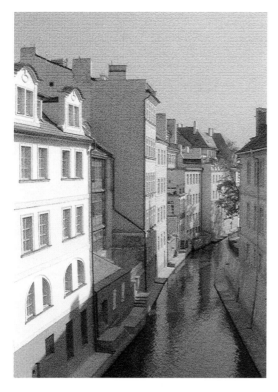

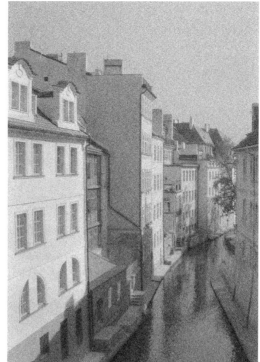

⬆ **ARTISTIC FILTERS**
Most image-editing programs include a range of artistic filters. Here, an attractive original (above) has been given (clockwise from top left) craquelure, grainy and watercolour treatments.

image like pieces of transparent film, blending the way they merge together. When working on a photograph it's a good idea to create a 'correction' layer that leaves the original image unchanged.

• Cutting and masking
Sometimes you want to remove parts of an image, and there are tools for masking and erasing elements according to need.

• Drawing and painting
Tools such as brushes, pencils, spraycans and buckets are standard issue on photo imaging programs. The size, and often the shape, of the tools can be adjusted.

• Cloning
A 'rubber stamp' tool allows you to get rid of blemishes and unwanted areas by cloning the pixels from an adjacent area for a perfect match.

• Filters
Filters offer a quick and easy recipe for completely transforming an image. Many are unique to a particular program, though some – such as turning a picture into a watercolour painting or adding grain – are pretty much universal.

• Zoom control
Because it's often hard to see precise details when an image is displayed on the screen, image editing programs allow you to zoom in to see things clearly. On many you can see the actual pixels that make up the image.

BASIC ADJUSTMENTS

There are a number of basic tweaks that many photographers carry out as a matter of course. These include correcting the colour balance if necessary, adjusting exposure and contrast, cropping the image, and adding some sharpening.

• Correcting colours

Colour balance is not always what it should be, either because of the original conditions or on account of slight shifts during the scanning process. You can fine-tune the hue and saturation until it's exactly how you want it. You can even enhance what's there. If a sunset isn't glowing enough it takes just seconds to increase the yellow/orange coloration. It's also possible to change any colour totally. If someone is wearing a blue shirt and it would look better red, you can make the switch in a few minutes.

• Correcting exposure and contrast

The first thing is to adjust the brightness of the picture, as scans are often a little dark or light. A number of controls allow you to vary both brightness and contrast, so not only can you improve good images, but you can also salvage photos that were under- or overexposed at the taking stage, which in the past would have been fit only for the bin. Many programs have an auto setting that adjusts exposure and contrast for you. It may not, though, give the results you're after, so be prepared to learn how controls such as levels and curves work if you want to get the best from your images. You can also selectively lighten and darken areas of the picture using controls called dodging and burning – names derived from darkroom printing techniques.

• Sharpening

Scans also benefit from a small amount of 'sharpening' – a digital process that gives images more visual 'bite' – because the scanning process introduces softness and diffusion. Some digital novices like to apply lots of sharpening because the results can be really vivid. But a little goes a long way, and unless there's a problem with the sharpness of the image itself, a small degree of 'unsharp mask' is generally all that is required.

⬆ SHARPENING
Most scanned images will be a little soft (top) and require sharpening. The best approach is to start by adding 'unsharp mask', which will often be sufficient (middle). If the image still is not crisp enough, try using the 'sharpen' control (above).

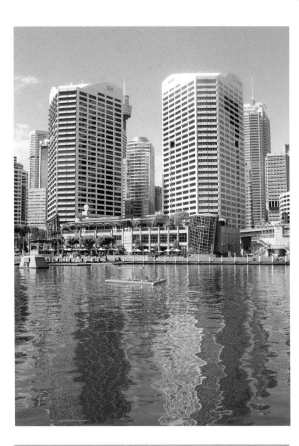

⬆ WARMING UP COLOUR
Taken in the middle of the day, this picture of buildings in Sydney, Australia, had a cold blue cast (top) which was easily corrected digitally (above).

↑ **CREATIVE CROPPING**
Image-editing allows you to consider whether the composition of images can be improved. Here, the long, thin panoramic and upright versions are more interesting than the original (above).

• Cropping images

Many shots have the potential to be improved by cropping. You may, as you look at the image on the screen, observe distracting elements that perhaps you didn't notice as you took the picture. Or it could be that you didn't have a long enough lens to fill the frame with the subject – lots of pictures can be strengthened by going in closer. Dispensing with unwanted parts of the image takes just a matter of seconds. And if you want, you can change the format – from upright to landscape or vice versa. You might even consider losing the 3:2 format of the 35mm frame and go for a square composition or a long, thin, letterbox panoramic if it suits the subject.

⬆ CONVERTING TO MONO
It's a simple matter to remove the colour from an image and make it black and white. You can then vary the contrast and make all the adjustments you would in a darkroom.

➡ SPECIAL EFFECTS
Dozens of different effects, many of them startling – such as extrude, used here – are available on most programs.

ADVANCED TECHNIQUES

Beyond the basics of image manipulation, there are dozens of things you can do to improve your pictures. In fact, you might come to regard the picture-taking stage as just the first part of the process, with the digital imaging 'lightroom' taking things on to the next dimension.

Some of the processes are remedial – such as removing red-eye or correcting for converging verticals – while others are creative, such as adding a frame or vignette, using filter effects, converting to black and white, toning and tinting, and creating montages of different elements.

• Working in mono

If you've taken a picture in colour that you think would look better in black and white, it's a simple matter to convert it. The best way is simply to desaturate the image completely. This 'hides' the colour information in the picture, but allows you to restore it should you ever want to.

If you're confident that you want the picture to stay black and white, change it to a grayscale image, which has the advantage of being a smaller file size. Once the photo is in mono form, you have the option of doing all the things you could do in a darkroom, such as changing the tonality from soft to contrasty, toning the image sepia, blue or some other shade, or colouring parts of the image. Of course, if you have pictures that were originally

taken in black and white, they too can be scanned and manipulated in all these ways, rather than using a darkroom.

• Correcting for red-eye

However careful you are when taking pictures using flash – using reduction facilities, bouncing the light – every now and again you're bound to suffer the dreaded red-eye. In the days of film it used to be a nightmare getting rid of it, but on a computer it's relatively straightforward. In fact, some programmes have the process automated, making it child's play. On others that don't there are various options, including simply painting over the offending area with a more appropriate colour.

• Correcting for converging verticals

Using stretching and transformational tools it's possible to correct for converging verticals in architectural shots – so the uprights really are upright, and the building no longer looks as if it's falling over backwards. All you have to do is drag the top left and top right corners out to the side and then crop the image back to a rectangle.

• Filter effects

Most image manipulation programs feature dozens of different 'filters' that completely transform the

image. There's everything from adding grain or blur to transforming the image to look as if it has been painted or stretching it out of all recognition. While they're fun to play with, some of the results can look truly awful.

Most people quickly get over the 'digital madness' of using filters on every picture and start to use them in subtle ways that enhance the subject matter. The artistic filters normally include a collection that replicates classic photo effects such as solarization and reticulation.

• Combining images

As you gain confidence and skill in your digital imaging, you'll find yourself wanting to combine different photographs.

The secret lies in cutting out the various elements carefully, and 'feathering' the edges so there's no sharp transition from one to the other. You also need to ensure the perspective and lighting are the same.

Since it's easy to take a wrong turning and find that something doesn't work, it's a good idea to save copies of the montage frequently at various stages of development, so you don't have to start from the beginning again.

⬆ CONVERGING VERTICALS
If you have pictures in which buildings appear to be falling over backwards, it's possible to correct them so they look upright.

◀ ⬆ COMBINING IMAGES
The background in this picture of a waterseller in Morocco (far left, top) is rather distracting. The main subject was therefore cut out from the background (far left, bottom) and a plain brown background was created using the paint bucket tool, and the cut out figure superimposed (left). An alternative version (above) was made in which the background was blurred so it was less of a distraction and the sharp cut out figure layered on top of it.

Cash from your camera

Photography can be an expensive hobby, but if you can take pictures that are sharp, well-exposed, attractively lit and interestingly composed, you could easily be earning money with your camera – certainly enough to cover your costs and maybe, eventually, sufficient to earn a living as a photographer. There are many professionals who began as amateurs and, as their skill and experience increased, started selling a few pictures here and there. Over time they reached the stage of being 'semi-professional', and ultimately had the confidence to 'turn pro'.

PHOTO MAGAZINES

One of the easiest ways of starting to profit from your pictures is to submit work to photographic magazines. By their very nature, these have a voracious appetite for new images and, with numerous weekly, monthly and quarterly titles on the market, there are plenty of opportunities to get your work published. What's more, the majority of these publications have a policy of favouring accessible work by amateur photographers.

The principal focus of the most successful magazines in the market is technique, and they have a constant need for pictures to illustrate 'how-to' articles on all subjects. While these can be individual shots, you're much more likely to get pictures accepted if you submit comparative sets. The kinds of things that are required are before-and-after filter shots, the effect of different apertures and shutter speeds or straight on and bounced flash, the use of different close-up accessories, taking pictures in good and bad lighting, and how perspective changes with focal length. And the good thing about having a set of pictures published rather than one is that you receive a bigger repro fee.

One of the best ways of working is to draw up a list of all the comparative sets you want to shoot on a piece of card that you keep in the back of your gadget bag. A flip through a book about photographic technique or a glance at some back issues of popular magazines should give you plenty of

⬆ ➡ PROFESSIONAL QUALITY
When taking pictures with a view to selling them you need to go the extra mile and produce professional quality work. Here the use of a sophisticated reflector system lifts this beauty shot out of the ordinary.

ideas. Then, when you're out and about, you won't ever find yourself wondering what to photograph.

When shooting pictures for the photo press it's worth remembering that the most popular subjects are people, landscapes, buildings, travel and wildlife. Photo magazines are more open-minded than most periodicals, and will usually accept prints and digital images as well as slides.

SPECIALIST MAGAZINES

Beyond photographic magazines, thousands of other specialists magazines and journals represent the biggest single market for freelance photography. There are titles in print covering every conceivable hobby, interest, age group and occupation, so the need for good-quality pictures is insatiable.

The easiest way to get started is by concentrating on magazines you're already familiar with. If you have another hobby – such as gardening, camping or restoring antiques – then you're halfway there because you'll know the relevant magazines on the market, and you should have a good idea of the type of picture they use. And since the topic interests you, the chances are you've got pictures already on file that may be suitable.

Alternatively, if you shoot a range of subjects, you can look around for magazines that use the type of pictures you take or have on file. A weekend by the coast, for example, might produce a set of shots that would be of interest to boating and yachting magazines, even though you know nothing about the subject.

The key to success is understanding what kind of pictures your chosen market needs. It's pointless sending colour pictures if only black-and-white are used, or moody, atmospheric shots when basic, illustrative material is preferred.

Although some hobbyist magazines will accept colour prints, transparencies are the preferred medium. Most magazines find 35mm perfectly acceptable. Black-and-white photographs should ideally be supplied as 10 x 8in glossy prints made on resin-coated paper.

Each submission should be accompanied by a neatly typed covering letter explaining briefly what the pictures have been sent for – such as a certain

MARKETABLE THEMES Many periodicals, especially the women's press, use quirky, humorous pictures as fillers. Each repro fee may not be high, but over time the sums can add up.

LOCAL INTEREST This shot was one of a series commissioned by a leading house building company, but could just as easily have been shot speculatively for use on a calendar, postcard or the cover of a county magazine.

feature in the magazine. Initially, your best bet is to offer pictures for the magazine's stock files, so they can be held for two or three months for possible use in any suitable features. Once you've made a few sales this way, however, you can then phone up and ask for specific picture requirements to increase the chance of making sales.

GREETINGS CARDS AND CALENDARS

If you're into photographing gardens or animals, the greetings card market could be tailor-made for you, as these two are by far the most popular photographic subjects used in this field. 'Florals', as they're known, tend to feature attractive garden scenes and still lifes, while the animal shots used tend to be cute or humorous. The vast majority of

⬆ CLASSIC VIEWS
Images of every
conceivable subject are
in demand by picture
libraries to meet the
needs of their clients.
In particular, it's worth
taking classic shots
recording the iconic
features of an area, such
as this picture of
Roquebrune in France.

postcards are bought when people are on holiday, so to be in with a chance you must first photograph the right places – coastal resorts, picturesque towns and villages, city sights and attractive landscapes – in colour. More often than not the pictures should also be taken during summer, featuring bright sunlight and attractive blue skies. Exceptions to this rule include moorlands, mountains, lakes and other areas that are visited all year round by people who are interested in more than getting a suntan.

It's a similar story with pictorial calendars. The general market is dominated by a handful of companies and they tend to want bright, colourful, well-composed seasonal shots of popular sights and scenes. Many calendars on sale to the public depict specific towns, cities or counties and regions, while a few are more diverse, containing pictures taken from all over the country. There's also a small market for subjects such as picturesque country cottages, gardens, flowers and pets.

Most postcard and greetings card publishers will accept 35mm, but some calendar publishers prefer medium and larger formats. For either market, however, you'll need to shoot transparencies, and, unless there's a specific reason for it, you should always use slow film to achieve fine-grained, well-saturated images.

PICTURE LIBRARIES

Commercial picture libraries work in a similar way to your local library – and are a great way for amateurs to get into freelancing. When a publisher requires an image for use in a book, advertisement, magazine, brochure, calendar, audio-visual presentation – or anything else – it will often approach a number of picture libraries to see if they have anything suitable. Big libraries keep millions of images on file, so even the most unlikely, or ordinary, requests can usually be accommodated. For the publisher, buying the rights to an image from a library is generally a much quicker and cheaper option than commissioning a photographer to take the picture specially.

Once a suitable image is found, a fee is agreed:

how much that is depends on how the picture is going to be used, where in the world, and for how long. The fee is then split, with the photographer usually receiving 40–50 per cent and the rest being retained by the library. This may sound like an unfair division as far the photographer is concerned, but you have to bear in mind that the library is doing all the marketing, negotiation and accounting for you.

Pictures are taken speculatively at the photographer's expense, and then submitted for selection. A library will take into its files only images it believes to be saleable.

Most libraries need to see an initial submission of 100–200 top-quality colour slides before they'll consider taking you on. If you are accepted you'll also be expected to make regular submissions. This isn't such a bad thing, though, because the more pictures you supply, the more money you stand to make. Ideally you need at least a thousand pictures on file to see a regular return, but if you're shooting at weekends and on holidays the numbers will soon mount up.

A lot of photographers make the mistake of thinking that they can shoot anything and it will sell. Unfortunately, life isn't like that. Your work will be competing with that of many other photographers, so only the best will do. But you can maximize your sales by finding out what kinds of pictures are lacking on the library's files and shooting to fill the gaps, and looking through stock catalogues to see what sorts of pictures are selling and making an effort to photograph saleable subjects.

If you think you're the right photographer for this type of discipline, check picture library listings to see the areas they specialize in and shortlist a few that might be interested in seeing your work.

PEOPLE AND PETS

Although most families possess a camera or two, the pictures they take are rarely more than snapshots. So there's a ready market for photographers who can create good-quality portraits.

The trend these days is away from stuffy 'old master' portraits, with stiff, formal poses shot in a studio, and towards more informal, relaxed compositions. Of course, the lighting and technical quality still has to be better than the subjects could achieve if they were taking the picture themselves. Particular attention should be given to getting the posing right.

Pets are now increasingly regarded as part of the family, so it's not surprising that many owners want portraits of Fido or Whiskers. But often this is easier said than done, as animals can be lively subjects, and skilled pet photographers are in great demand.

WEDDINGS

Another option is to go into wedding photography – but do think carefully before saying 'I do' to a couple planning to get hitched. You must be absolutely, totally, one hundred per cent confident in your abilities before making such a commitment.

Weddings are unrepeatable, once-in-a-lifetime events, and taking the all-important pictures of such occasions is really best left to professionals – who are experienced in producing high-quality images of large numbers of people while working against the clock. But if the idea of shooting weddings appeals to you, the best way of developing the skills required is to approach an established wedding photographer and ask if you can assist for a period before setting out on your own.

WEDDINGS
Shooting weddings is a skilled business, and should never be undertaken by anyone who doesn't feel confident in their ability to deliver. But for those with the many skills required, it can be a profitable pursuit.

CHILD STUDIES
This picture has been published a number of times, both as direct sales to children's magazines and via a stock library. Quality images of children and adults are always required.

Storage and presentation

You invest a lot of time, effort and money into taking great pictures, so it's important that you both show them off to the best advantage and make sure they're safely stored for posterity.

It's all too easy to be so excited about getting out and taking new photographs that those you have are shoved into shoeboxes or left in the envelopes and boxes in which they came back from the lab. What a waste. But it doesn't have to be that way.

PRESENTATION MATTERS

When you take a picture that's really special, have an enlargement made, so you can appreciate it properly and share it with others. Don't just get a 10 x 8in print, but something with impact – 12 x 16in or even a 20 x 16in blow-up if it's pin-sharp and shot on a fine-grained film. Shop around and you'll find the cost is very reasonable.

But don't just leave it at that. If you want to maximize the impact of your pictures it's worth getting them properly mounted. And while you could hand the job over to a framing company, you'll find it a lot more satisfying – not to mention cheaper – to do it yourself.

Most prints benefit from having a large border round them, and the most effective way of providing this is with a bevel-edged window mount. Here's a step-by-step guide to making one:

1 Visit your local art and craft supplier and choose the material for your mount. You'll find art boards in a wide range of types and colours. You'll want a sheet that gives you a border of at least 5cm (2in) all around the picture, so for a 12 x 16in print you'll need a sheet measuring 40 x 50cm (16 x 20in). Unless you have a specific effect in mind, stick to white or grey board.

2 Now you need to mark out on the card the size and position of the window you intend to cut out. Deduct the length and width of the print from the length and width of the board and divide the results in half to give the border widths.

3 Using a clean ruler, measure the borders and mark them with faint pencil lines on the back of the card to show the area that needs to be cut out.

4 You'll need a mountcutter – available from craft suppliers – to achieve a 45° bevel-edged effect around the window. Actually cutting the card is best done from the back. Line up the cutter against the pencil line and slide it back and forth with a smooth action until a clean cut has been made. Then cut the other three sides in turn.

5 Use strong but low-tack masking tape to hold the print in place.

If the picture is to be displayed, you'll probably want to put it into a frame. A wide range of frames can be bought ready-made from gift and department stores, or you can go to a specialist framing company. If the picture is to go in a portfolio, some kind of transparent sleeve will be essential to protect it.

Beyond simple enlargements there are many other ways to make your pictures part of your everyday life: you can have images printed on to T-shirts, mugs, watches, table mats, baseball caps and business cards. These are things you'll use all the time, allowing you to enjoy your pictures on a regular basis. They also make wonderful personal gifts for family and friends.

STORAGE MATTERS

Admittedly, storage isn't very exciting. But it is important. If you don't look after your images they could easily get damaged, you won't be able to find them when you want them, and they may not be around for future generations to appreciate. But if you protect them from harmful chemicals, excessive heat and humidity, strong daylight and physical damage, they'll be around for a long time to come.

• Slides

Keeping slides in the plastic boxes supplied by the processing lab in may seem convenient, but as your collection grows this can become a real nightmare. Which box was that picture in? And where's that box now?

Instead, nip the problem in the bud and start as you mean to go on with a decent transparency filing system. Many companies produce transparent filing pages, enabling you to store 20 or 24 slides in each. All you have to do to view them is hold them up to the light or place them on a lightbox. Depending upon the size of your collection, you can buy pages that either fit in a ring binder or hang in a filing cabinet on suspension bars. But don't cram slide storage sheets into a filing cabinet. If air can't circulate they can easily develop mould. It's also important to check that the pages you buy are achivally safe and don't contain chemicals that could damage the slides.

• Negatives

It's a similar story with negatives. These are normally cut into strips of six or seven frames, and are best filed in special A4 sheets, each designed to accommodate one 36-exposure or 24-exposure film. Keep them in an A4 ring binder, together with a contact sheet made on 10 x 8in paper. If you choose negative filing sheets that are completely transparent you can produce the contact sheet without having to remove the negative strips. This minimizes the risk of scratching and problems with dust and debris. Once again, it's really important to ascertain that the sheets you are using are chemically inert.

• Prints

The main issue with regard to print storage is light. You need only leave a colour print exposed to sunlight for a little while to see the colour start to drain away from it and a blue cast appear. Clearly when you frame a picture and display it on a wall or mantelpiece it's going to fade, but you can reduce the speed at which it fades by placing it out of direct sunlight. Other prints are best stored away from light completely: in albums, portfolio cases and, yes, even the envelopes in which they came back from the lab.

What went wrong?

Even with the high level of automation available on modern cameras, things can still go wrong, and it's not always easy to understand the reason, as some of the faults have similar effects. The most common problems you're likely to encounter are described here – along with advice on how to avoid them in the future

SUBJECT OUT OF FOCUS

Problem: The most important part of the picture is fuzzy and indistinct, while other areas are sharp.

Cause: It's a focusing problem; exactly what type will depend upon the kind of camera used. If it's an autofocus camera, the chances are that the focusing sensor at the centre of the viewfinder area has missed the main subject, perhaps focusing on the background instead. If it's a manual focus camera, then focusing has not been accurate.

Cure: With autofocus cameras, either make sure the main subject falls under the central focusing window, or use the focus lock to ensure that an off-centre subject is correctly focused. With manual focus cameras use the microprism/split-image aid at the centre of the viewfinder to ensure critical focus. If problems persist, have your eyes tested.

PICTURE BLURRED

Problem: The whole picture is blurred.

Cause: This is camera-shake: the camera moved during the time that the shutter was open.

Cure: When you are hand-holding, always set a shutter speed that is at least 1/the focal length of the lens in use. If it's a 50mm lens, use at least 1/60 sec; if it's 200mm, use 1/250 sec; and if it's 600mm, use 1/1,000 sec. If those speeds are not possible, use a tripod to give the camera firm sup-

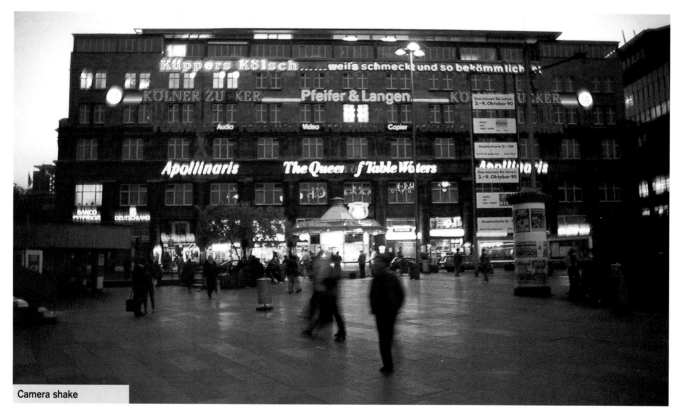

Camera shake

port and a cable release to avoid jarring it when firing the shutter release.

FOREGROUND SUBJECT NOT SHARP

Problem: The subject was close to the camera but came out blurred.

Cause: The picture was taken on a 35mm compact and the subject was closer than the camera's closest focusing distance.

Cure: Make sure you know what the camera's close-focusing distance is and avoid having anything closer.

PICTURE TOO DARK

Problem: The picture is too dark.

Cause: The film has suffered serious underexposure – that is, not enough light has fallen on it. The exact problem depends upon the camera used and

the picture-taking situation. If the subject was extremely light in tone, or you were shooting into the light, it's likely that the camera's meter was fooled by the excess brightness.

Cure: Use exposure compensation when dealing with light/bright subjects. If you suspect a metering fault, have the camera checked over by a trained technician.

PICTURE TOO LIGHT

Problem: The picture is too light.

Cause: The film has suffered serious overexposure – that is, too much light has fallen on it. The exact problem depends upon the camera used and the picture-taking situation. If the subject was extremely dark the camera's meter may have been fooled by the excess darkness.

Cure: Use exposure compensation when dealing with dark subjects. If you suspect the problem is due to a metering fault, have the camera checked over by a trained technician.

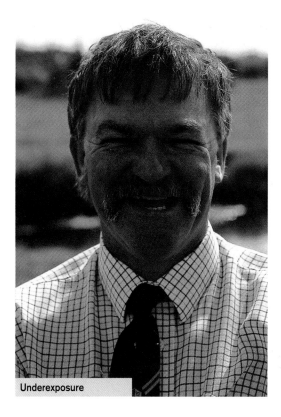

Underexposure

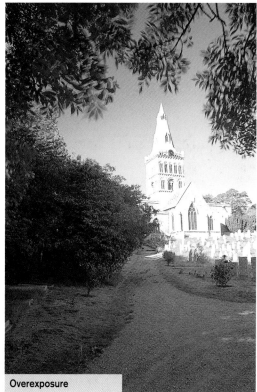

Overexposure

ORANGE CAST

Problem: The picture has an overall orange colour.

Cause: The picture was taken using daylight-balanced film under tungsten lighting, which, although our eyes don't always see it, gives out a light that is extremely orange in colour.

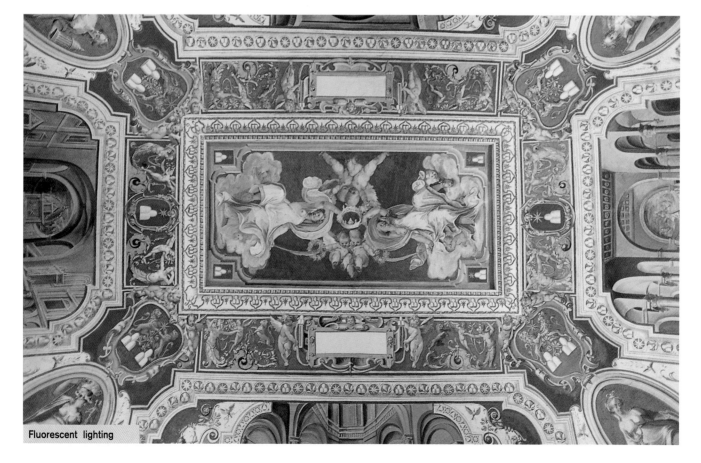

Tungsten lighting

Fluorescent lighting

Cure: One option is to use electronic flash, which will blot out the tungsten, although that will alter the mood of the shot. Another solution would be to fit a strong blue filter (80A) over the lens to absorb the worst of the orange. You could also load up with a film specifically designed for use under tungsten lighting. Finally, you could shoot in black and white, when the colour of the light is irrelevant.

BLACK BAND

Problem: There is a black band across the photograph.

Cause: The picture was probably taken using electronic flash with the wrong flash synchronization speed set. One other possible, but less likely, explanation is that the film did not travel correctly through the lab's automated processing machinery.

Cure: When using electronic flash, ensure that the shutter speed is never faster than the camera manufacturer's recommended speed. This tends to be somewhere between 1/60 sec and 1/125 sec for

amateur cameras, and around 1/200 sec to 1/250 sec for professional models. There is no problem if you use a longer shutter speed. If no flash was used, take up the matter with whoever processed the film.

ORANGE PATCHES

Problem: While parts of the picture look perfect, parts have bright orange patches on them.

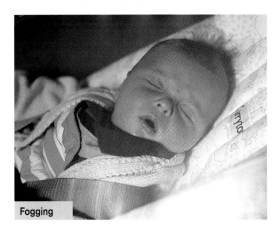
Fogging

Cause: The film has been partially fogged. That is, stray light fell on to it before it was processed. The most likely explanation is that the camera back was opened accidentally while the film was being loaded, or that the back itself has a leak. Occasionally, the problem may be a faulty felt light-trap on the film cassette, and very rarely the damage may have occurred at the lab.

Cure: Very quickly run through a 12-exposure film to see if the problem repeats itself. If it does, suspect a leak in the camera. If the film looks fine, the problem may have been a one-off. In future, make doubly sure that the film back is never opened while a film is loaded.

OVERLAPPING FRAMES

Problem: All the images on the film overlap and run into each other.

Cause: The film didn't advance correctly through the camera and the first frame was not fully moved on, with the result that part of the next frame was exposed on top of it.

Cure: On most cameras this is not a user-fault. You should have the camera checked over by a trained technician.

RED-EYE

Problem: On pictures taken with electronic flash people have glowing red eyes.

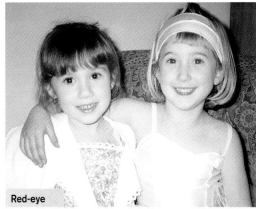
Red-eye

Cause: The flash was reflected back from the blood vessels at the back of the eyes.

Cure: If you have an external flashgun with a bounce head, use it, or take the gun off the camera and hold it to one side. If that's not possible, use the camera's red-eye reduction facility if it has one. If not, switch on any room lights so the pupils of your subjects' eyes close down, minimizing the risk of red-eye.

BLEACHED-OUT FACE

Problem: On a portrait taken with electronic flash the face is white and harshly lit.

Cause: The flashgun/camera was too close to the subject, causing overexposure.

Cure: Keeping at least 1–1.5m (3–5ft) between you and your subject should solve the problem of overexposure. The harshness of the light is caused by the direct nature of the flash, and can be softened by fitting some kind of diffuser, or by bouncing the light from a wall or ceiling if your flashgun offers that facility.

Thumb in view

OBSCURED CORNER

Problem: A strange, round, orange shape appears at the corner of the picture or along the edge.

Cause: Your finger was partly over the lens when the picture was taken.

Cure: Learn to hold the camera at both sides so that your fingers can't stray over the lens.

DOUBLE-EXPOSED FILM

Problem: There are two sets of images all the way down the film, with images overlapping each other.

Cause: The film has been put through the camera twice.

Cure: If your camera doesn't wind the leader fully back into the cassette when it rewinds the film, do so yourself manually, by rotating the top part of the cassette. This makes it simple to check whether a film's been used: if the leader is out, it hasn't; if the leader is in, it has.

FLARE

Problem: Loss of contrast and sharpness when shooting towards the light.

Flare

Cause: Non-image-forming light scattered by reflections within a lens or enlarger/camera interior, which reduces image contrast and detail. Flare can affect film by causing a lowering of image contrast.

Cure: Avoid having light falling directly on to the front element of the lens by changing your position so you're in shade, fitting an effective lens hood, or holding your free hand up above the lens just out of shot to block the sunlight.

Index

Bold numbers indicate main entries

Acknowledgments

I would like to acknowledge and thank everyone who contributed in any way to this book.

First of all to Amanda, Helen and Jack, who are a constant inspiration.

To all the people who I've learned from over the years, and those who have kindly allowed me to photograph them.

To photographic companies including Canon UK, Hasselblad UK, Lastolite, Leica and Christie's (www.christies.com/cameras) who provided equipment pictures.

Thanks also to Lloyd Design and Stamford Homes for whom I took the photographs on p90, p114 (croissants), p115 (rocks), and p116 (eggs)

And last, but not least, to all the team at David & Charles for their consummate professionalism, including Neil Baber, Sue Cleave, Freya Dangerfield, Lewis Birchon, Kelly Smith and Jane Simmonds.